Hands in Harmony

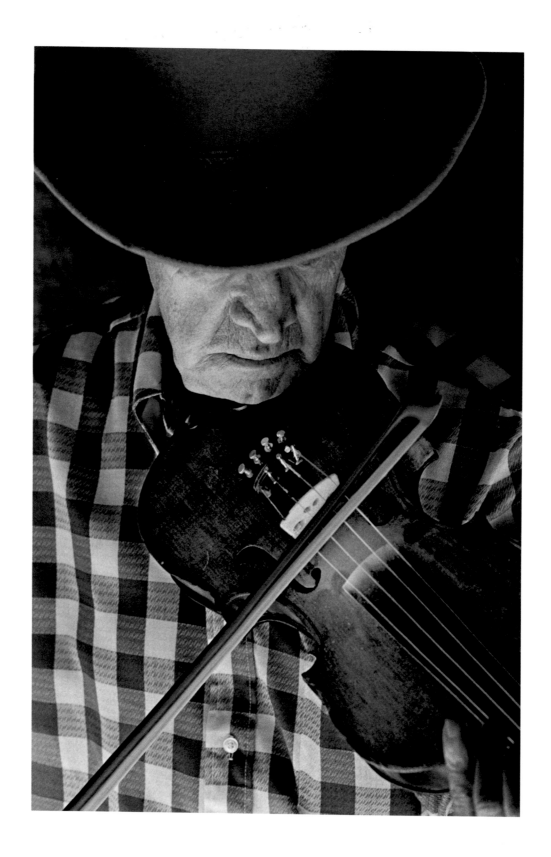

Byard Ray playing fiddle, 1978 • Asheville, Buncombe County, NC

Hands in Harmony

TRADITIONAL CRAFTS AND MUSIC IN APPALACHIA

TIM BARNWELL

FOREWORD BY JAN DAVIDSON

W. W. NORTON & COMPANY, INC. • NEW YORK • LONDON

Hands in Harmony: Traditional Crafts and Music in Appalachia
Tim Barnwell
Copyright © 2009 by Tim Barnwell

Manufacturing by Mondadori Publishing, Inc.
Book design and composition in Electra

Library of Congress Cataloging-in-Publication Data
Barnwell, Tim, 1955-
Hands in harmony: traditional crafts and music in Appalachia /
Tim Barnwell; foreword by Jan Davidson.—1st ed.
p. cm.
ISBN 978-0-393-06815-3 (hardcover)
1. Photography of handicraft.
2. Country musicians—Appalachian Region—Portraits.
3. Barnwell, Tim, 1955–
4. Appalachian Region—Social life and customs—Pictorial works.
I. Title.

TR658.5.B37 2009
779'.9781642–dc22
2009010723

W. W. Norton & Company, 500 Fifth Avenue, New York, NY 10110
www.wwnorton.com

W. W. Norton & Company Ltd., Castle House, 75/76 Wells Street, London, W1T 3QT

NOTES ON THE LOCATIONS OF PHOTOGRAPHS
The photographs in this book were made over a twenty-five-year period, in North Carolina, Tennessee, Virginia, and Kentucky. Accompanying titles identify the subject, location, and the year they were taken.

IDENTIFICATION OF PEOPLE IN GROUP PHOTOGRAPHS
Following is a list of people appearing in group photographs who are not identified in the image title. Names are arranged as the people appear from left to right in the image. Page 54: Mark Howard, Jonathan Yudkin, John Hartford, Roy Husky Jr.; page 56: Janice Birchfield, Greg Speas, Bill Birchfield, Ivy Lindley; page 81: Minnie Adkins, Greg Adkins, Herman Peters.

Cover photo: Carlson Tuttle with handmade brooms, 2006 • Burnsville, Yancey County, NC

Contents

Acknowledgments

I would like to thank my wife, Kathryn, for her unwavering support of my work and for understanding the long hours involved in both completing this project and bringing it to book form. A special thanks goes to my daughter, Callie. Born several years after I began this project, she has grown up around it and has been a great help in preparing the book materials. To my friend Nick Lanier I am indebted for his invaluable assistance in all phases of this project. I would also like to thank the following folks and organizations for their assistance in this particular project: Janet Wiseman and the staff of the Folk Art Center, Merlefest, Bruce Greene, Sheila Kay Adams, David Holt, Nancy Conseen, Kituwa staff, Betty DuPuy and the Qualla Arts and Crafts Mutual, Phil Jamison and the staff of the Swannanoa Gathering at Warren Wilson College, Alice Gerrard, Jean Pedi, Loy McWhirter, Micah Sherrill, Adrian Swain and Matt Collinsworth of the Kentucky Folk Art Center, Suzanne McDowell and staff of the Mountain Heritage Center at Western Carolina University, Josh Graves, Michael Sherrill, the Opportunity Corporation of Madison County, the Orange Peel Club, Harper and Wanona Van Hoy of Fiddlers Grove, Cara Ellen Modisett of *Blue Ridge Country* magazine, Leesa Sutton Brandon and the Mountain Dance and Folk Festival, Ron Ruehl and Lawson Warren of the *Liberty Flyer* radio program, Craig Smith and the staff of *Our State* magazine, Eric Seeger and *WNC* magazine, and especially my current and former studio assistants Kari Metcalf, Richard Hasselberg, Anna Calloway, Tad Stamm, Steve Mann, Rachel Calloway, Chelsey Knight, Nicole Mahshie, and Scott Allen.

A special thanks to Jane Woodside and Loveeta Baker for their help in transcribing the many hours of taped interviews, and Jane for assistance with some biographies. Many thanks go to George Tice, an ardent and longtime supporter of my work, for his advice, knowledge, and assistance. To all the folks at W. W. Norton and Company, including my editor James Mairs, editorial assistant Austin O'Driscoll, and book designer Katy Homans, I am greatly indebted.

My deep gratitude goes to Don Pedi, a wonderful musician and close friend, who introduced me to many of the musicians and accompanied me on visits to photograph them, for his advice on old-time music and musicians and help with the CD music selection and production. This project would not have been a successful one without his input and assistance.

Although it is impossible to thank all the people who have helped and supported my work over the past thirty years, and I apologize to anyone I may have omitted, I would like to extend my heartfelt appreciation to the following people: Virginia and Harris Campbell, Howard and Alice Barnwell, Ken and Alice Lawson, Ralph Burns, Carson Graves, Judy Canty, Brigid Burns, Sally Stark, Steve Brechbuhl, Robert Brunk, John and Phyllis Smith, John Cram, William Clift, and Robert Yellowlees, Tony Casadonte, and Laura Noel of the Lumiere Gallery of Photography in Atlanta.

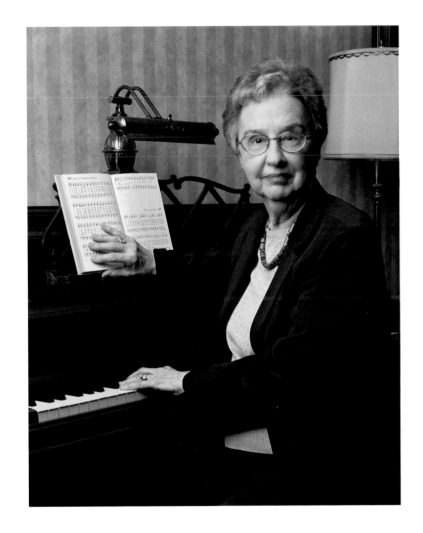

FOR MY MOTHER,
VIRGINIA G. CAMPBELL

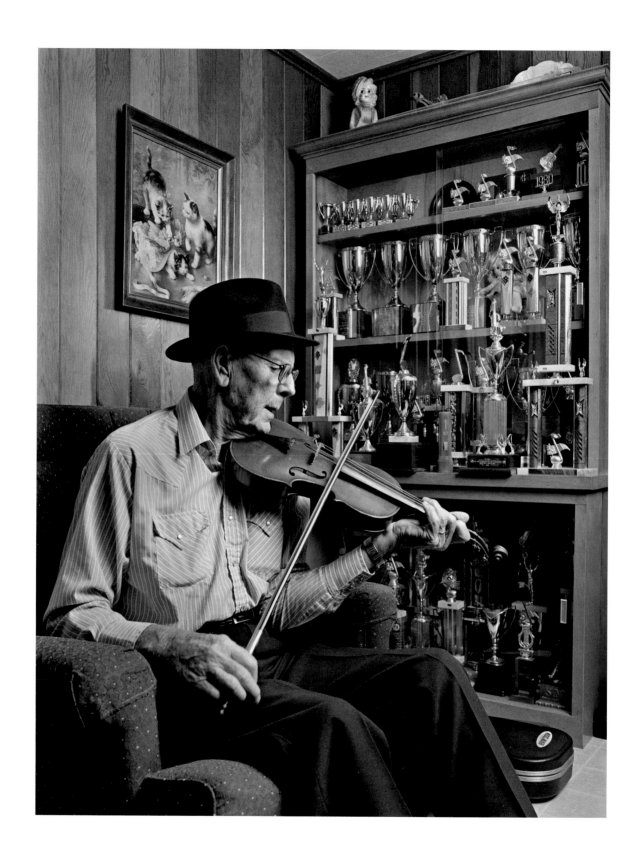

Benton Flippen and music trophies, 2007 • Mount Airy, Surry County, NC

Foreword

These remarkable pictures were made over a period of thirty years in a region that extends from North Carolina flatlands east of Raleigh, north into Kentucky and west to Nashville. Though it ranges beyond the usual geographical boundaries, this body of work is "Appalachian." In most of the places shown in this book, "where you from?" is still an important question. Western North Carolina, where Tim is from, and Asheville in particular, have a special importance in the history of the idea of Appalachia and the multiple layers of meaning it has for us today. Here an early scholarly interest in the music, especially the ballads, was followed by a commercial interest that became "Country Music," and in its formative years featured mountain musicians prominently. And here began the first handicraft revival and related marketing programs.

From its beginnings, the Western North Carolina Handicraft Revival was national and international in its connections. Most of the people who took special notice of mountain ballads and weavings early in the Twentieth Century were from "off." Francis Goodrich, Olive Campbell, and Cecil Sharp came from outside the region, as did Ralph Peer, who recorded "hill country music" in a makeshift studio on the roof of the Vanderbilt Hotel in 1925 for Okeh Records. One of the people he recorded was a local lawyer and folklorist, Bascom Lunsford. In 1927, Lunsford helped start a music and dance component of the local Rhododendron Festival, which became the Mountain Dance and Folk Festival. It was at this Festival, in 1936, that a teenaged Pete Seeger found his life suddenly changed by the sound of the five-string banjo. Seeger was not the first, nor the last, Yankee to find part of his missing roots here in the mountains, at a festival designed for the purpose.

Over the course of a hundred years, Appalachia developed a reputation for being old-timey. At the beginning of the Twentieth Century, we were known for ballads and bedspreads. Early ballad hunters sought the remnants of the Scottish and English songs that seemed to reveal mountain people as a survival of the past—"contemporary ancestors," as President Frost of Berea College put it. Among the things that seemed to confirm it were old songs about knights and magic, and the survival of skills such as home weaving and spinning, long after the Industrial Revolution had displaced them elsewhere. It was not just the old-time nature of the fiber arts that attracted the women who made the Revival; the home-centered fiber arts were a contrast to the textile mill life nearby that regulated days by the factory whistle instead of the rooster crow.

Outsiders first fussed about mountain music because it contained ballads that were obviously very old survivals from English and especially Scottish origins. Harvard professor Francis James Child had canonized ballads in *The English and Scottish Popular Ballads* (1882–1898), drawing on texts collected earlier, such as Sir Walter Scott's from about 1800. Olive Campbell, starting in 1907, documented the texts and tunes of Appalachian singers of these ballads. She involved the English ballad scholar Cecil Sharp, and they published *English Folk Songs of the Appalachians* in 1917. The genealogy from here goes on interminably, but let me assert that without Olive Campbell, there would be no Joan Baez, no Bob Dylan the folksinger, and surely no Grateful Dead. Just take my word for it.

In 1895, Francis Louisa Goodrich, a Yale-educated watercolor artist from Ohio, began an organization that was Western North Carolina's first handicraft revival program, centered around the production of woven overshot coverlets, bedspreads that had been made among mountain families in the generation preceding her arrival. At a time when the necessity of home weaving was lessened by the arrival of railroads and availability of "store-bought goods," when big looms were being chopped up for firewood, Goodrich envisioned a market for bedspreads in the North and mid-West among the ladies of old New England families with colonial and "colonial revival" homes.

Goodrich found a few older ladies in Madison County, North Carolina who were willing to teach the skills of carding, dying, spinning and weaving to the younger women. Her linking up of mentors and learners of spinning and weaving around nearby Allanstand, in 1897, was an important seed of the great craft schools, John C. Campbell Folk School and Penland School of Crafts. Both were started in the 1920s by younger women, Olive Campbell and Lucy Morgan, who studied and appreciated Miss Goodrich's "Allanstand Craft Industries." In 1931, the Southern Highland Handicraft Guild in Asheville was born, with Campbell and Morgan as two of the prime movers, and Miss Goodrich generously turning over to the Guild the Allanstand operation. In the post-World War II period, the Eastern Band of Cherokee developed attractions to teach their history, such as the Oconoluftee Village, where many old skills were passed on through demonstrations, and the Qualla Arts and Craft Mutual, which has provided a respectful and effective center for education and marketing crafts.

Asheville was the center and market town for a large mountain area of tiny county seats and expanses of thinly settled rural areas. It was a small resort city with international upper crust folks, the Vanderbilts of Biltmore notably, and a large summer population of middle-class vacationers, TB patients and retirees. It was one of the few places in Western North Carolina where any sizable amount of surplus income existed, and thus was the place where crafts, jellies, and pickles might find a market.

The kinds of cultural tourism and heritage events that cover the map today were invented decades ago in places like Asheville and have been a part of life there for generations. The mountain culture has been remarked upon, written about, documented and observed as a culture for a long time. We left behind the era of unreflective innocence long ago, and our cultural manifestations—banjos, ballads, quilts, dances, recipes, and stories—exist as very normal parts of our lives, but they have also become iconic.

By the time Tim and I discovered that we were Appalachian, somewhere in the early 60s, the concept had already been around for two or three generations. Some people thought it was the Scotch-Irishness that made an Appalachian out of you, while others thought it was the rural nature and small mountain town life. Finally, the consensus was that Appalachians are those people who live "up there," and do Appalachian things like making music, handcrafts and small farming. Today's Appalachia is full of baby boomers that had to leave the region for their education or careers, and have returned in retirement to try to live as much like Papaw and Mamaw as possible.

In theirs and many American homes of the 1960s, was great black and white photography lying around in piles of magazines. Publications including *Life* and *Look*, not only spread the

best journalistic photography across their big pages, but also paid tribute to photography as an art form. Tim spent hours looking at these and later the portraits of Imogen Cunningham and Arnold Newman, and landscapes by Ansel Adams. He was printing pictures in his basement darkroom before he was a teenager, and became a full-service commercial photographer and teacher of the art, after graduating college. While most of his commercial work is color digital, when he wants to show his love and give a gift to his own people, it is likely to be from black and white film.

Tim Barnwell is an Appalachian photographer, by birth and subject matter. His work stands comfortably in the company of Doris Ulmann, Bayard Wootten, William Barnhill, and Margaret Morley, all of who produced stunning portraits of mountain people early in the Twentieth Century. In many ways Tim's work goes deeper than theirs, as most of the early photographers of Appalachia worked here over short periods of time: Barnhill 1913–1917 and Ulmann 1933–1934. Tim's documentation of farming, music, crafts and family life spans over thirty years and is still going strong.

Tim is a gentleman, blessed with a kind heart, and that makes his pictures of people better. For him, photography comes at the end of a long process of getting acquainted and establishing the trust necessary for the collaborative act of portraiture. In many instances, the photography did not take place until the third or fourth visit. The resulting images seem timeless at first, but a closer examination will reveal details that ground them in time and place. The images take you to interesting places, full of textures, shapes and information, where you and a remarkable person meet. The moment caught in an instant, captured in a blink of light that illuminates the long corridors of time. One tends to forget Tim is here, too, and it is just you and Peggy Seeger or George Goings, or you and Etta Baker on the porch.

Much of what passes for portraiture today is about celebrity, representations of faces that are as instantly understood and registered as any other corporate symbol. When you see the face, you know the whole story. Tim's people are not folks you know perhaps, but ones you want to know: Max Woody awash in chairs, Bill Monroe singing for thousands, Dellie Norton out by the corn patch, singing just for herself—and for Tim, of course. I forgot he was there. Here are such faces, still formidable, still making music and beautiful objects, filled with dignity and promise. I have had the honor of meeting almost everybody depicted here, and know some quite well. It is a delight to see them here for the ages, looking, one suspects, just as they would want to be. Some are gone now, and their pictures and words are an even more special treasure. Their words, their craft, their music flows on like the river.

Tim is a craftsman and an artist, here saluting his fellow creators and singers of life's songs. If you're only seeing nostalgia here, you're missing the point. The greatest accomplishment of this body of his Appalachian work is that it honors the past, but is also about the future. This is not the end of the old song, but another chance to learn from it. Here you will see some time-tested faces filled with hope, joy and love. Even the happiest ones bear the marks of struggle and sadness, sorrow and loss. They remind us that these are the experiences of every family, every person. Here is your family album.

JAN DAVIDSON

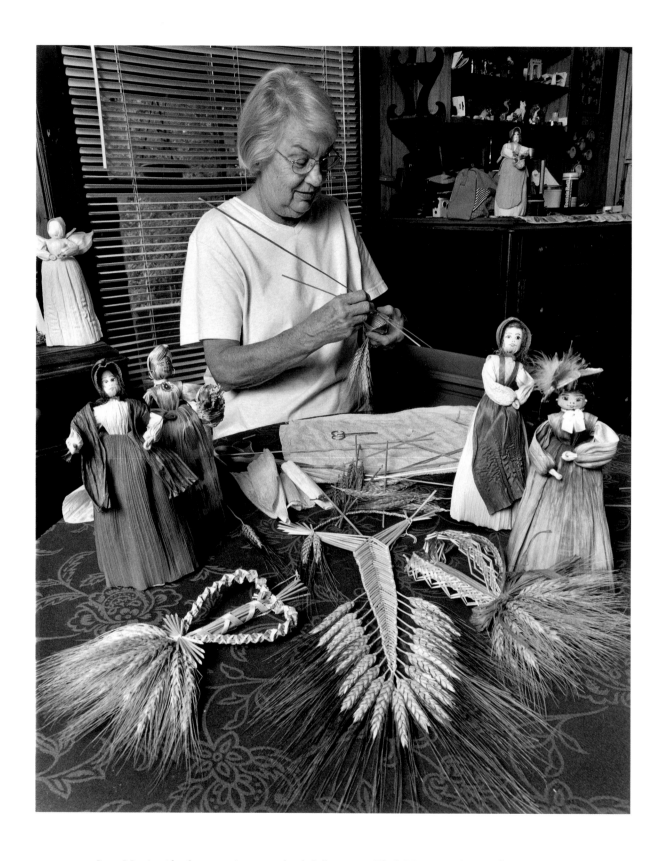

Janet Morris with wheat weavings, cornshuck dolls, 2003 • Black Mountain, Buncombe County, NC

Introduction

This project grew out of my fascination with traditional music and handcrafts, both expressions of the creative mind and accomplished hand. They are themes that have run through my photographic work for thirty years, but starting about 2001 I decided to delve deeper and make a concentrated effort to identify and photograph those involved with these wonderful arts. This book of images with accompanying interviews, biographies and music CD is the result.

Historically handcrafts were functional, utilitarian items, produced by an agrarian, pre-industrial society to meet everyday needs around the home. They were useful items which included ceramic vessels for the kitchen, baskets for storing and transporting, furniture for the home, clothing for the family, quilts for bedding, ironwork from the blacksmith, and the occasional toy for a child. Craftsmen gathered their raw materials from the earth-clay, wood, metals and plant fibers to mold, carve, forge and weave their creations. Many of these skills were passed from mother to daughter and father to son, and are still being practiced.

Today, however, their use and place in our society has been greatly diminished. With the industrial revolution came standardization, mass production, and cheap disposable products. From the standpoint of convenience and functionality, most handmade items have been surpassed by modern, manufactured goods made from superior, synthetic material, so if we choose to purchase handcrafts it is largely an aesthetic choice. They stand out among the generic, mass-produced forms from the super mart, and we value them for their beauty and uniqueness even if they aren't stain resistant, non-stick, microwave and dishwasher safe. These unique wares are a connection to our past, to an era of craftsmanship and ownership of the creative process and reflect the heart and soul of their creator. They are also the basis for many of today's artistic forms, the sculptural, figurative, and decorative creations we see in museums and galleries.

Folk music has been an integral part of our culture as well, brought to America mainly by European immigrants. It blended elements from each of those cultures and with Native and, later, African American influences. Primarily it was a form of entertainment, shared with family and neighbors at community gatherings, square dances, and church services, passed down through an oral tradition and tutorship, as opposed to learned from a music book. There is an authenticity to this music that is missing in much of today's "manufactured" popular music. Traditional tunes resonate; they feel old, timeless, a part of our heritage and culture and connect us with the past, our cultural roots, and are a signature part of our regional identity. They are songs of hearth and home, tragedy, loss, and love, and continue to enrich our lives today.

Boundaries between musical styles overlap and are largely artificial, created by retailers and marketing departments. Classifications that include traditional, old-time, bluegrass, new grass, roots, blues, alternative, Americana, and singer/songwriter, are splinters from the broad categories of "country" or "folk" of just a few years ago. Where one ends and the other takes up is difficult to define. For instance, old-time music, largely the focus of this book, encompasses fiddle tunes from the British Isles, blues, sacred songs, banjo tunes, and early country music like the

Carter Family's recordings. These styles of music were incorporated into string band repertoires and are the foundation of many of today's popular genres including bluegrass with its amplified sounds, solos, and instrumental virtuosity. So you can discuss old-time without mentioning bluegrass, but you can't explore the development of bluegrass without studying old-time. And while some have spent their careers exploring one genre, others, like Jerry Douglas, who got his start playing country and bluegrass, have expanded their repertoires to include new grass, jazz, blues, Celtic and world beats, further defying musical boundaries and classifications.

Hearing musicians perform was such an integral part of this project that I felt is was important to be able to share some of that experience with readers. To that end I secured permission from a number of the artist and their labels so that I could include a selection of tunes on an audio CD. While no substitute for a live performance, I believe it makes a wonderful introduction for those who might not be familiar with this music or a particular musician. Those interested in finding out more about an artist and the CD's they have available will find contact information listed with each track.

The accompanying CD showcases a diverse range of musical styles that include fiddle and banjo tunes, a capella ballads, Piedmont blues, folk music, and shape note singing. All are traditional tunes selected to give the listener an entry into the world of old-time music from southern Appalachia, and the surrounding region. I have included both traditional renditions as well as more modern interpretations to show directions musicians have taken the original songs.

In choosing musicians and craftspeople to feature, I concerned myself with talent rather than celebrity. For instance, the world of old-time music is a small but vibrant community, and while many of the folks are renowned within it's ranks they may not have received widespread exposure, as commercial radio is monopolized by Top 40 rock and country songs. They run the spectrum from hobbyist to the accomplished professional, and while many have established national reputations, others create simply for their own enjoyment. I have tried to include folks who represent a wide variety of musical and craft styles, all of who possess unique talents and abilities and are well respected by their peers. However, this is not meant to be an encyclopedic effort; indeed for every person included there are dozens more that could have been selected. I hope you enjoy learning about them, hearing their stories, seeing them create, and listening to their music as much as I have, and will be inspired to further explore the fascinating world of traditional music and crafts.

TIM BARNWELL

Hands in Harmony

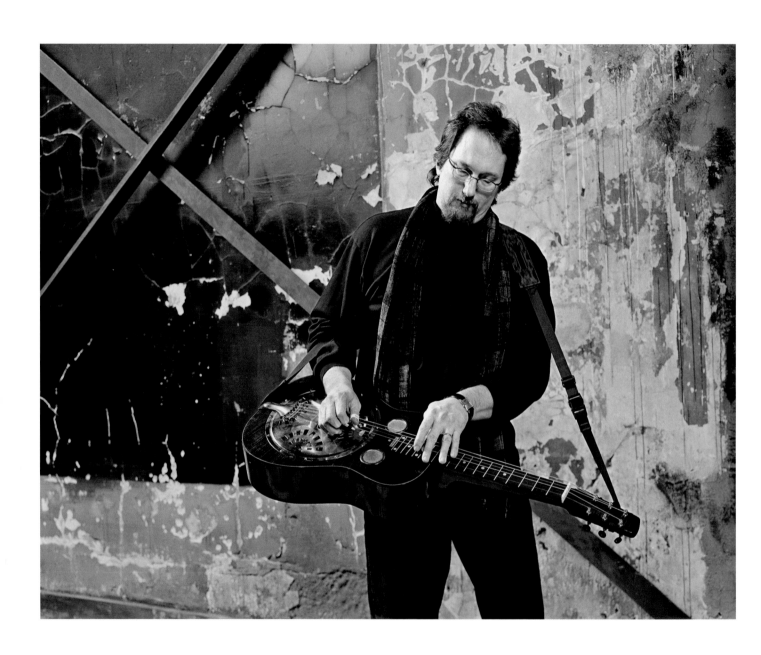

Jerry Douglas playing Dobro at Orange Peel club, 2003 • Asheville, Buncombe County, NC

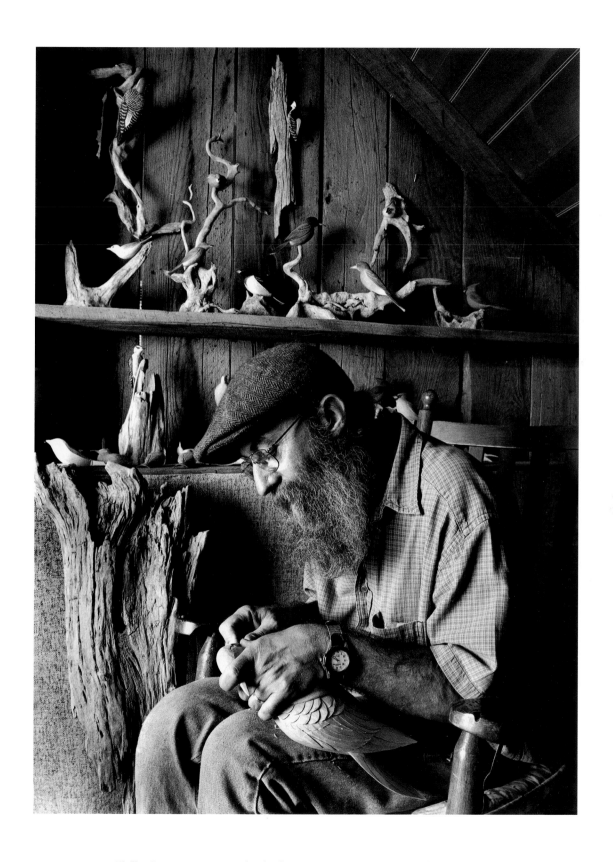

Phillip Brown carving wooden bird, 2003 • Swannanoa, Buncombe County, NC

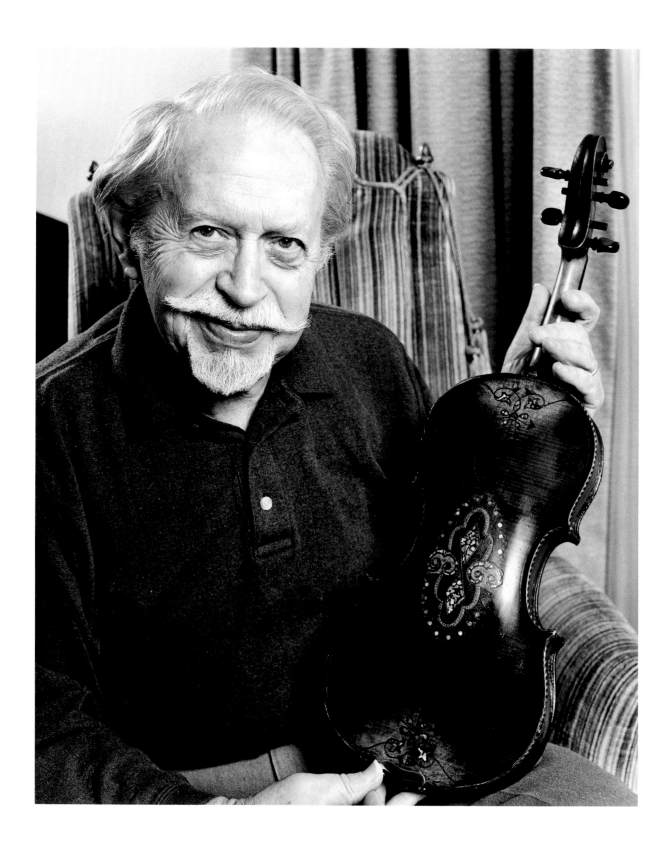

Paul David Smith with fiddle, his home, 2005 • Hardy, Pike County, KY

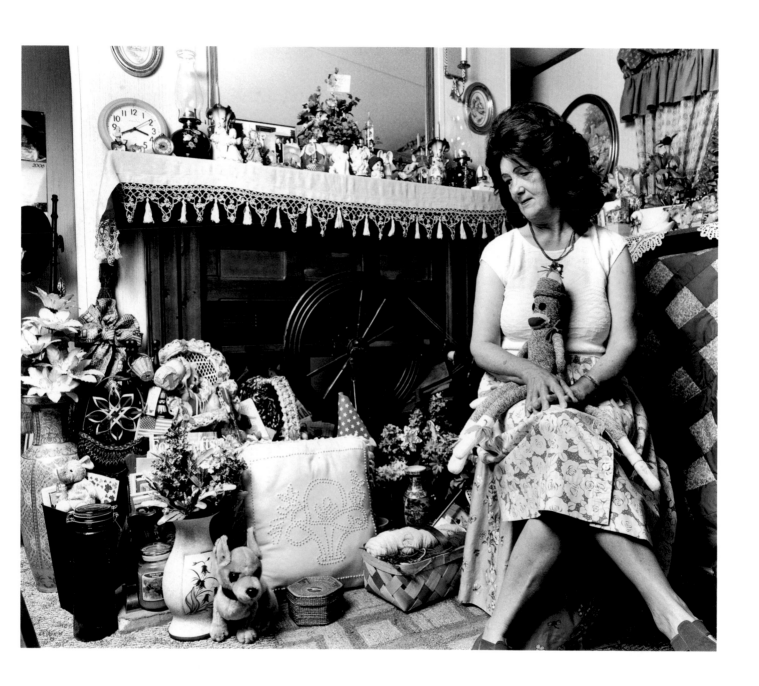

Leniavell Trivette in living room, holding sock monkey, 2006 • Zionville, Watauga County, NC

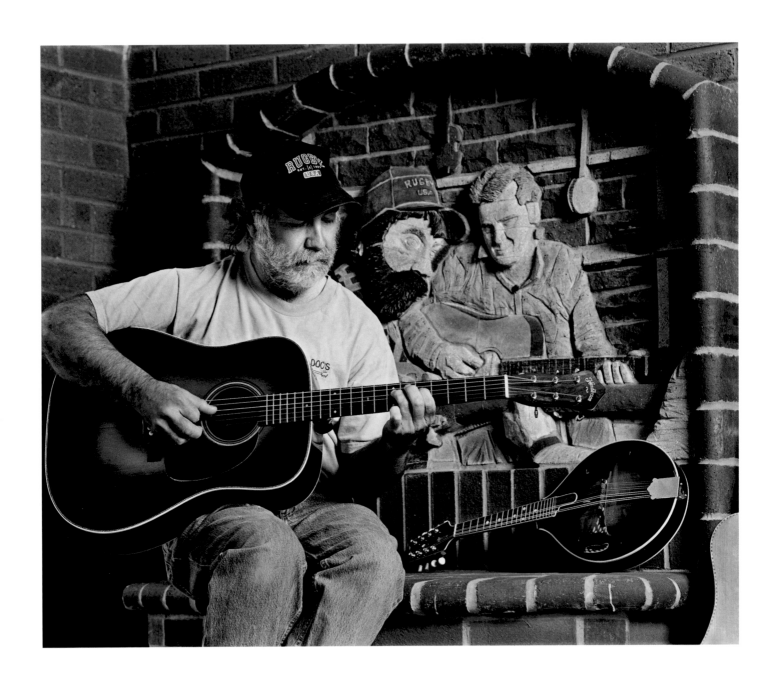

Wayne Henderson, brick sculpture of himself and Doc Watson, 2005 • Rugby, Grayson County, VA

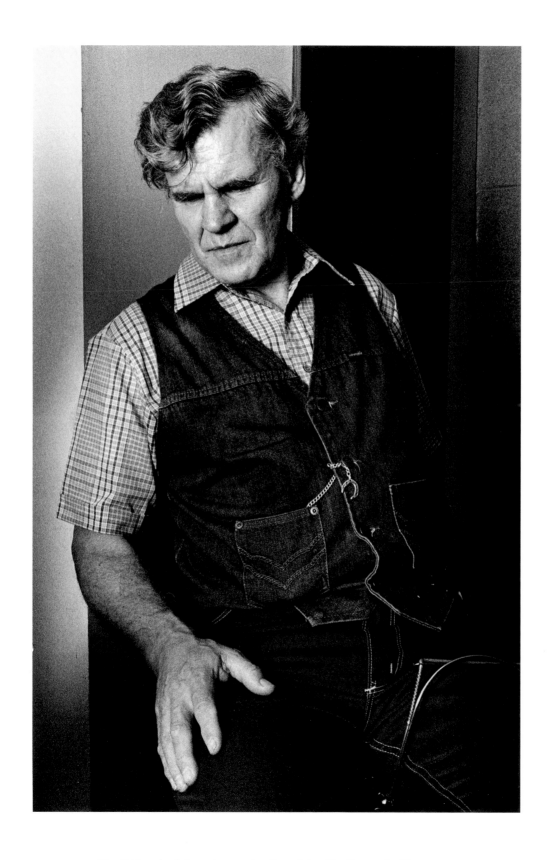

Doc Watson backstage at concert, 1983 • Asheville, Buncombe County, NC

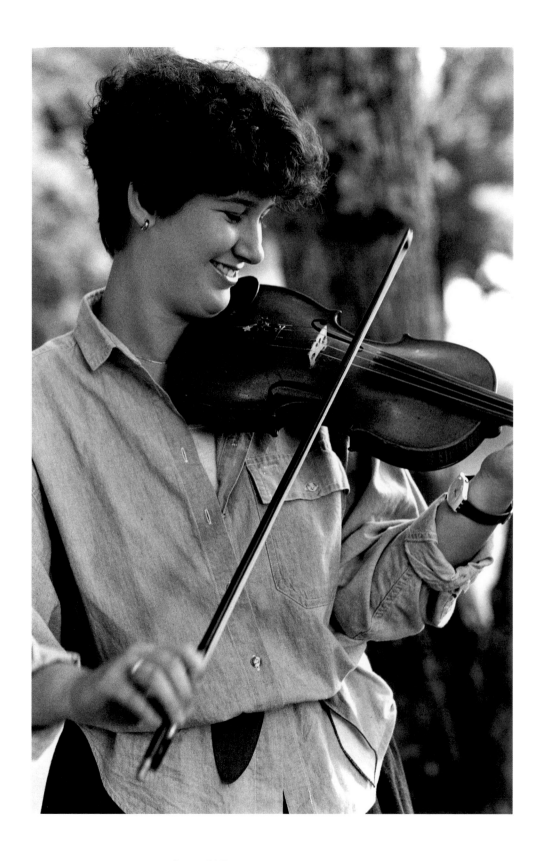

Leesa Sutton playing fiddle, 1987 • Waynesville, Haywood County, NC

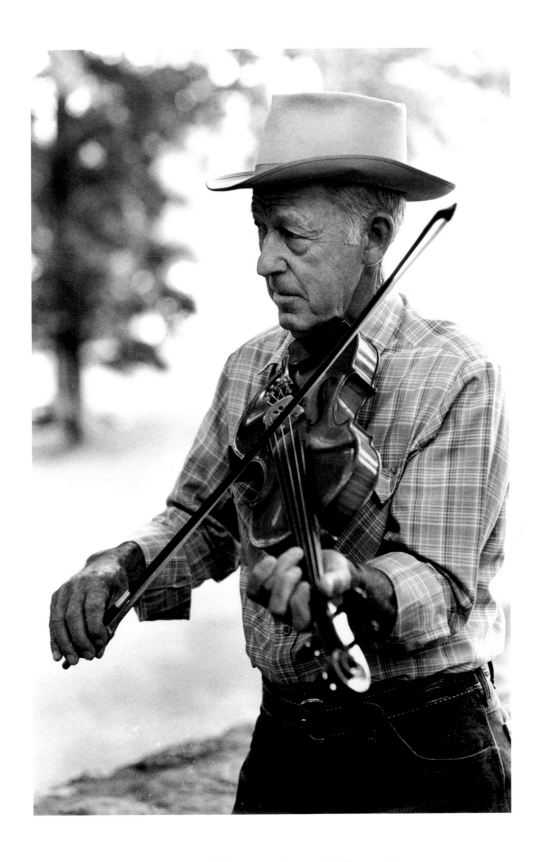

Grover Sutton playing fiddle, 1987 • Waynesville, Haywood County, NC

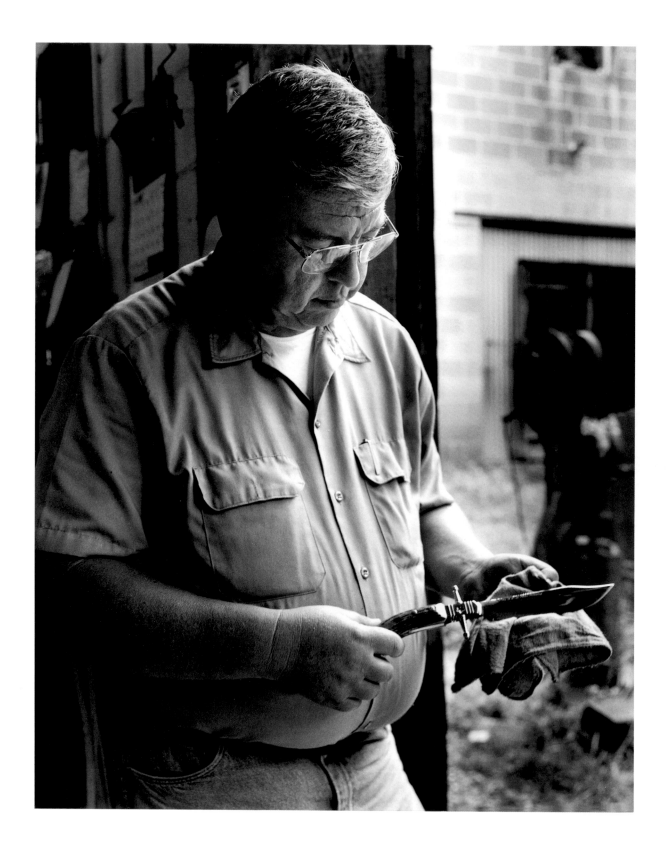

Mike Hensley holding handmade knife, 2002 • Spruce Pine, Mitchell County, NC

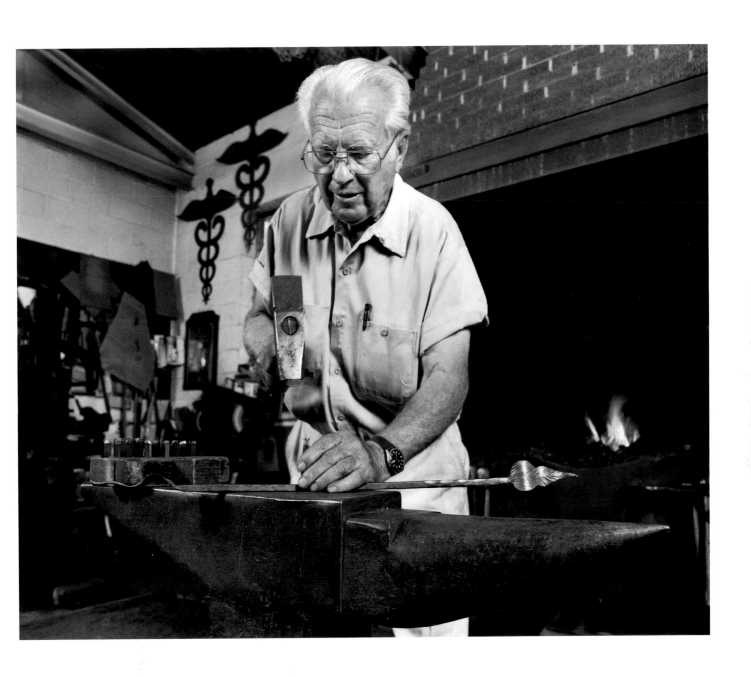

Bea Hensley in blacksmith shop, 2002 • Spruce Pine, Mitchell County, NC

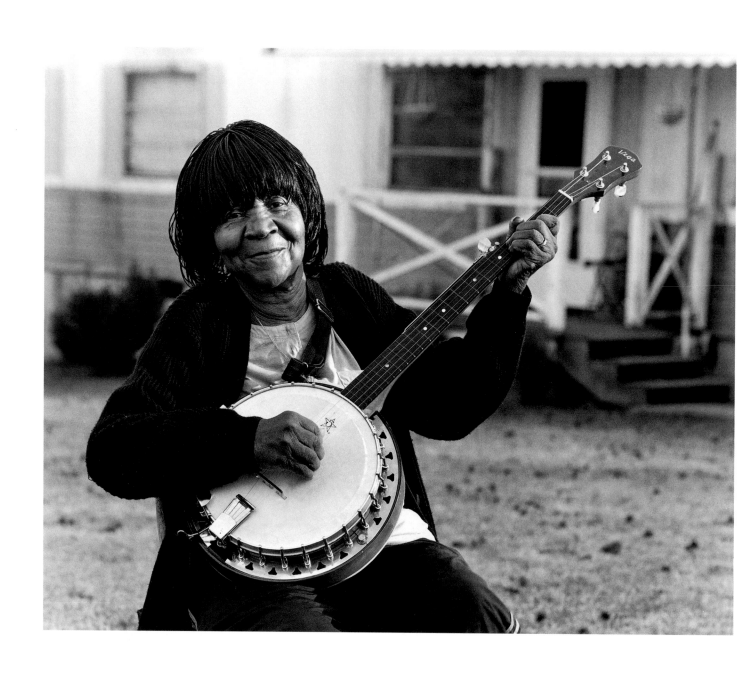

Algia Mae Hinton playing banjo, 2007 • Middlesex, Nash County, NC

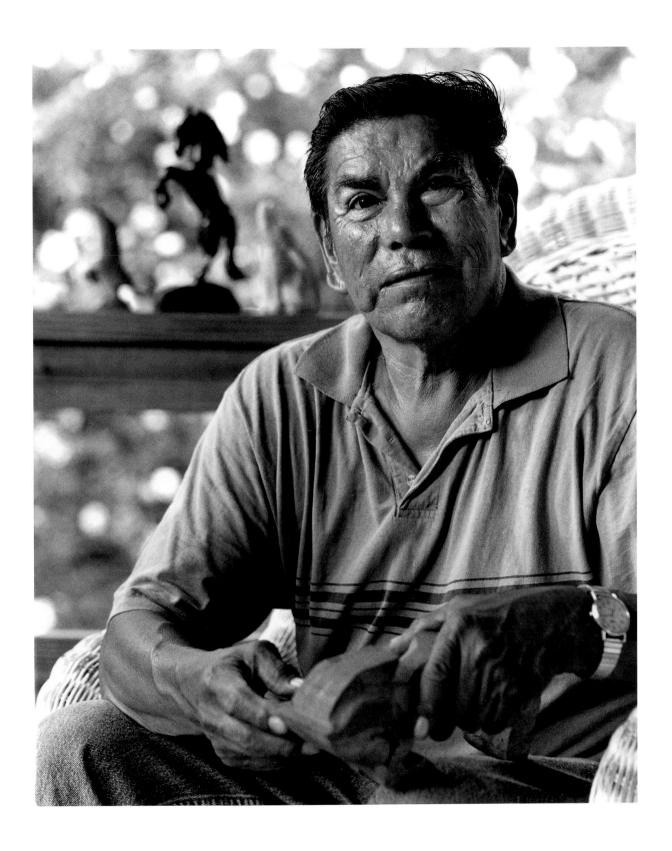

George "Butch" Goings with wood carvings, 2003 • Cherokee, Swain County, NC

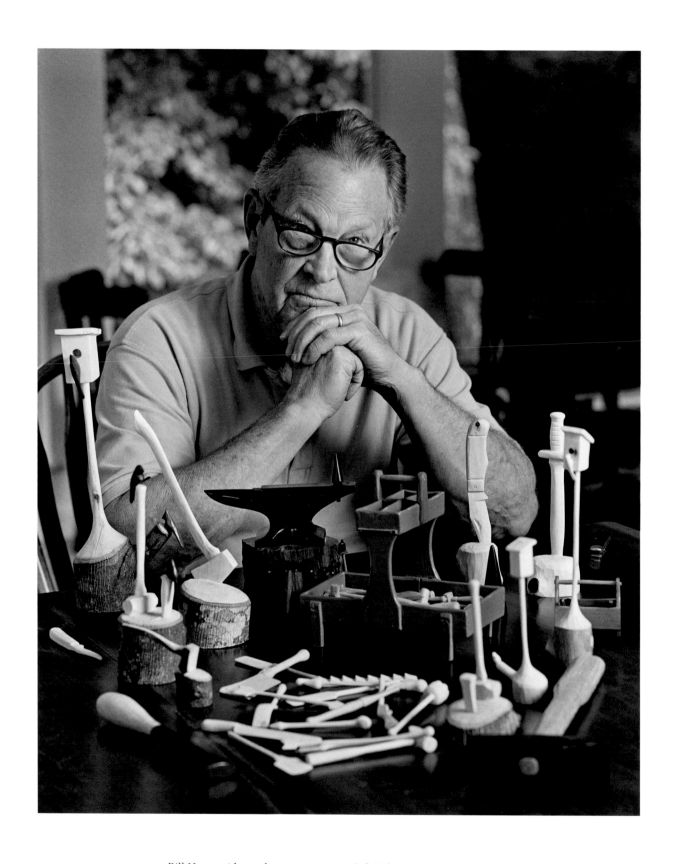

Bill Henry with wood carvings, 2003 • Oak Ridge, Anderson County, TN

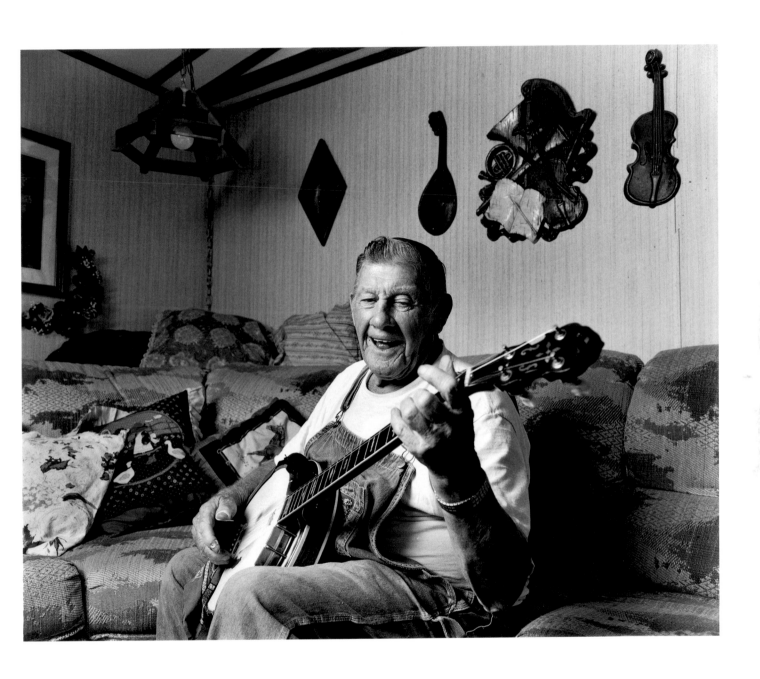

Lee Sexton playing banjo, 2007 • Line Fork, Letcher County, KY

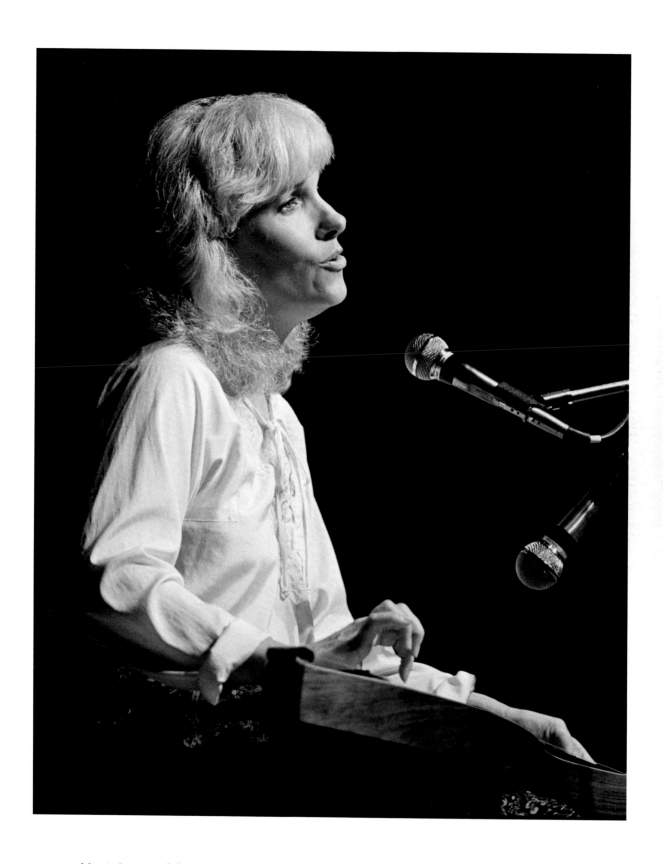

Maggie Lauterer, dulcimer, Mountain Dance and Folk Festival, 1983 • Asheville, Buncombe County, NC

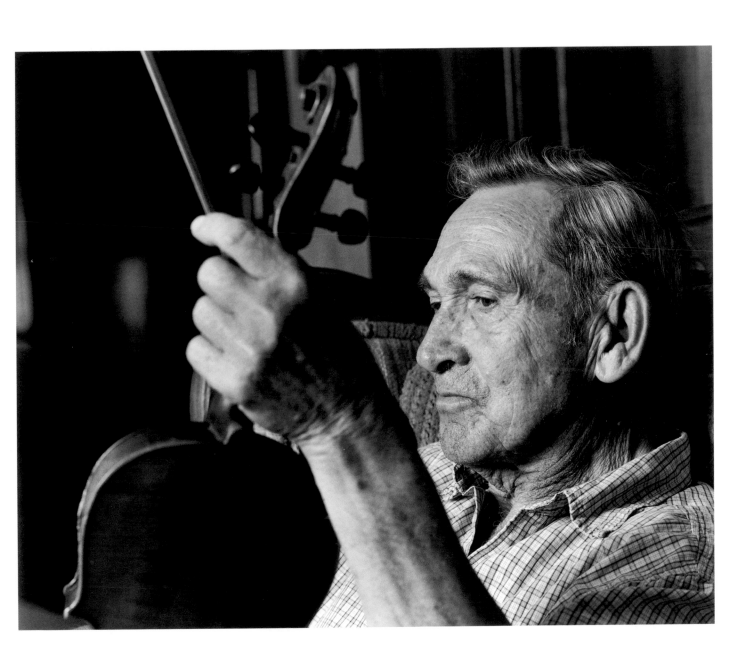

Gordon Freeman holding fiddle, 2002 • Alexander, Madison County, NC

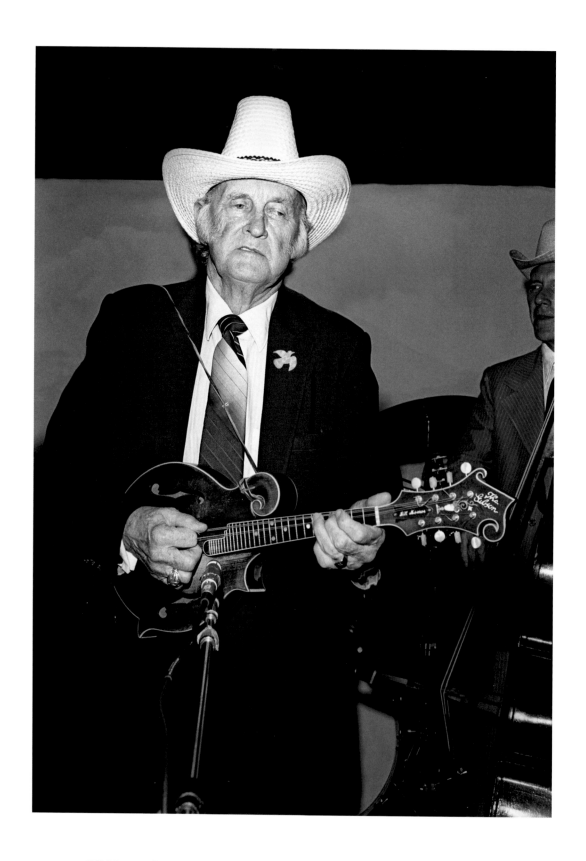

Bill Monroe playing mandolin, in concert, 1985 • Asheville, Buncombe County, NC

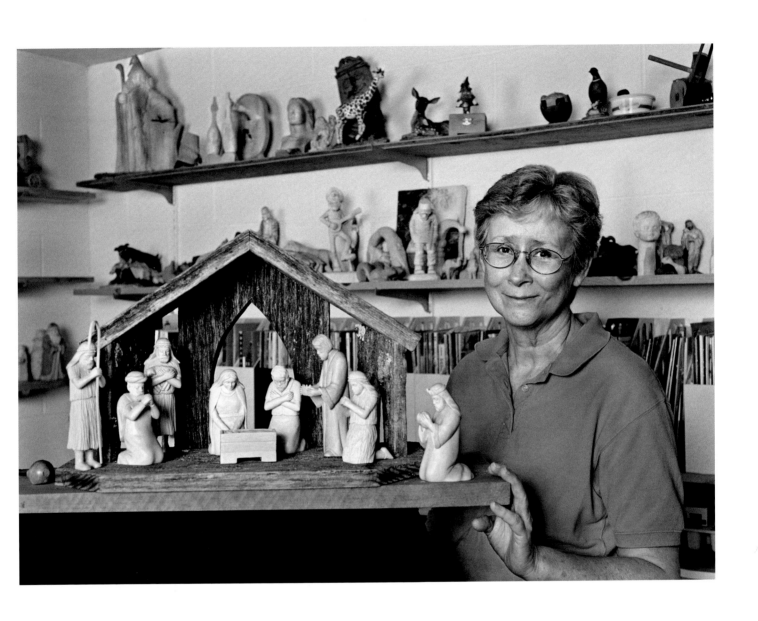

Helen Gibson with wood carvings, 2004 • Brasstown, Clay County, NC

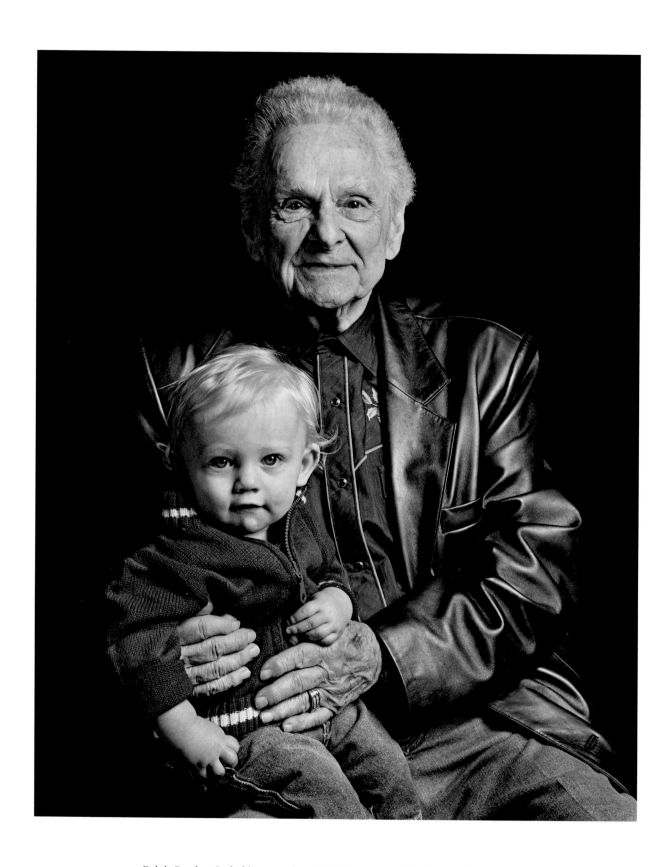

Ralph Stanley, Sr. holding grandson, Ralph III, 2007 • Coeburn, Wise County, VA

Ralph Stanley II, at home, 2007 • Coeburn, Wise County, VA

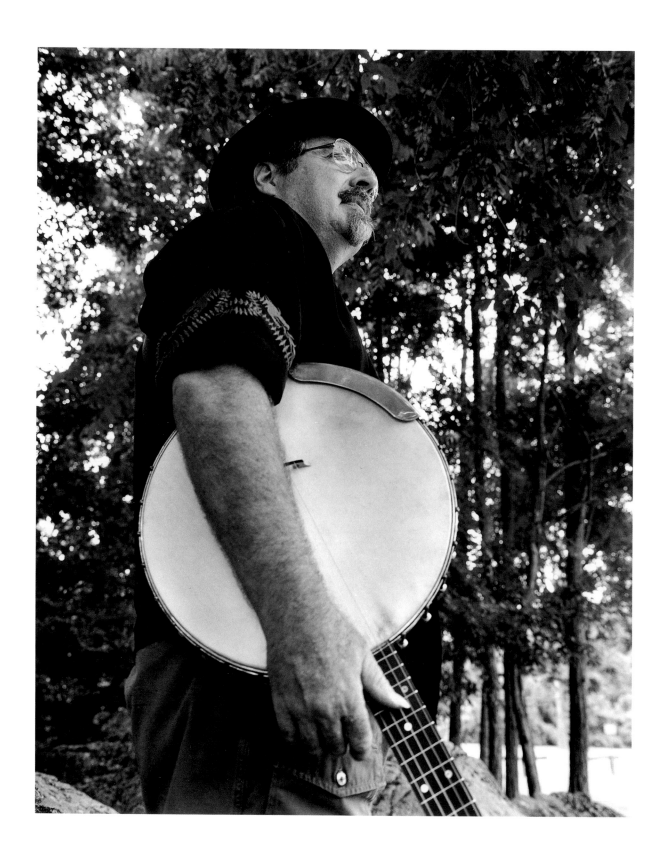

Jerry Adams holding banjo, 2002 • Hot Springs, Madison County, NC

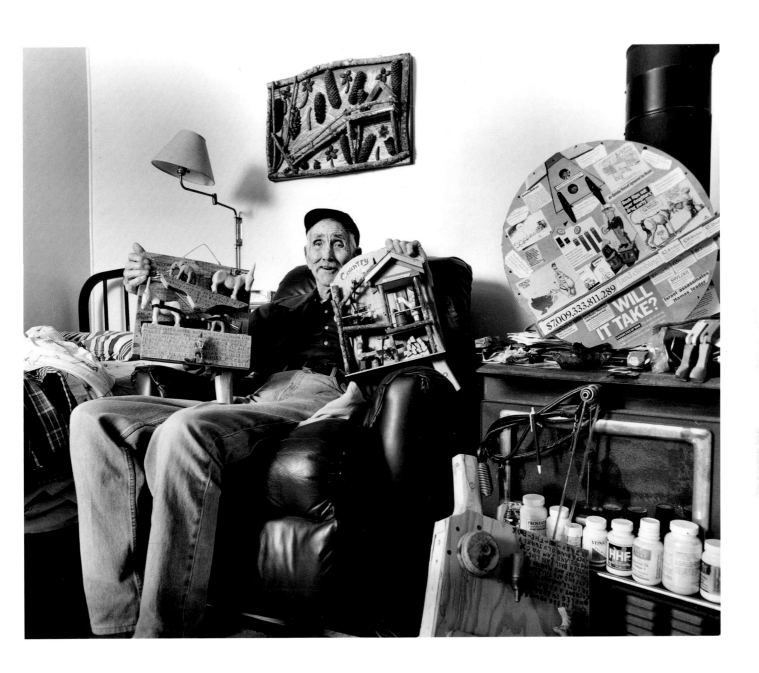

Harold Garrison with wood creations, 2004 • Jupiter, Buncombe County, NC

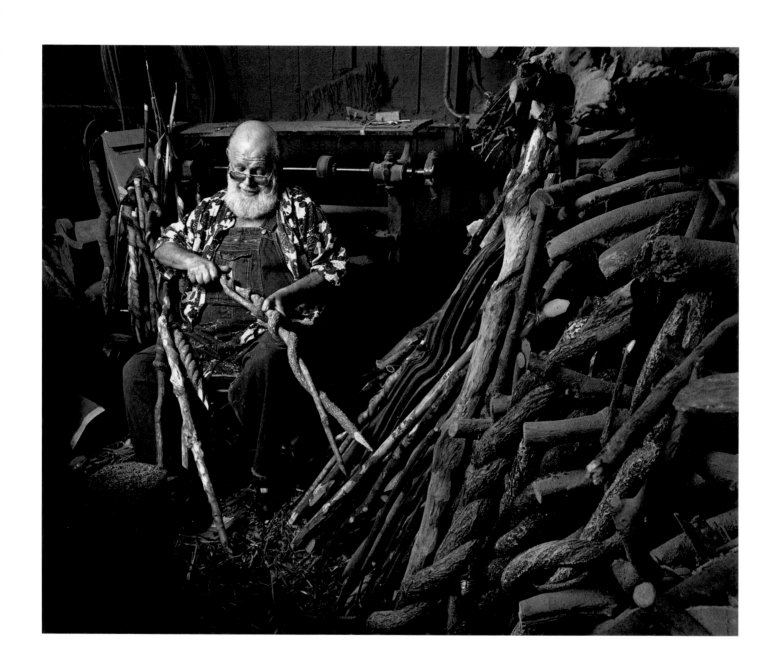

Ralph Gates making broom handle, 2003 • Big Sandy Mush, Buncombe County, NC

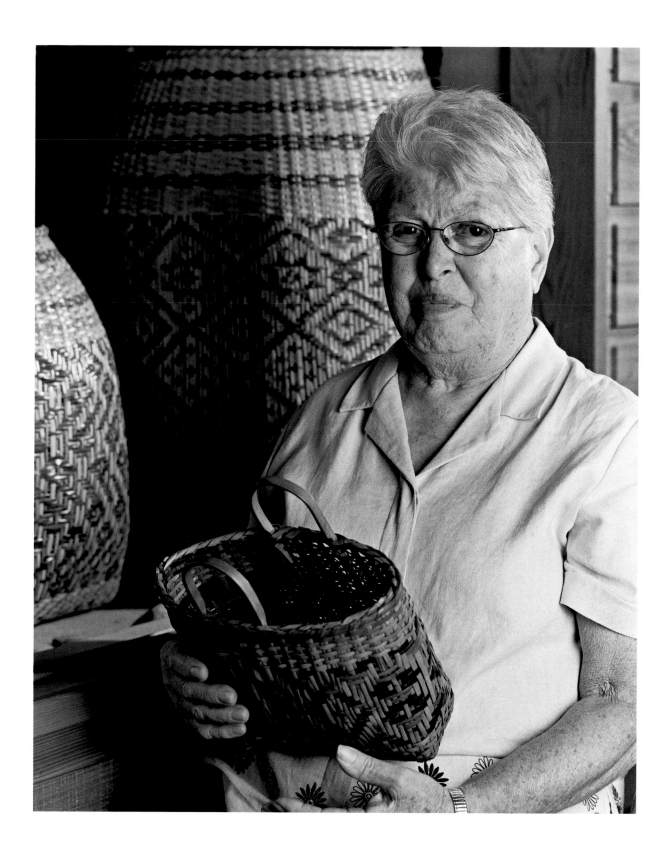

Betty Dupree at Qualla Arts & Crafts, 2003 • Cherokee, Swain County, NC

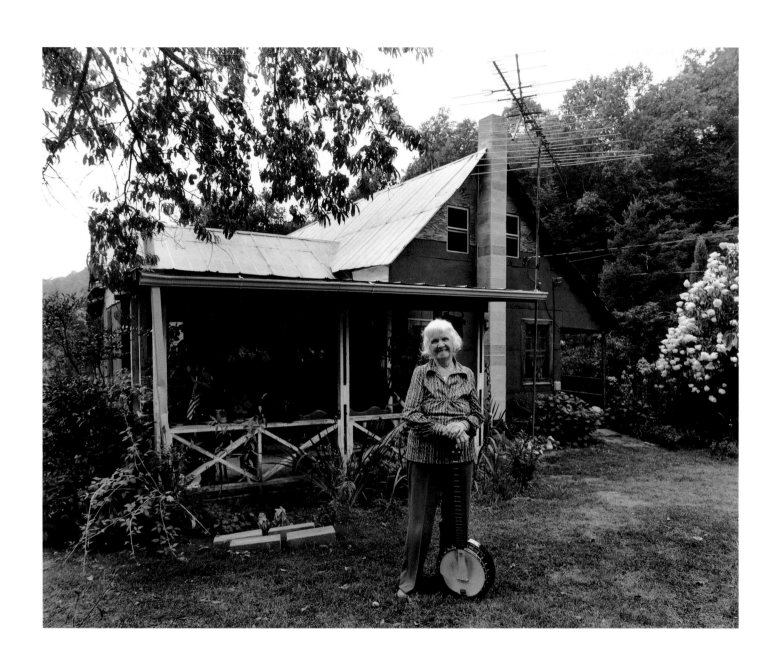

Mary Jane Queen with banjo, her home, 2002 • Caney Fork, Jackson County, NC

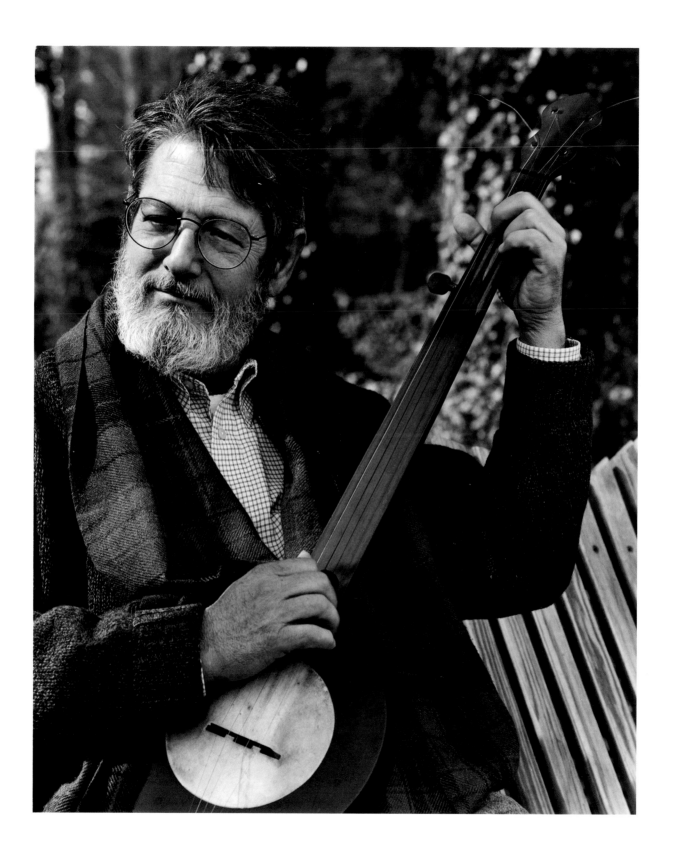

Jan Davidson playing banjo, Campbell Folk School, 2003 • Brasstown, Clay County, NC

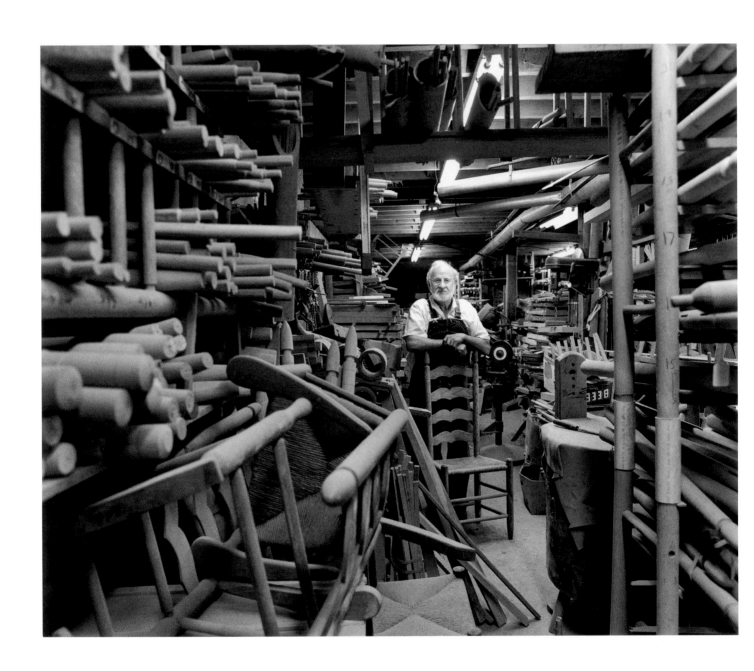

Max Woody in his chair-making shop, 2002 • Old Fort, McDowell County, NC

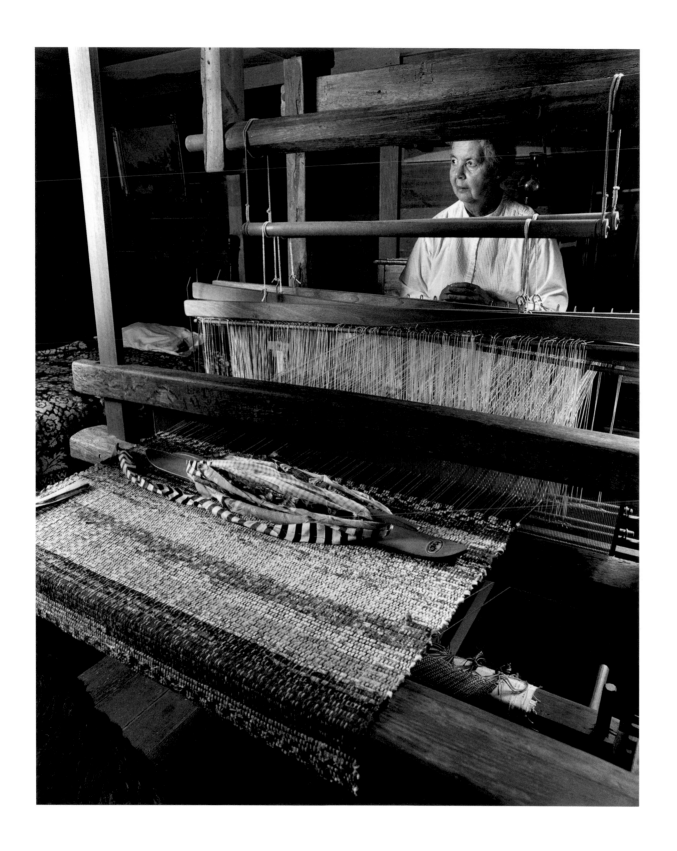

Barbara Miller at loom, Cradle of Forestry, 2003 • Brevard, Transylvania County, NC

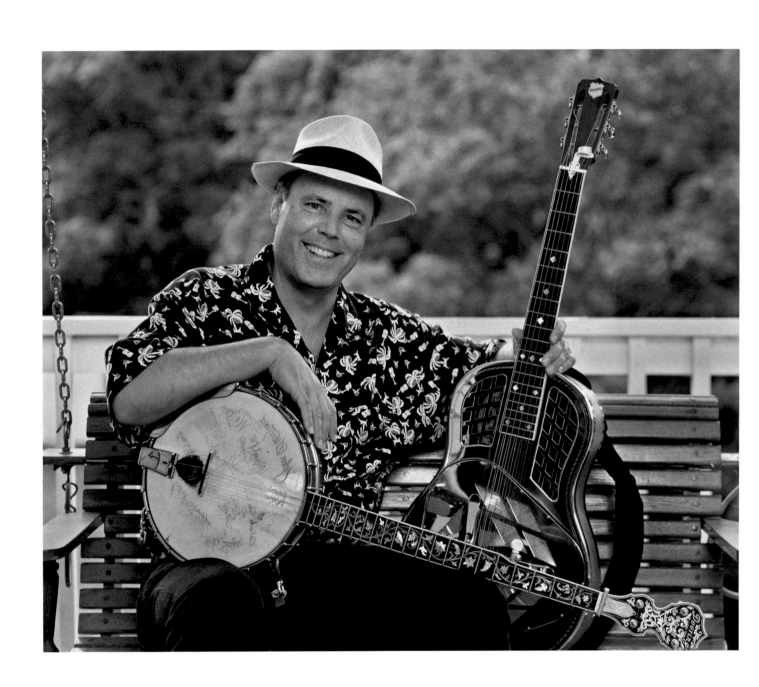

David Holt with banjo and guitar, at Doc Watson's home, 2002 • Deep Gap, Watauga County, NC

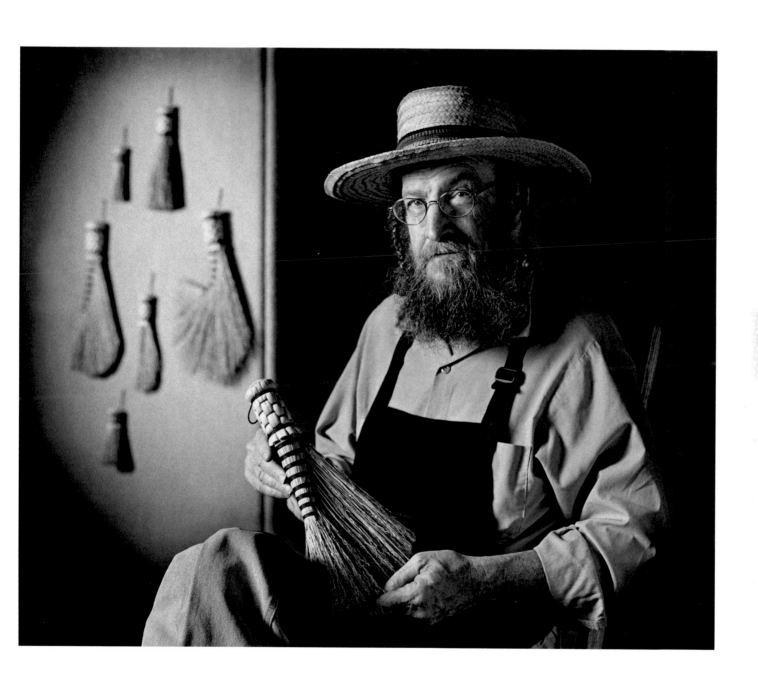

Carlson Tuttle with handmade brooms, 2006 • Burnsville, Yancey County, NC

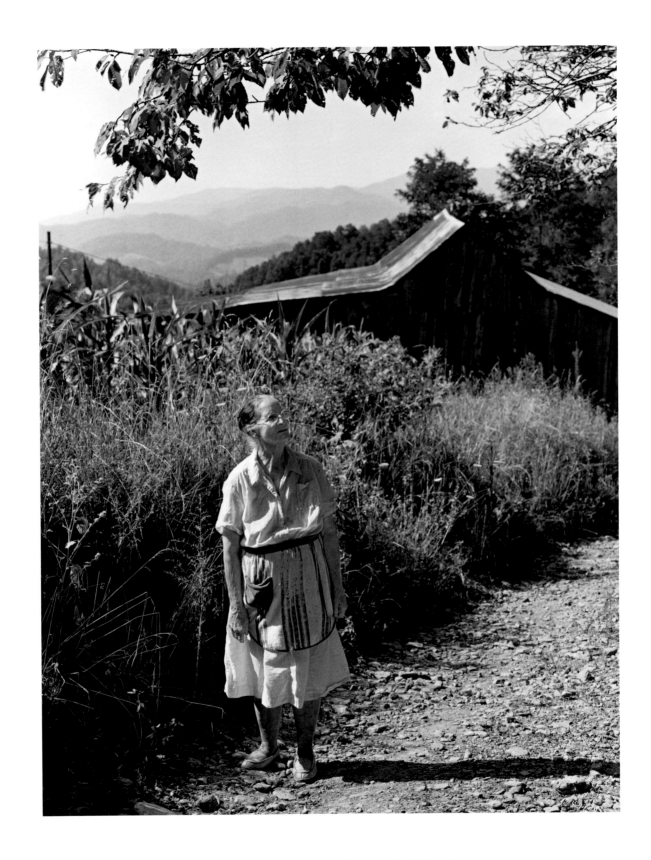

Dellie Norton, ballad singer, 1980 • Sodom Laurel, Madison County, NC

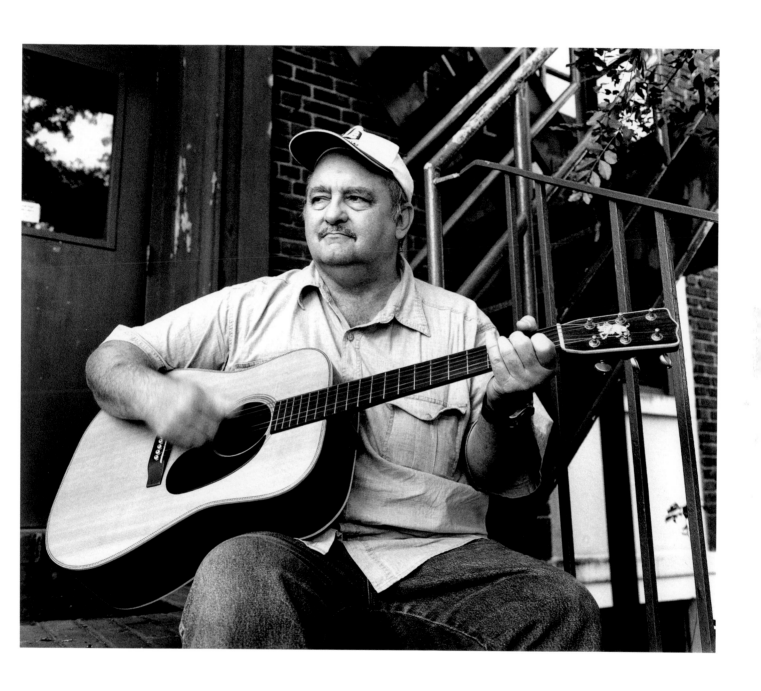

Bobby McMillan, musician and storyteller, 2006 • Lenior, Caldwell County, NC

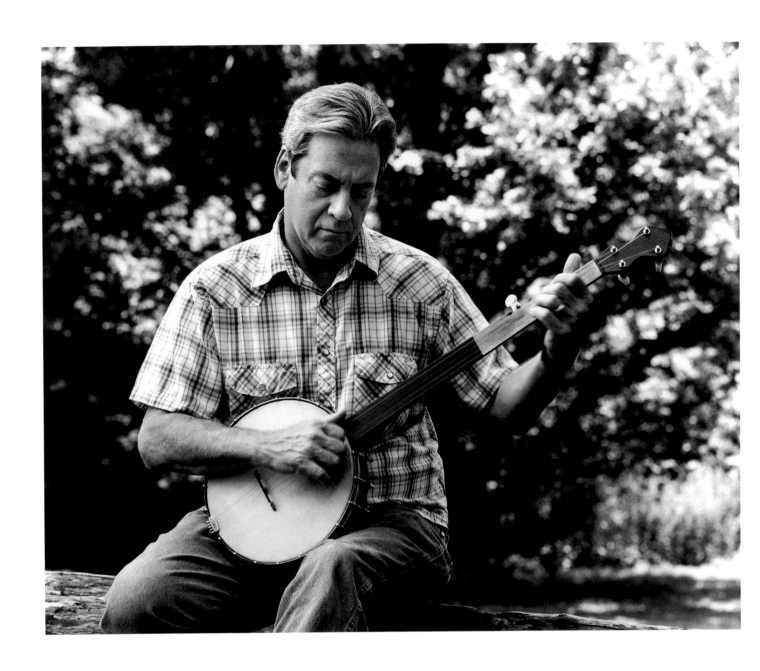

Tom Sauber, Old-time Music Week, Warren Wilson College, 2007 • Swannanoa, Buncombe County, NC

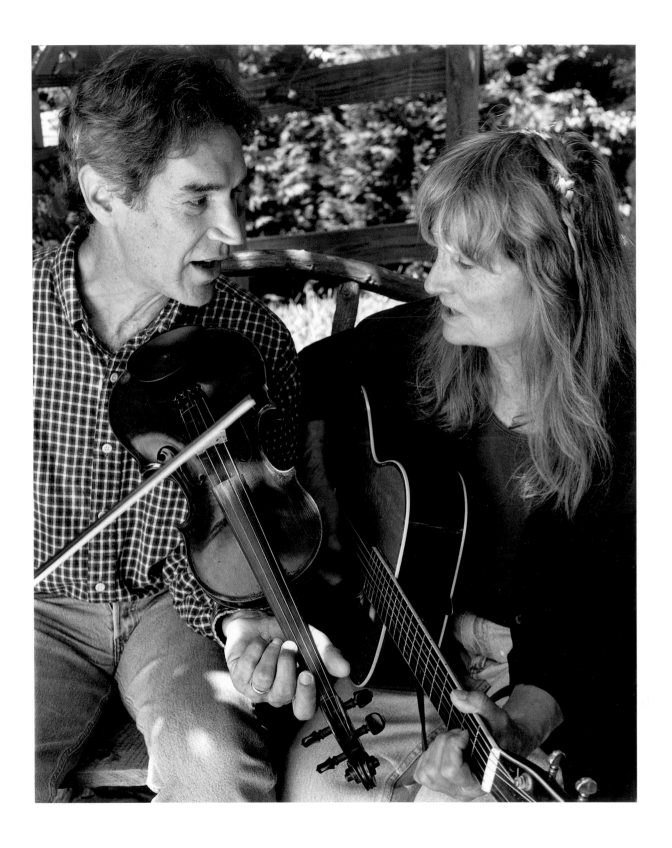

Brad Leftwich and Alice Gerrard, at friend's home, 2003 • Weaverville, Buncombe County, NC

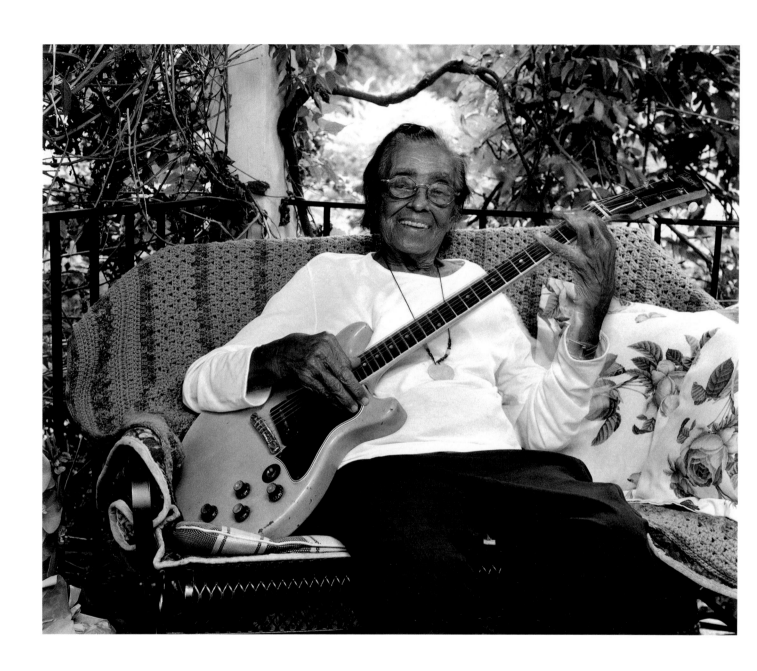

Etta Baker with electric guitar, 2005 • Morganton, Burke County, NC

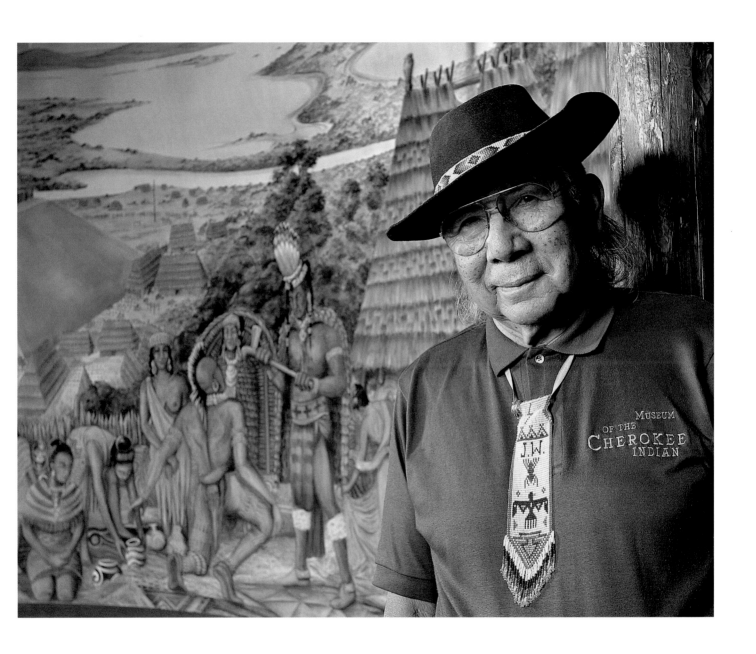

Jerry Wolfe, storyteller, in Cherokee Museum, 2007 • Cherokee, Swain County, NC

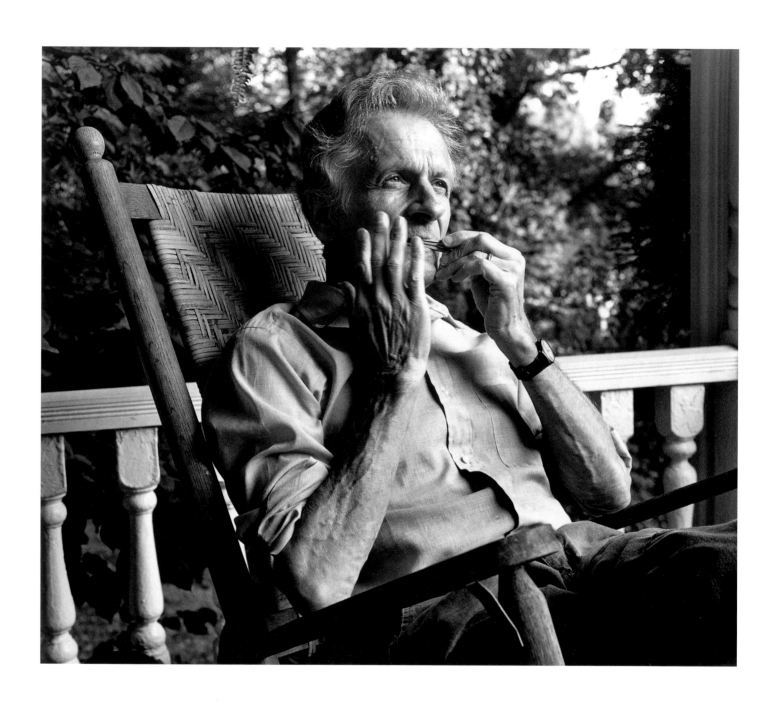

Mike Seeger playing jew's harp, Old-time Music Week, Warren Wilson College, 2003 • Swannanoa, Buncombe County, NC

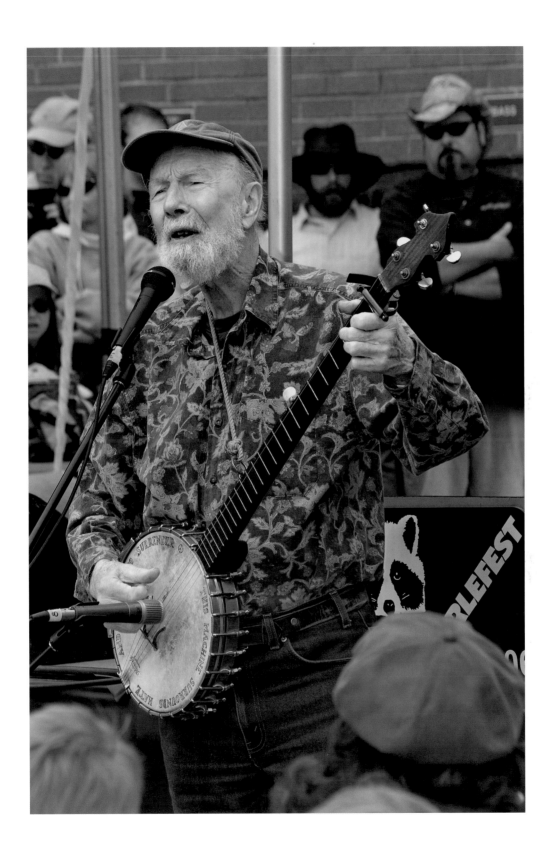

Pete Seeger playing banjo at Merlefest, 2006 • North Wilkesboro, Wilkes County, NC

John Hartford and band, Liberty Flyer radio recording session, 1985 • Asheville, Buncombe County, NC

Oscar "Red" Wilson with fiddle, 2002 • Bakersville, Mitchell County, NC

Roan Mountain Hilltoppers at Fiddler's Grove, 2003 • Union Grove, Iredell County, NC

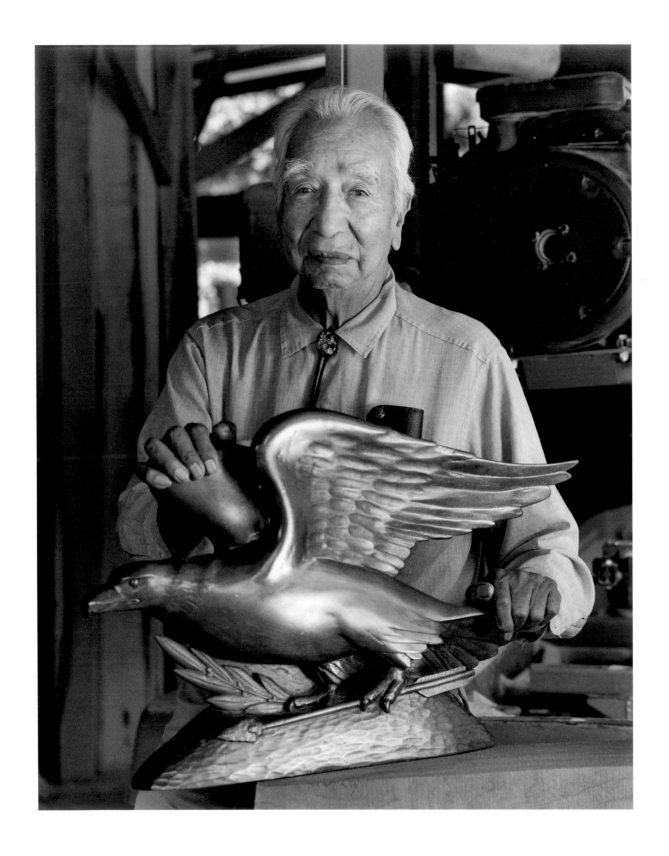

Going Back Chiltosky with wood carving, 1991 • Cherokee, Swain County, NC

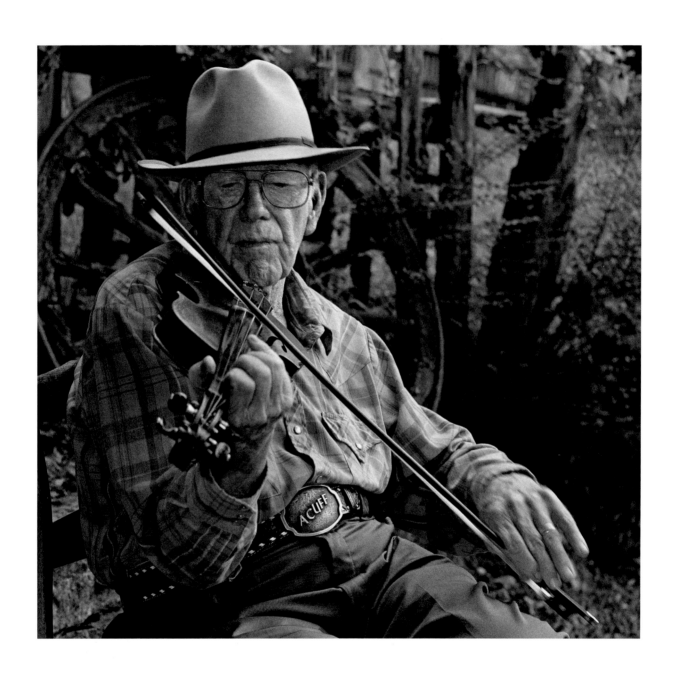

Charlie Acuff playing at the Museum of Appalachia, 2003 • Norris, Anderson County, TN

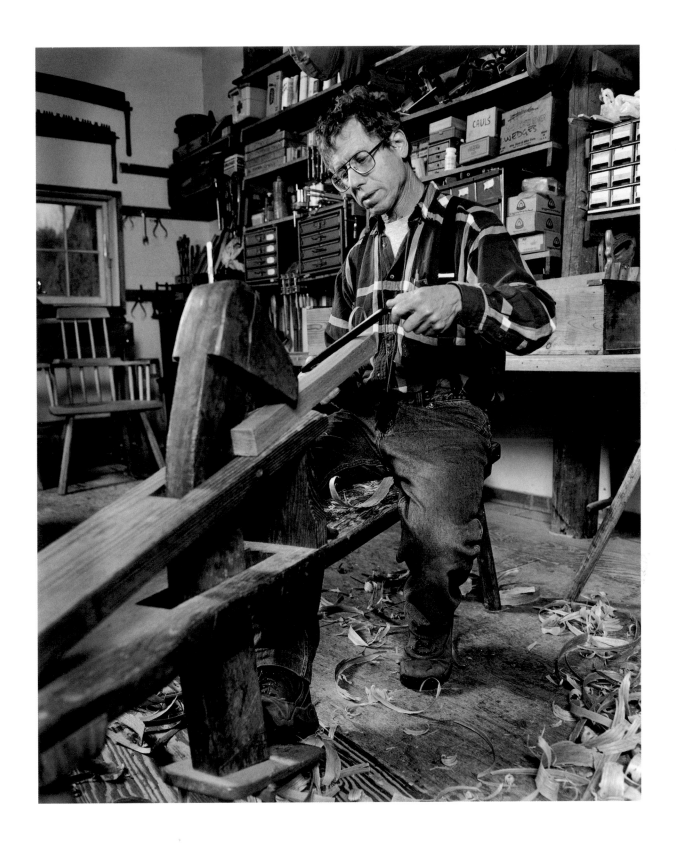

Drew Langsner making chair parts on shaving horse, 2004 • Marshall, Madison County, NC

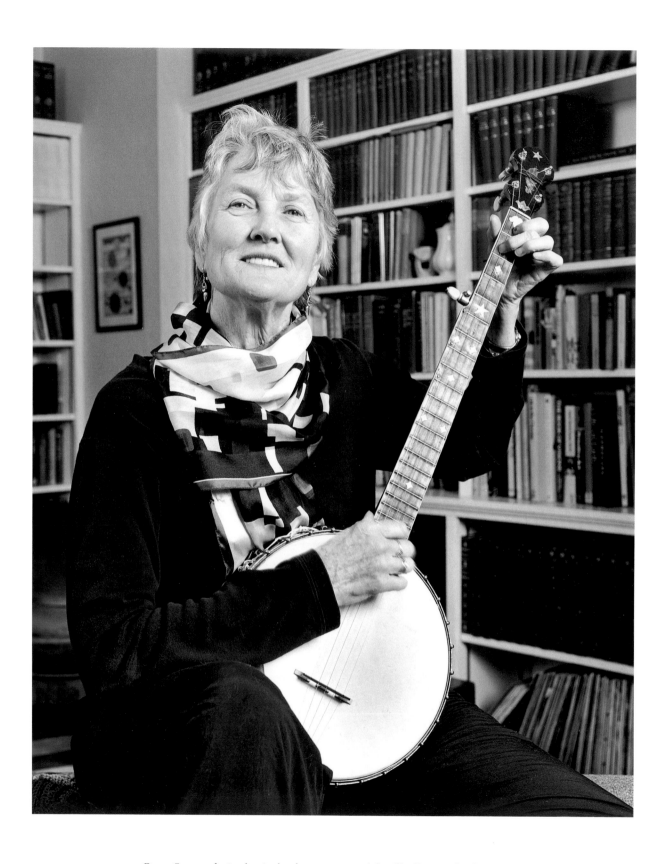

Peggy Seeger playing banjo, her home, 2004 • Asheville, Buncombe County, NC

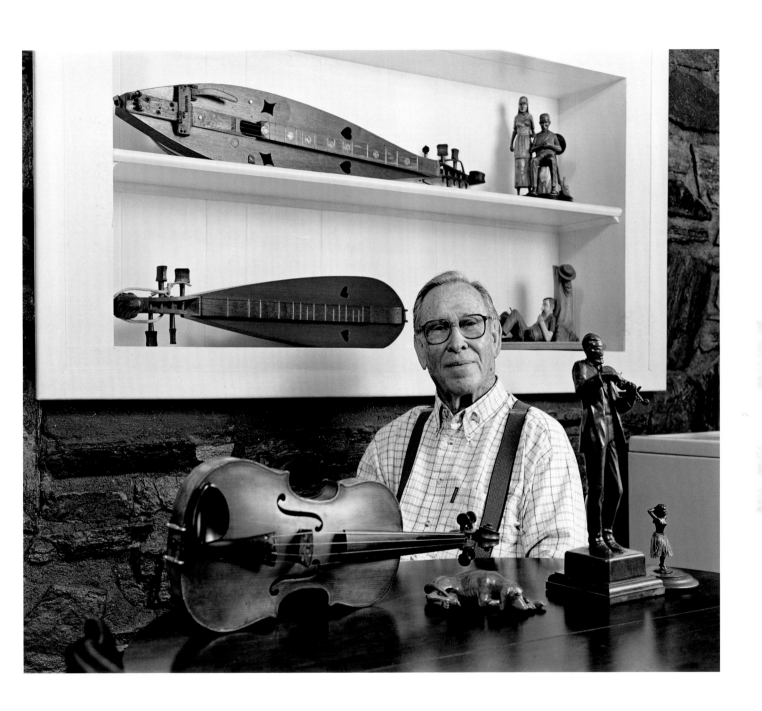

Wade Martin with wood carvings and fiddle, 2002 • Swannanoa, Buncombe County, NC

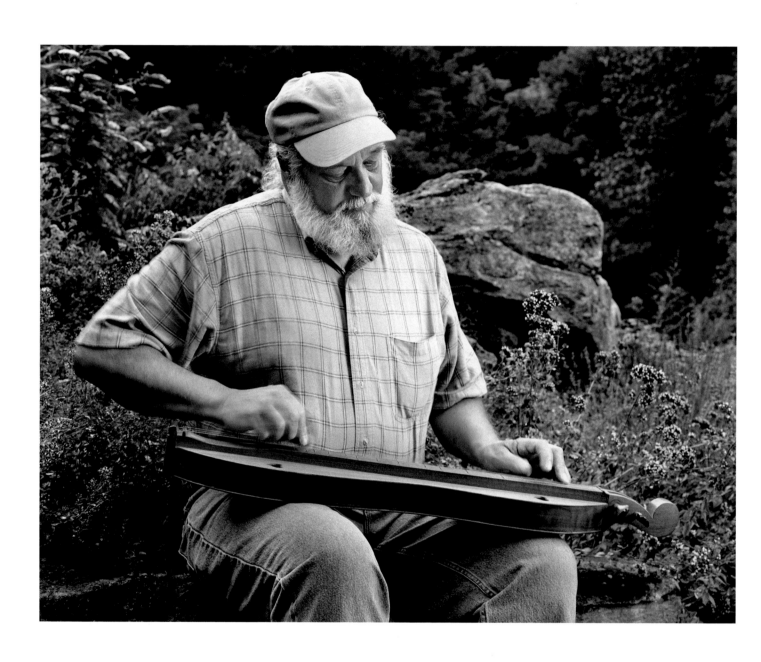

Don Pedi playing mountain dulcimer, 2002 • Grapevine, Madison County, NC

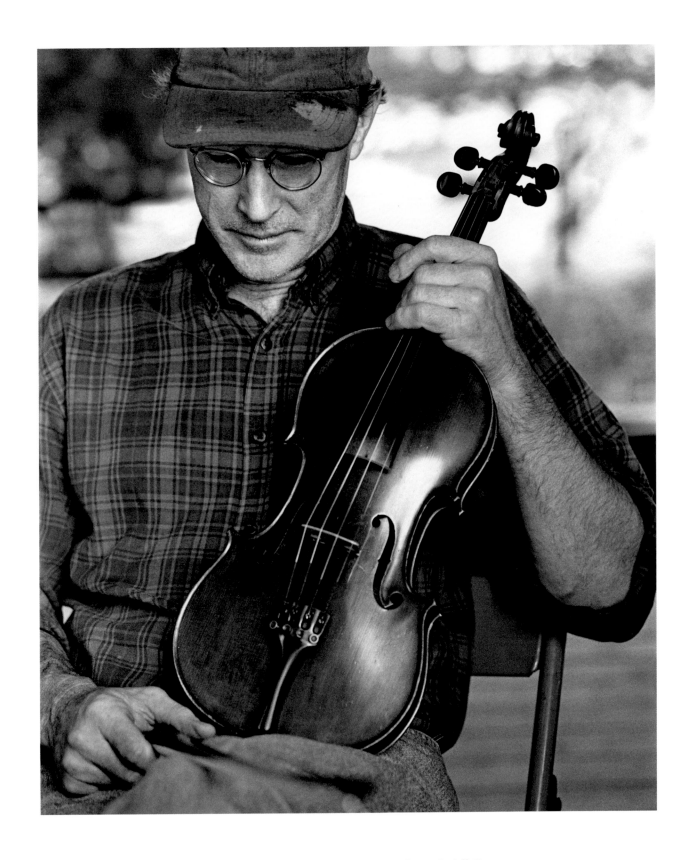

Bruce Greene at Fiddler's Grove, 2003 • Union Grove, Iredell County, NC

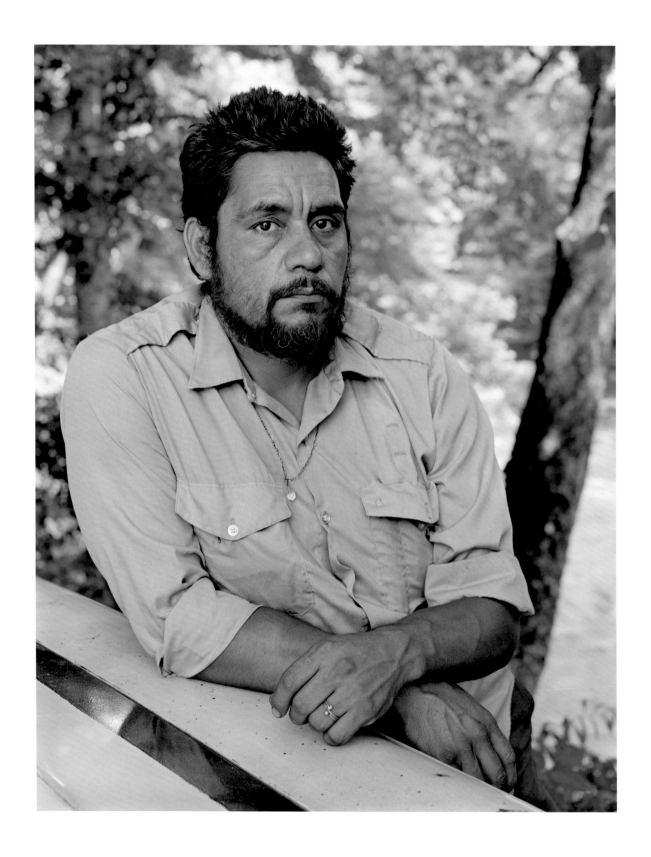

John Julius Wilnoty, soapstone carver, 1980 • Cherokee, Swain County, NC

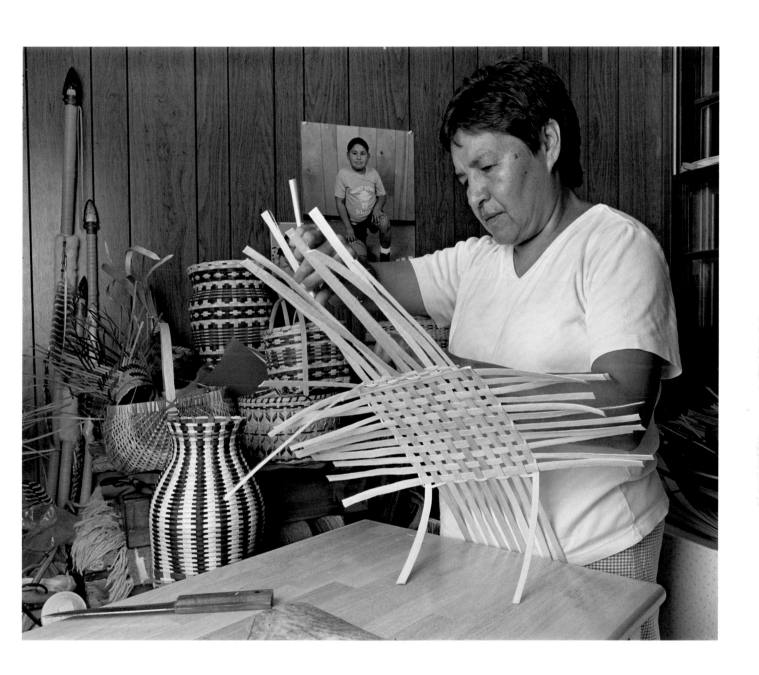

Louise Goings making basket, 2003 • Cherokee, Swain County, NC

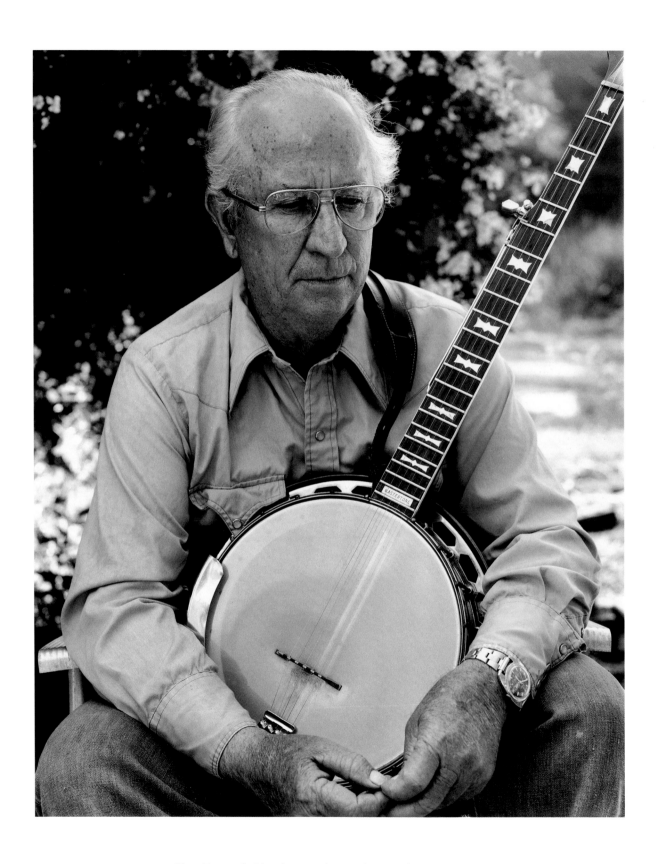

Obray Ramsey holding banjo, 1981 • Walnut, Madison County, NC

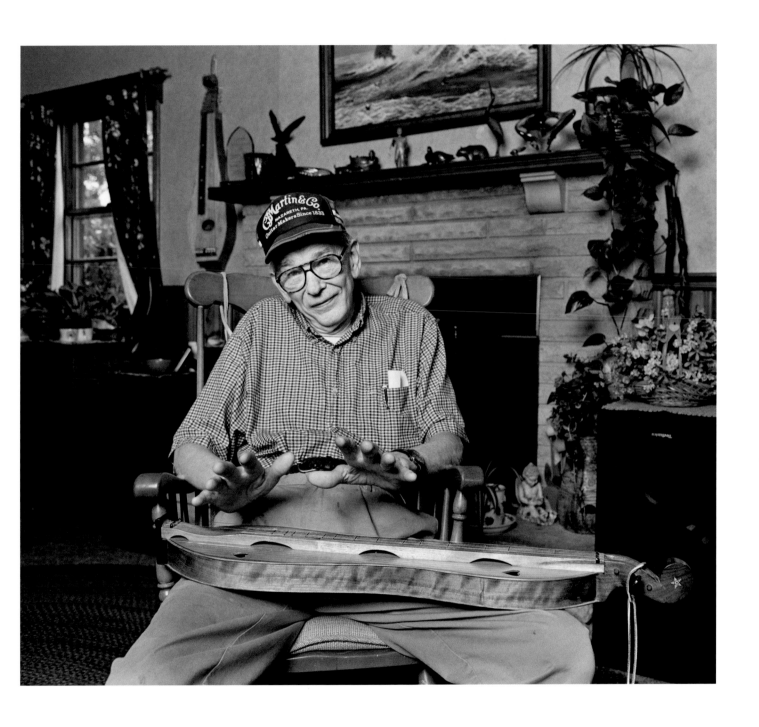

Homer Ledford with mountain dulcimer, his home, 2005 • Winchester, Clark County, KY

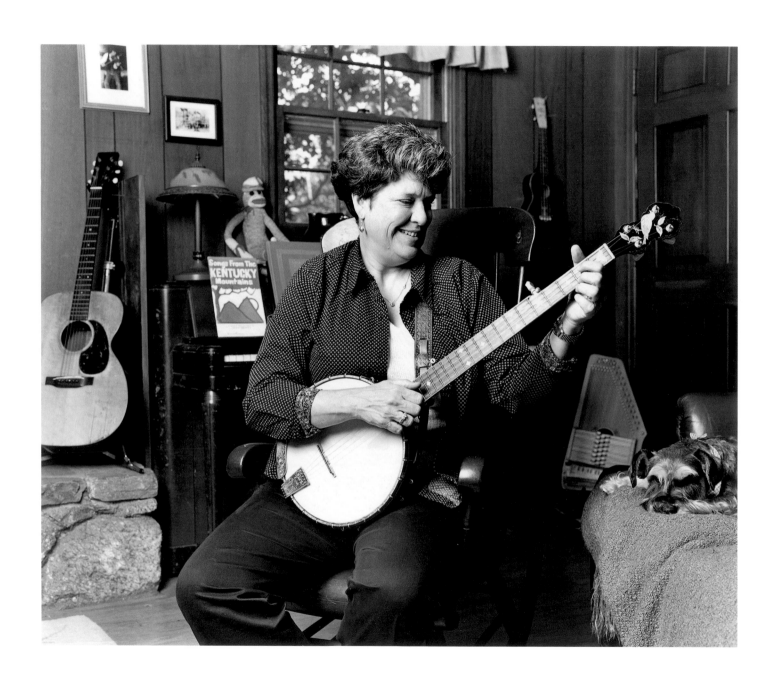

Laura Boosinger playing banjo, her home, 2006 • Asheville, Buncombe County, NC

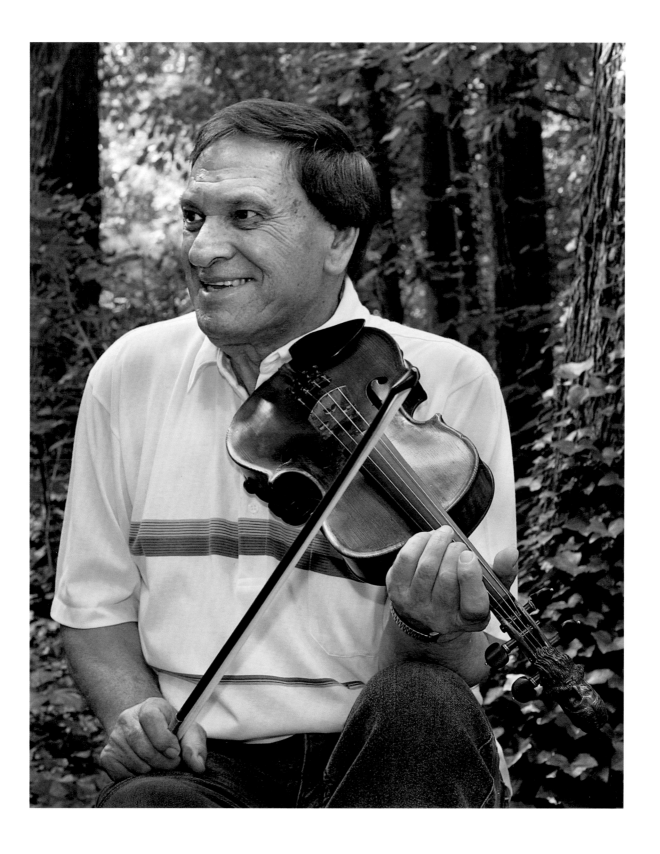

Arvil Freeman with fiddle, 2005 • Weaverville, Buncombe County, NC

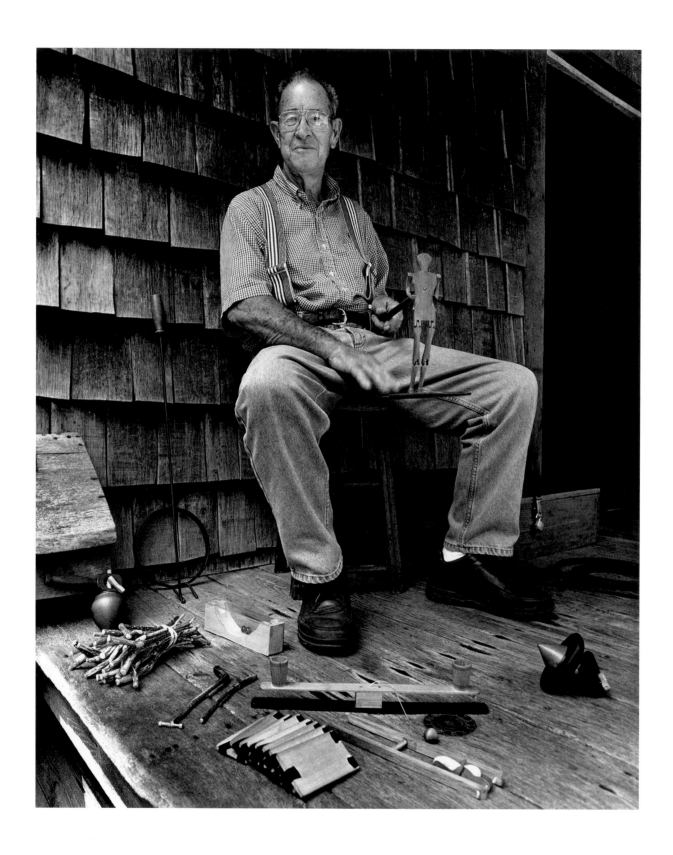

Bob Miller with handmade wooden toys, Cradle of Forestry, 2003 • Brevard, Transylvania County, NC

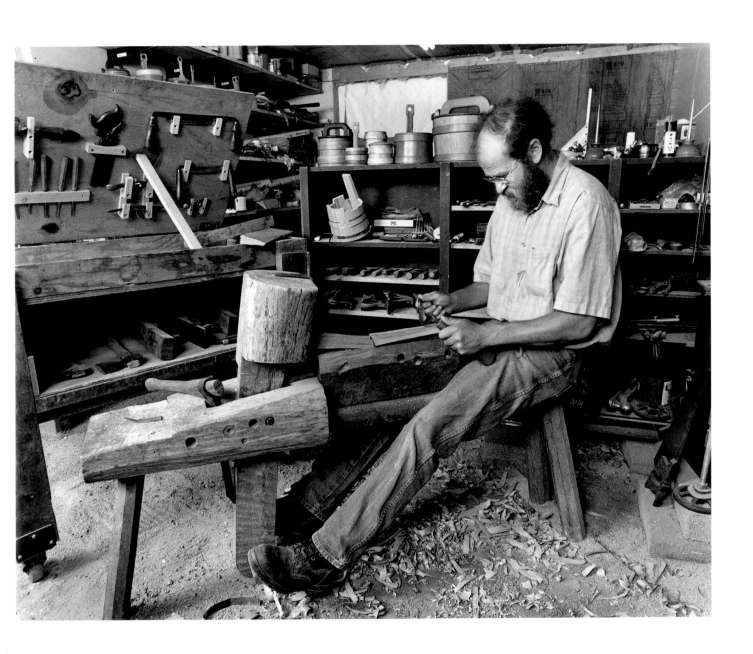

Will Hines, cooper, working on shaving horse, 2004 • Greeneville, Greene County, TN

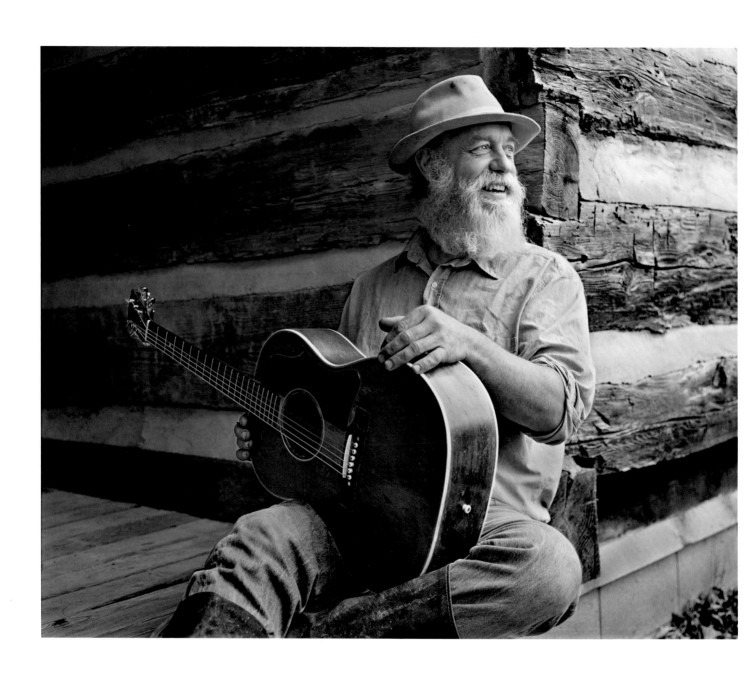

Steve Rice at Fiddler's Grove, 2003 • Union Grove, Iredell County, NC

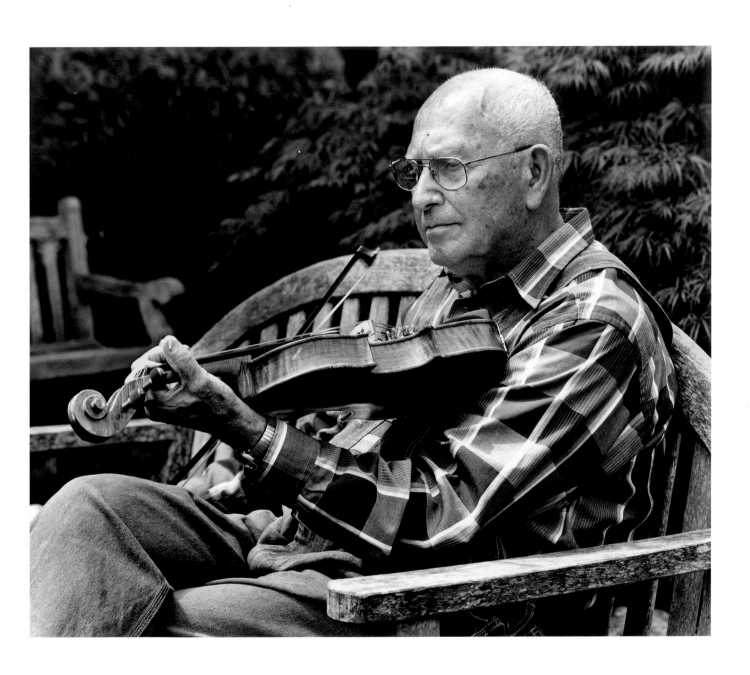

Clyde Davenport, Old-time Music Week, Warren Wilson College, 2006 • Swannanoa, Buncombe County, NC

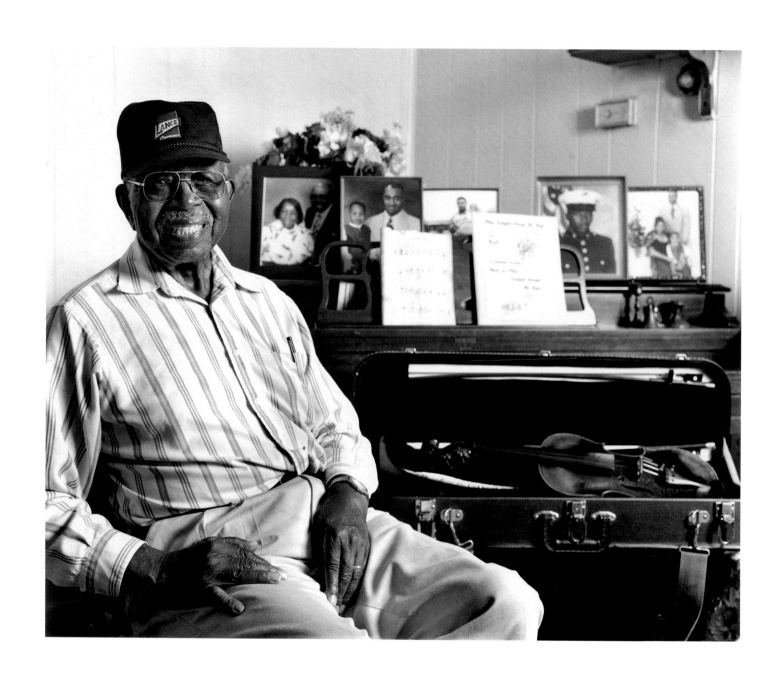

Joe Thompson, fiddle player, his home, 2005 • Mebane, Alamance County, NC

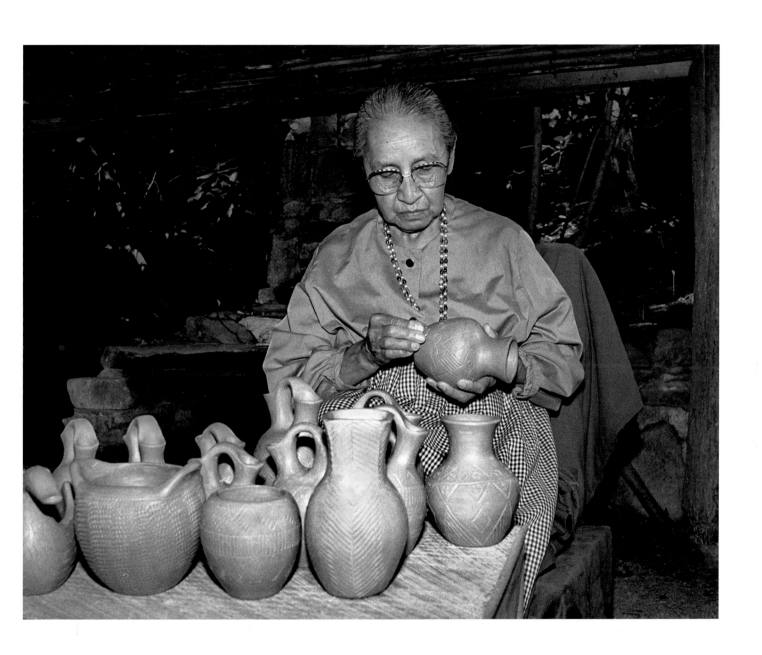

Amanda Swimmer making pottery, 1989 • Cherokee, Swain County, NC

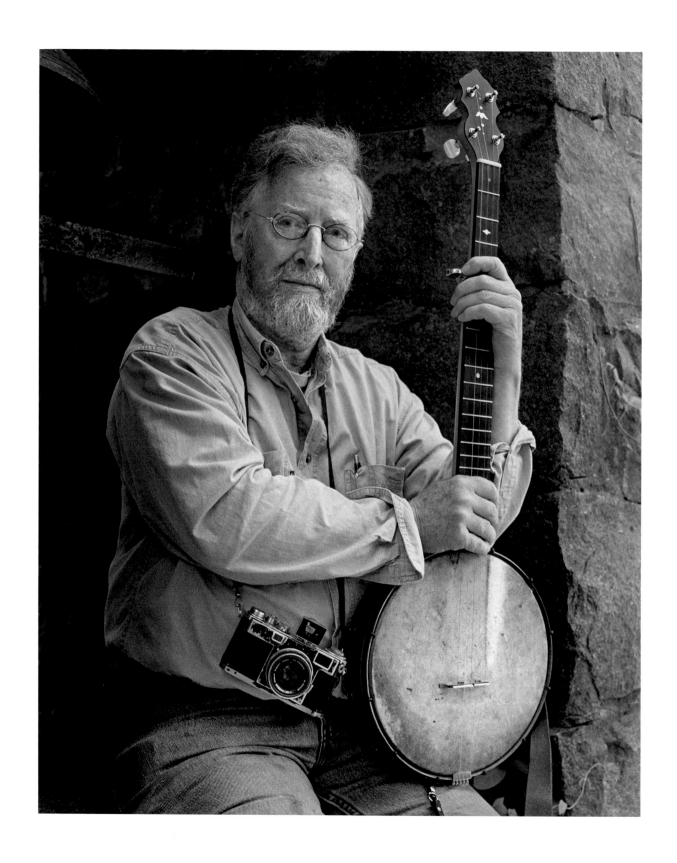

John Cohen, Old-time Music Week, Warren Wilson College, 2003 • Swannanoa, Buncombe County, NC

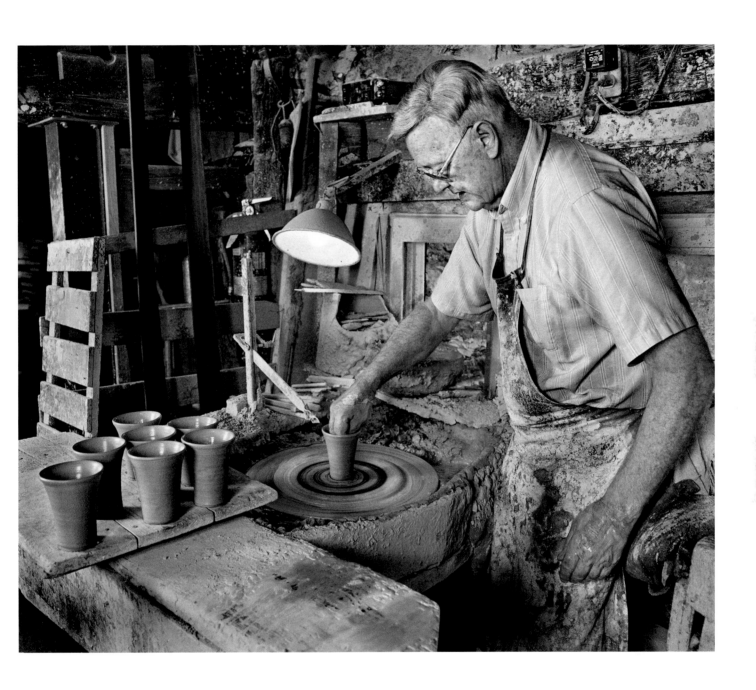

Walter Cornelison at wheel, Bybee Pottery, 2005 • Waco, Madison County, KY

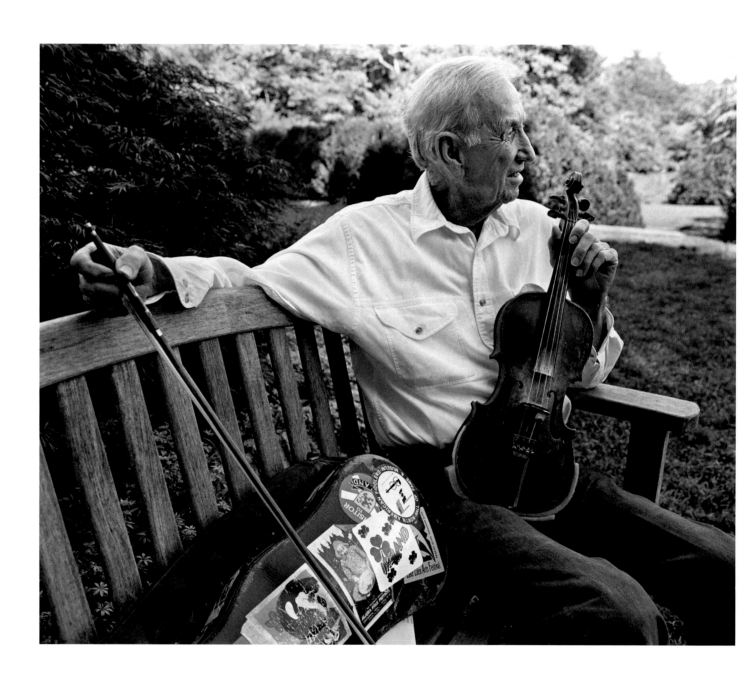

Ralph Blizzard, Old-time Music Week, Warren Wilson College, 2003 • Swannanoa, Buncombe County, NC

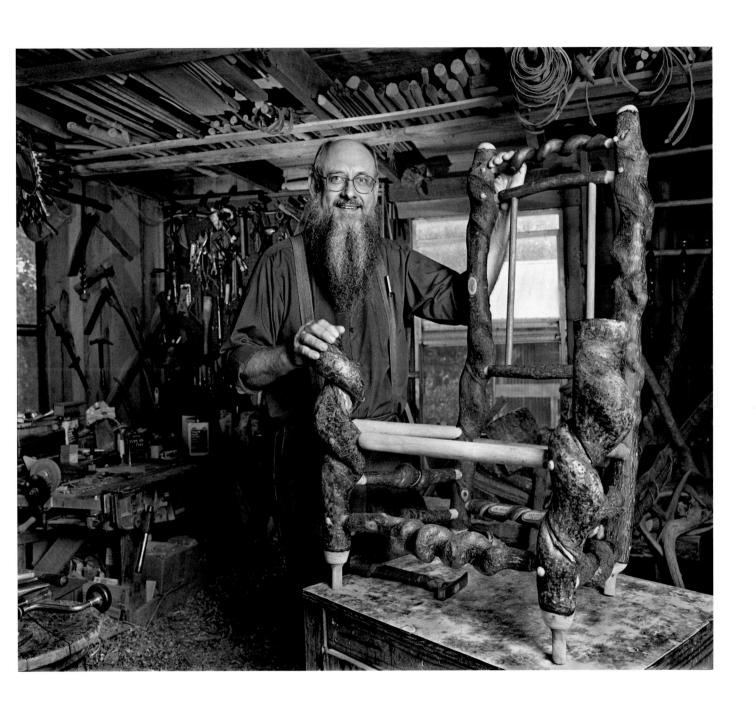

Jim McGie working on handmade chair, 2005 • Livingston, Overton County, TN

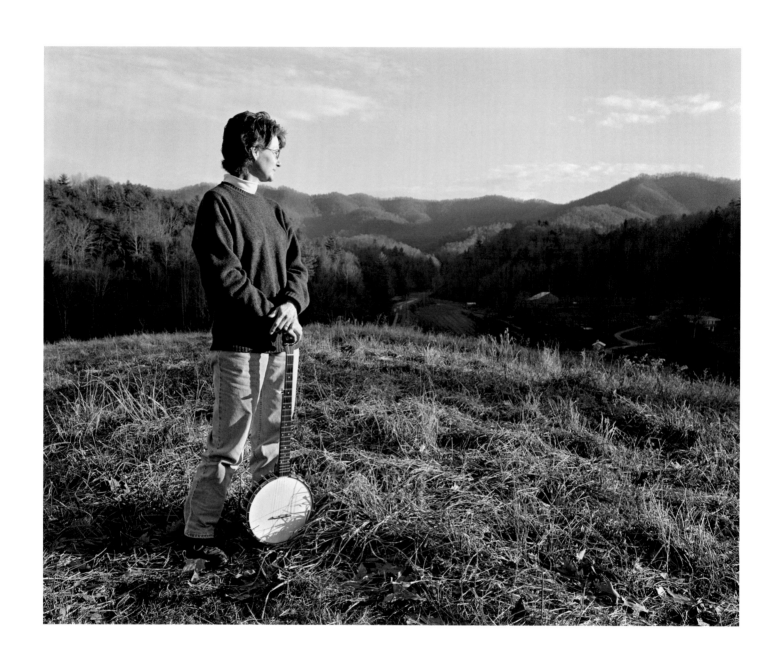

Sheila Kay Adams with banjo, 2003 • Sodom Laurel, Madison County, NC

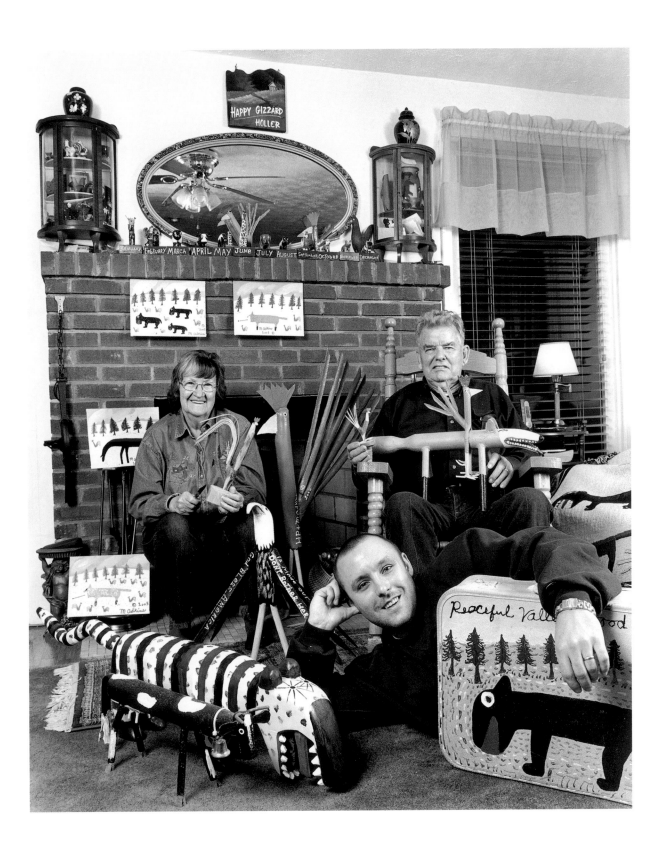

Minnie Adkins & family, folk artist, 2005 • Isonville, Elliott County, KY

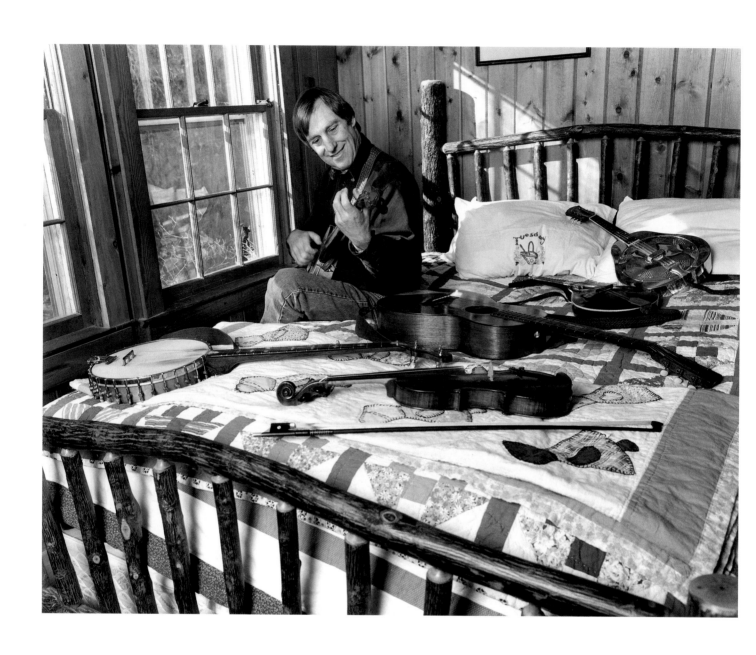

Wayne Erbsen with instruments, his home, 2003 • Asheville, Buncombe County, NC

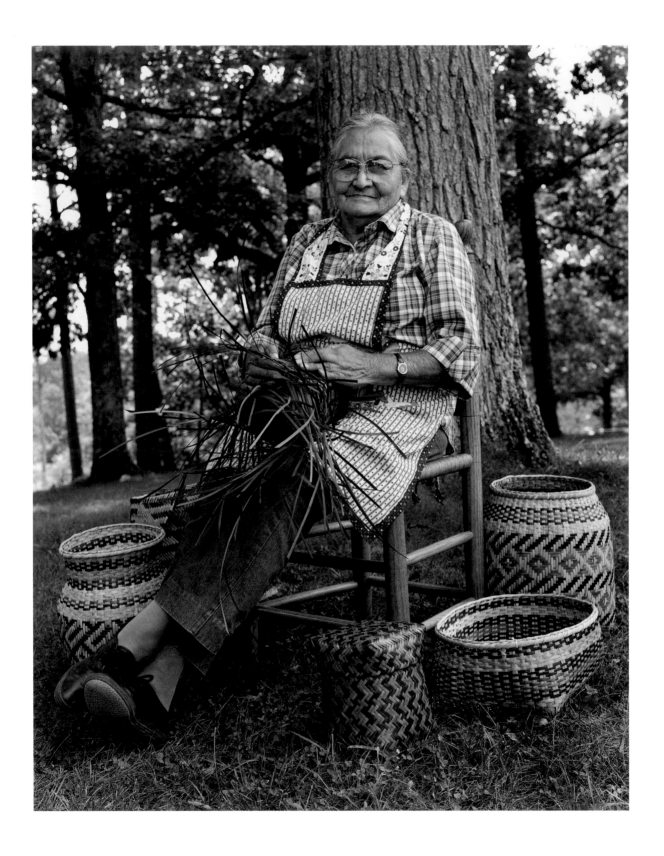

Rowena Bradley making double weave rivercane baskets, 1991 • Cherokee, Swain County, NC

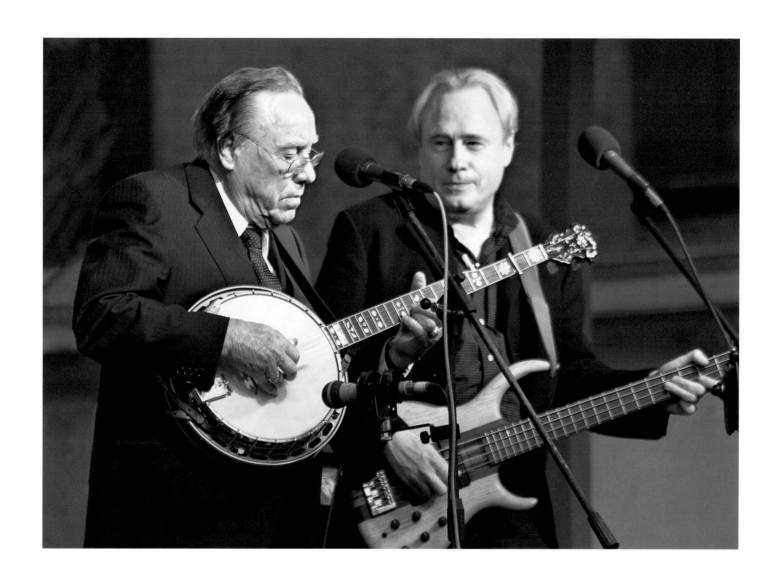

Earl Scruggs and son Gary, in concert, 2007 • Cherokee, Jackson County, NC

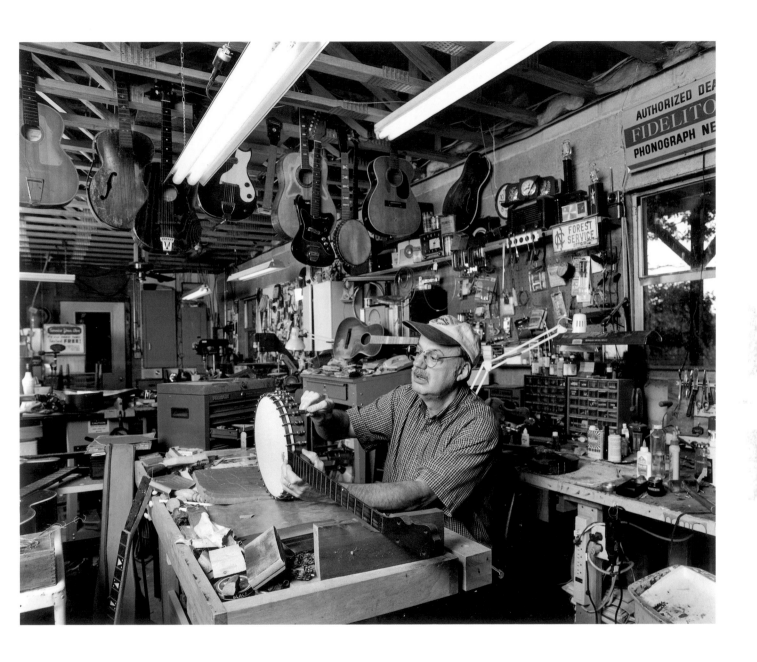

Roger Howell in musical instrument repair shop, 2002 • Banjo Branch, Madison County, NC

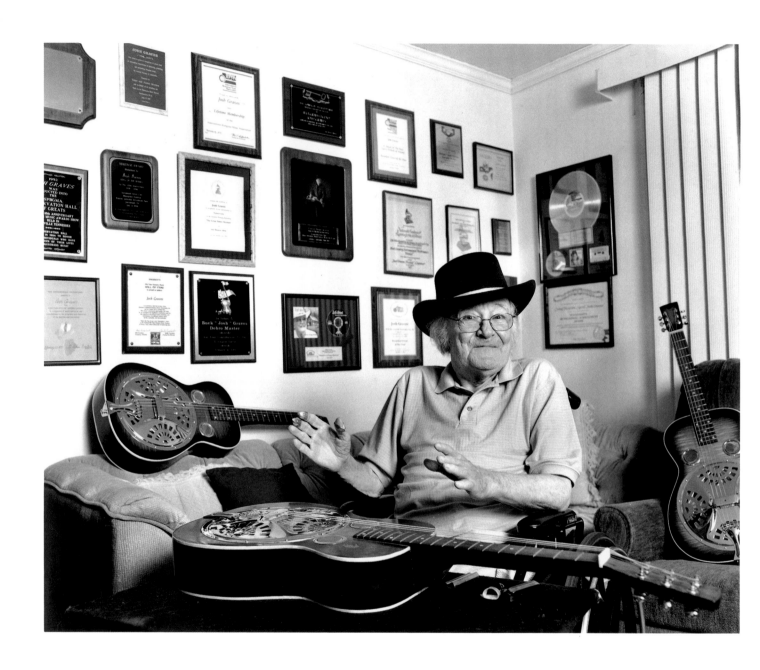

"Uncle Josh" Graves with Dobros and music awards, his home, 2005 • Nashville, Davidson County, TN

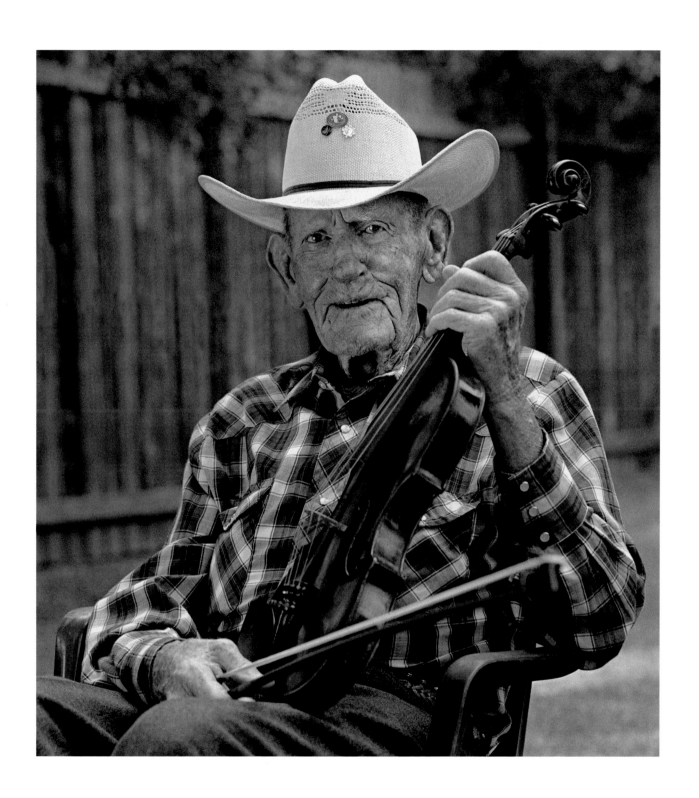

Kenny Baker with fiddle, 2005 • Nashville, Davidson County, TN

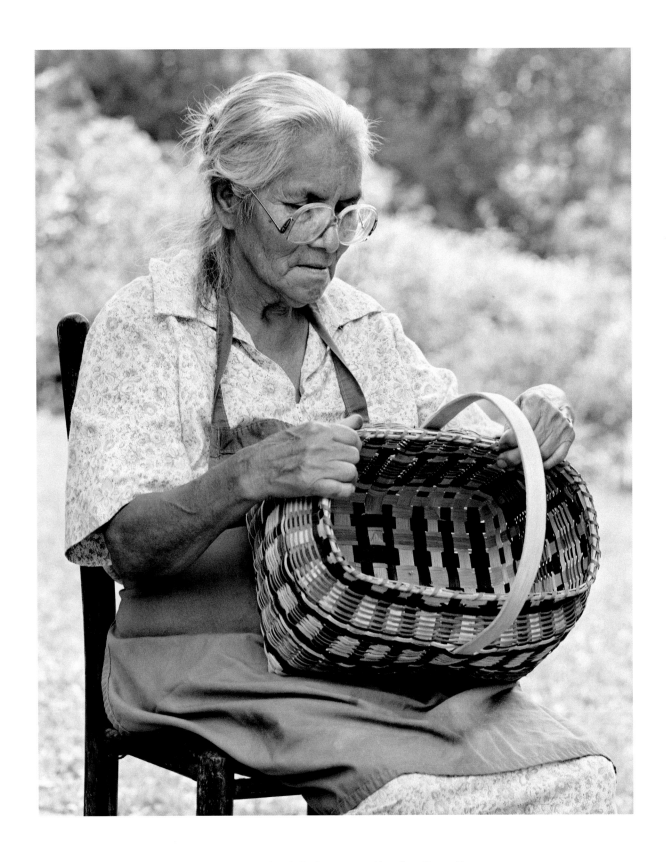

Agnes Welch with handmade basket, 1991 • Cherokee, Swain County, NC

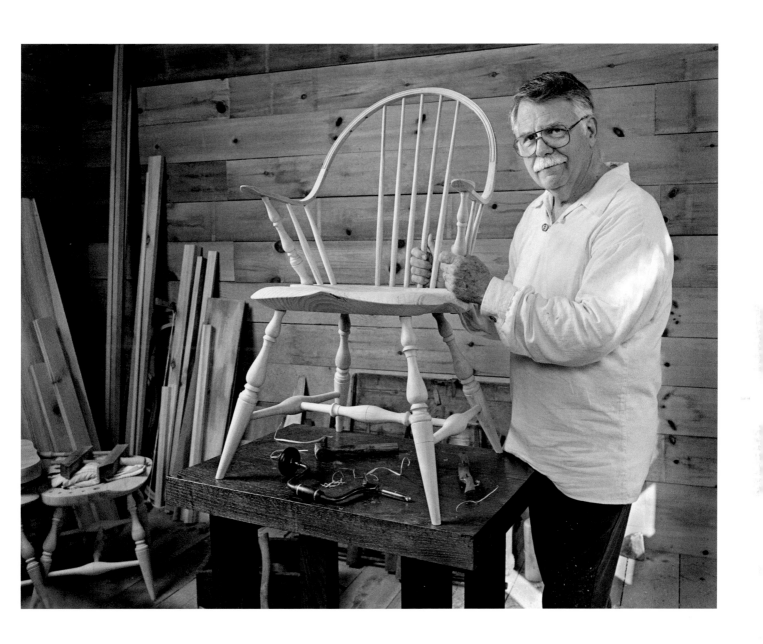

Bill Showalter with handmade Windsor chair, 2004 • Greeneville, Greene County, TN

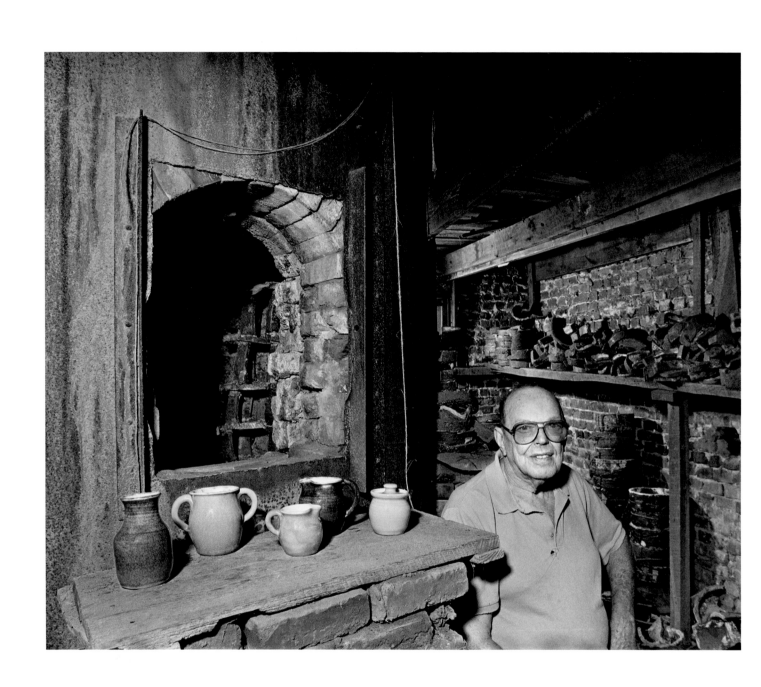

Thomas Case at bottle kiln, Pisgah Pottery, 2003 • Arden, Buncombe County, NC

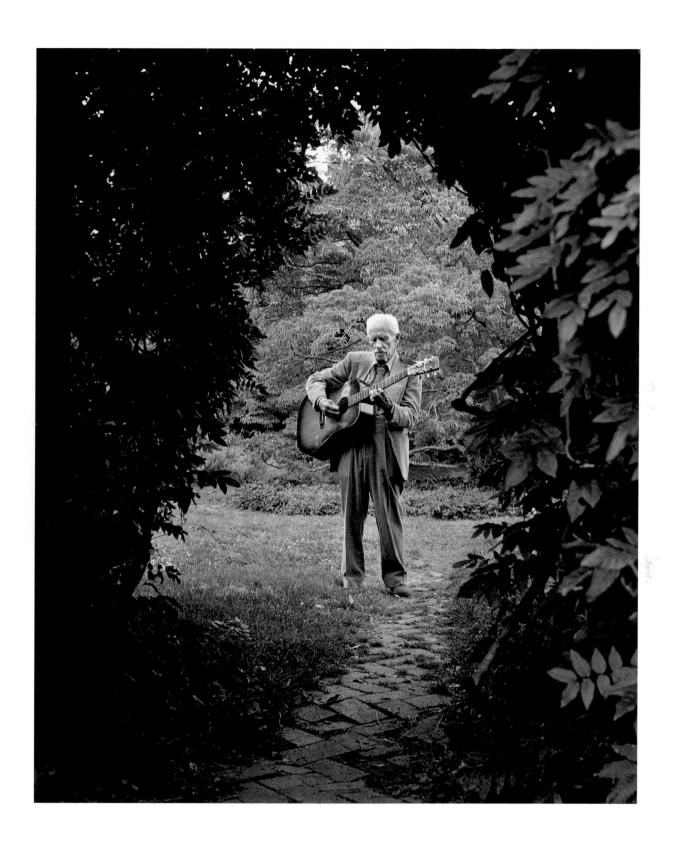

Kasper "Stranger" Malone, Old-time Music Week, Warren Wilson College, 2004 • Swannanoa, Buncombe County, NC

Oral Histories

Following are excerpts taken from conversations I had with many of the people I photographed. These are stories they told about their lives that I have edited from my taped recordings. These recollections represent an oral history and, as such, are only as factually accurate as the memories of the persons involved and may occasionally be tinted by time and forgetfulness. Nevertheless, they allow the viewer to see events through the eyes of the subject and provide context for the photographs.

Though there are a few people who I did not have the opportunity to interview, I have written a short biography for everyone to provide basic background information and give readers a sense of how they fit into their respective music or craft communities. I have listed a Web site, where available, containing additional information as a starting point for those interested in knowing more about a musician's available music or to see samples of finished pieces created by a craftsperson.

page 2

BYARD RAY (1910–1988) *was an old-time fiddler and banjo player who grew up in the Shelton Laurel section of Madison County, North Carolina, surrounded by oral history, ballads, and music. Many area musicians, including his great-uncle Mitch Wallin, influenced him. He made numerous recordings including two albums in the 1960s with cousin and banjoist Obray Ramsey and solo recordings including* Traditional Music of Southern Appalachia. *Ray and Ramsey made their movie debut together in 1971 in the "first electric western,"* Zachariah, *and recorded under the group name White Lightnin', releasing* File Under Rock *and* White Lightnin' Fresh Air. *Ray's music is featured on a new release from Ivy Creek Records, titled* Byard Ray . . . A Twentieth Century Bard.

The Byard Ray Folk Festival ran for many years at Mars Hill College in western North Carolina, highlighting many of the prominent musicians from this mountainous area. Byard taught music classes at nearby Warren Wilson College and Berea College in Kentucky. He received an NEA grant and the Bascom Lamar Lunsford award in 1981 for "significant contributions to the folk traditions in the southern mountains." His daughter, Lena Jean Ray, and granddaughter, Donna Ray Norton, are also accomplished musicians and ballad singers (www.ivycreek.com).

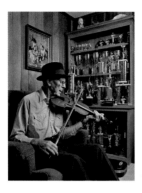
page 8

BENTON FLIPPEN *was born in 1920 to a musical family and into what turned out to be a hotbed of old-time music—Surry County, North Carolina. Home to well-known traditional musicians such as Tommy Jarrell, Fred Cockerham, Kyle Creed, and Earnest East, this is where Flippen learned first guitar and banjo, then the fiddle, his instrument of choice. He worked most of his life in hosiery mills near his home in Mount Airy and performed at fiddling competitions, square dances, and parties. Flippen honed his unique style, which features the use of slides and a strong rhythmic bowing technique, while playing with groups such as the Green Valley Boys, Smokey Valley Boys, Camp Creek Boys, and the Dryhill Draggers. He was awarded the North Carolina Folk Heritage Award in 1990 (www.musicmaker.org; search artist).*

My daddy farmed for a living and so did I till I was twenty-three. I lost a crop of tobacco. Had five acres just about ready and a storm got it. Broke seventy-five percent of it off to the ground. I quit farming and went and got me a job at Pine State Knitting Mill. I was there about ten year, then worked in the sock mills up till I was sixty-nine.

My daddy played the fiddle, my uncle played, two brothers played the fiddle, and one played clawhammer banjo. I'm the youngest boy in the family, but I'm not young now. I'm eighty-seven. I started out on the guitar, but I didn't like it 'cause it was hurting my fingers. I got me a banjo, played it awhile, and then got to playing the fiddle. I never did even look at any books of music. I learned by ear.

I started going to fiddlers' conventions when I was young, and over the years I got over a hundred blue ribbons, and these trophies in the case. I was bad to get nervous playing in front of people. It's right funny, though, the biggest crowd I ever played to—seventeen thousand up there at Newport—I didn't even think about getting nervous. I don't know why.

I was playing with Kyle Creed then. I've played with several different bands, with the Camp Creek Boys in the 1960s, and the Green Valley Boys with Leake Caudill, Glenn McPeak, and Esker Hutchins. That's where I learned the most style on the fiddle, from Mr. Hutchins, just by watching him. He was a number one old-time fiddler. Then in the 1970s I formed the Smokey Valley Boys and we won lots of ribbons and trophies. We played at Mount Airy and about all the festivals around. I've been to every convention they've ever had at Galax, Virginia. I won first place on the fiddle seven times, and stayed in the top ten for twenty-seven years. I played at the big fiddlers' convention at Union Grove, and got Fiddler of the Festival twice, and the World's Champion once.

They used to have way more old-time bands at these festivals than they did bluegrass ones, but now the bluegrass are way ahead of 'em. I like bluegrass, but I don't like it the way they play it. You can't even tell what they're playing lots of the time. They play it too fast, ain't putting it all in there. The very best bluegrass I ever heared on the fiddle is Kenny Baker. Now somebody else may think different, but he's number one in my book.

I've got three or four songs I've written. Tommy Jarrell named one of 'em "Benton's Dream." He used to live in a little bitty house out there on South Franklin Road. I used to play right smart down there with them. Tommy was kinda independent. He always had a bottle of hundred-proof liquor in his side coat pocket. He was sitting on the back of the truck up at the festival in Galax and took out that bottle and started to drink. Them cops seen him, said, "Old man, you're old but if you do that any more, we're going to carry you out of here and put you in jail." You can take about three ounces of that stuff and get by with it, but if you take that second drink, you'd just as well put your fiddle in the case—you can't play it. I used to take a little drink. It helped settle my nerves so I could get on stage, but I don't drink no more. Not since my heart operation.

I just lost my wife. That's the worst thing that's ever happened to me. I knew her from a young'un on up. We went to school together when we was both small. We were married sixty-three years. Our son, Larry, is the best one ever stood beside me with a guitar. He just picked it right up. Now he's got a boy, and he's learned him to play the guitar. They come keep an eye on me now that my wife's passed.

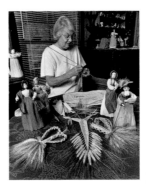

page 12

JANET MORRIS *lives in Black Mountain, North Carolina, and is a member of the Southern Highlands Craft Guild. She has taught many classes and workshops at local institutions, including Asheville-Buncombe College and Mars Hill College. She makes a variety of items including corn shuck dolls, baskets, wheat weavings, and seedpod work (www.southernhighlandguild.org).*

I've always done artwork. I love the arts, painting, and sculpture. I love the outdoors and working with natural materials. I see things in plants, stumps, and leaves that nobody else sees. In the fall you can get your nuts and things, and in the wintertime I love to collect my seedpods because a lot of times the pinecones are the best.

I was raised in Ohio. Dad moved us down here when I was sixteen. I married a mountain boy and had our six kids. I lost my husband in 1972, started going to different shops showing my things. I joined the High Country Crafters to sell my work and also began teaching for colleges, libraries, schools, scouts, home extension, and just here in my yard. I taught the corn shuck dolls, basketry, wheat weaving, chair bottoms, and the seedpod work, which are pinecones, nuts, and stuff.

In the early seventies I had gone to the Craftsmen's Fair and seen an older woman

making beautiful dolls just using corn shucks out of her field. I started making those. I like to dress the ladies in the period they came from. I don't go too modern. You think I'm making the doll, but at a certain point, when you start dressing them, she develops a personality, becomes an individual. Like my island doll, I call her my elegant lady. All of a sudden I can see her with the turban on, with the bright colored skirt, and so forth. I add jewelry to them. I even do the basket they're holding.

It goes back to the Indians here in the Appalachians. They would use the whole cob and carve out where the neck was going to be and bring it back down and tie it, and then put shucks in for the arms, braid those. None of the shucks was dyed back then. They were gathered straight out of their cornfields. The pioneer women in the mountains would make primitive ones, too, and might add a few scraps left over from making clothing and quilts to make a small doll. It depended on their wealth so to speak. Both kinds served a purpose. The little girl had a doll.

Before the Barbie, dolls were meant to be played with, but now they're collector's items. In the early years, even in the sixties when I was first going to crafts fairs, dolls did not have faces on them. The Indians would tell their little girls that the gods stole their face because they were too vain, so that sent a message to the child. But in the seventies shops stopped accepting dolls without faces because customers were coming in and saying, "I want a little face on it." I've had people come in and ask me to put faces on my angels, and they really have to twist my arm to do it because, if you want a face, your imagination puts it on there.

I don't set a flat schedule for myself—it's flexible. Used to be turn 'em out, turn 'em out, but now I work when I want to. I can keep going as long as my hands and my body let me. Somebody else won't tell me to retire. You're better off if you're doing something. If you enjoy it like I do, so much the better.

page 16

JERRY DOUGLAS *is an innovative musician and master of the Dobro who has appeared on more than two thousand albums, including the eight-million-plus-selling movie soundtrack to* O Brother, Where Art Thou? *He has been a part of numerous groundbreaking groups over his long career, including the Country Gentlemen and J. D. Crowe and the New South, and since 1998 has been a key member of Alison Krauss + Union Station. In addition to appearing on albums by James Taylor, Earl Scruggs, Ray Charles, Lyle Lovett, and Paul Simon, he has had an honored career as a solo artist. The Country Music Association named Jerry "Musician of the Year" in 2002, 2005, and 2007, an honor the Academy of Country Music has bestowed on him ten times. Jerry has won numerous International Bluegrass Music Awards and earned twelve Grammy Awards (www.jerrydouglas.com).*

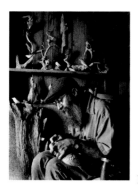

page 17

PHILLIP BROWN *is a wood carver, renowned for his carved birds. He moved to Swannanoa, North Carolina, as a teenager from Detroit, and later built a shop next to his home where he works today. Phil's carvings were featured on the Home and Garden network's* Modern Masters *TV series after Barbara Bush commissioned one of his birds for the White House Christmas tree in 2002. He is a member of the Southern Highland Craft Guild and sells work at art and craft fairs throughout the country (www.southernhighlandguild.org).*

With wood carving you're essentially carrying on a tradition that came over from Europe, but this particular type of bird carving seems like it came out of the Appalachian part of the country. Rather than going into full intricate detail work with the feathers and tufts and all, you just carve it, do a little sanding, and a fairly decent paint job on them. All the birds are mounted on driftwood rather than putting them on a turned plate base. It adds to the carving as far as being natural-looking as well as giving it something sturdy for support. You can hang it on the wall or set it down, either one.

I was in my early teens when I first started carving. I was influenced a lot by Edsel Martin. It wasn't sit down one-on-one teaching. I think it's for the better that way. He carved birds similar to these but we have two different styles. You gotta develop your own style, you don't want to copy anybody's. He was a one-of-a-kind character and one of my best friends. He passed away three years ago. It was a blow, but the impression he made on me is stuck, forever. As a kid I remember watching him carve. I would sit there and think, "Man, oh, man, if I could do that, that would be the life, to be a wood carver." It's funny to think back like that, some thirty-odd years ago now.

By the time I was eighteen years old I was carving and dealing with some of the local craft shops around, selling pieces. I was in construction work for a while and I carved along with it, but for the last twenty years it's been full-time wood carving, nothing else. Been pretty fortunate to be able to do something that I love to do and make a living, raise a family and all.

I make chickadees, wrens, mocking-birds, cardinals, hummingbirds, indigo buntings, painted buntings, towhees, just common birds that you'll find around your feeder, especially during the spring and summer. I'd say ninety-eight percent of them you can find right out here in my yard. I use some reference books when I carve and paint them to get things right, but there's nothing like the real thing to let you know if you are headed the right way. Most of them are the songbirds, but occasionally I will do something like a big pileated woodpecker or owls. I like to carve the little gray screech owls. They're about six, seven inches tall, real comical-looking little fellows.

I love it or I wouldn't be doing it. I wake up early and go to bed late. I can get too involved, putting in fifteen- sixteen-hour days. I get up in the morning right at daylight, six o'clock. I have a couple cups of coffee and head on out here to the shop. I'll take an hour

or two off for lunch, run any errands that need to be done. I live right here next to the shop so I just walk to the house for dinner and then I'm back out here in the evenings. Seems like early in the morning and real late in the evening are the quiet times of the day and that's when you can get a lot better concentration on what you're doing, for me anyhow.

I enjoy being a craftsman, that's the main thing right there. Just to be able to be a professional at it and make a living at what I do. The most fulfilling part of it all is seeing the reaction on people's faces, see their eyes light up and that they're happy when they come by here to pick up a piece from me. That makes me feel pretty good.

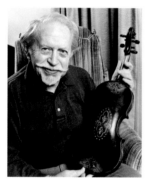

page 18

PAUL DAVID SMITH *lives in Hardy, Kentucky. An accountant by trade, he learned tunes from legendary Pike County fiddler Snake Chapman. He has played with a number of different bands over the years and has been featured as a guest artist and master fiddler at such prestigious gatherings as the Appalachian String Band Festival at Clifftop, West Virginia, the Augusta Heritage Workshops in Elkins, West Virginia, the Festival of American Fiddle Tunes in Port Townsend, Washington, and Fiddlers' Grove. He accompanied Snake Chapman on his two Rounder CDs and is featured on his own,* Devil Eat the Groundhog *(Rounder Select, 1999).*

I was born in 1933 and raised here in Pike County. I started playing when I was seven or eight years old. I played around the biggest part of my life with this type of music, bluegrass or old-time or whatever you want to call it. I never circulated much out of this area and about the only fiddle player that I had any association with was the great old-time fiddler Owen "Snake" Chapman. I was privileged to play off and on with him for forty, forty-five years. That's where I got most of my old-time fiddle playing.

Snake was part of a little three-piece band with two brothers, and they played on the Williamson radio station. At the time it was either bluegrass or country music on the radio. People didn't call it bluegrass then, they called it hillbilly music, and what they call country music now has almost no bearing upon what I heard as country music then. Country music now is what, soft rock, I guess?

My dad was one of Snake's good friends and got them to come to our house one night and play. I was six or eight years old and I just set there with my mouth open. I'd heard the music but that was my first exposure to actually seeing it played, and I said to myself, "That's pretty neat. I'd like to do that," and it just went from there. Snake played around just locally. Most of the time he worked in the coal mines. When I got older, we'd get together and play on Saturday nights, just for fun, sitting in the kitchen. We'd play three, four, five hours, depending upon how things were going.

John Hartford got interested in the music of Ed Haley, a blind fiddler out of the Ashland, Kentucky area. He came up here doing research and that led him to Snake, 'cause Snake had played with Ed. Rounder Records got interested in Snake and made a couple of CDs of his music and I played banjo on those. They found out I played fiddle and said, "Well,

we're going to have to make another CD," so they made one of myself.

Most of the old-time stuff that I know I learned from Snake. Then, of course, some of the more modern bluegrass stuff from Kenny Baker. He played with Bill Monroe, go and stick with him maybe six months, a year, get tired of it and come home. He'd get tired of that coal mining a lot faster than he was that fiddling so then he'd go back with Bill. Kenny's a great bluegrass fiddler but does a lot of old-time tunes, too. There's a distinction between them and when he was playing with Monroe, Bill didn't want him to play that old-time stuff, felt that it would corrupt his bluegrass fiddling. We'd go to the festivals when Bill's group would come around and get in a big jam session, but we'd have to go way out on the field somewhere and get away from Bill 'cause he'd get mad about it, really. But, oh gosh, Kenny loved it.

Most of the bluegrass bands that came through the area, like Bill Monroe, Lester Flatt, Stanley Brothers, Goins Brothers, played the local venues. Back in those days you didn't get in your car and drive two or three hundred miles to hear a show, which people do now. Roads were not conducive to making a very long trip. Those guys played wherever they could find an area big enough to get a few people in, little one- and two-room schools, or at the high school's gym if the school was big and lucky enough to have one. I went to see Lester and Earl at a drive-in theater up there at Williamson, West Virginia, and they played on top of the projection stand—the concession stand in the middle of the thing. It was a flat-top thing and they just got a ladder and set 'em up on top of the building.

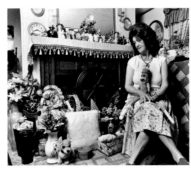

page 19

LENIAVELL TRIVETTE *graduated from Cranberry High School in her native Avery County, North Carolina. She worked two years at Newland Knitting Mills, then seventeen for Blue Ridge Hearthside Crafts, a craft co-op. Leniavell has demonstrated quilting at the North Carolina State Fair for twenty-five years alongside her mother, renowned quilter Elsie Harmon Trivette. She has attended Merlefest for eighteen years doing colonial knotted bedspread and hand-tied fringe work, demonstrated rug hooking at the World's Fair in Knoxville, and participates regularly at heritage events at the Folk Art Center in Asheville. She does spinning and quilting and makes dolls, animals, and sock monkeys.*

When I worked at Blue Ridge Hearthside Crafts, we shipped orders to shops all over the United States and overseas. We had different members that made the crafts and we'd go out and pick up their stuff in Yancey, Mitchell, Watauga, and Avery counties and ship the orders out. They did all range of crafts. We sold brooms, birdhouses, sock animals, dolls, and quilts. We took orders for quilts and pottery of every kind.

Mom always made sock monkeys and I like to do it, too. Used to, about every two weeks I'd go pick up crafts. It's a hundred-and-seventy-five-mile trip, and sometimes we'd be gone fifteen hours. Mama would take her materials

and work on 'em all the way. I remember one day she made eighteen on that trip.

Her mother, Polly Harmon, done a lot of knitting, crocheting, hooked rugs, quilts, and stuff. She always said I wanted to keep everything she made, but I did want to keep at least something. I've probably got four of her bedspreads, and this quilt and spinning wheel was hers. I took the last spool off that she done and kept it. I had an extra spool to put on it and I spin. I also started doing quilts and I've won some ribbons from different places, and I've made pillows, rugs, sunbonnets, the sock monkeys, and other little animals like bears and such.

Mom used to do rug hooking. We didn't have electricity then and she would put the rug up on the back of chairs and set the lamp on the table and hook at night. When I was seven she would give me a nickel to unravel a sack. We would just take an old burlap sack and dye it and then I'd pull the strings out one at a time for her. Mama used to do the natural dyes just from things around the mountains, blue from indigo, brown from walnut, and yellow from goldenrod. You can make your own patterns, use a crayon or mix up the dye and use a little brush to mark the pattern on 'em, take them strings and hook them into the burlap.

She'd also quilt and do knotting. In the center of her bedspreads she'd do colonial knotting and add a hand-tied fringe. She sold one to Goldie Hawn, the movie star. That was in 1988. They were here filming that movie *Winter People*, and Kurt Russell came out to the house and wanted Mama to teach Goldie to spin on a spinning wheel.

I'd always come to watch when Goldie was going to be taking spinning lessons. Goldie came out the first day, so Mama taught Goldie to spin and I taught her daughter, Kate, who

probably was about thirteen then. About two weeks later Kurt, Goldie, and Kate all come out and they stayed the biggest part of the day, just visiting. Goldie had Mama to make two pillows and she bought one of the bedspreads. They got ready to leave and Mama put the bedspread and the pillows in a big old black garbage bag. We got out in the yard and took a bunch of pictures and all. When the pictures come back, they're of Kurt still holding that bag, and Mama said, "Well, it looks like Kurt's carrying out the garbage!"

page 20

WAYNE HENDERSON *is a guitar builder and musician living in Rugby, Virginia, where he sponsors an annual music festival. He received a National Heritage Award in 1995 from the NEA honoring him as a master of traditional arts. He has built hundreds of musical instruments including guitars for Doc Watson, Tommy Emmanuel, Peter Rowan, Gillian Welch, and Eric Clapton, making him the subject of the book* Clapton's Guitar: Watching Wayne Henderson Build the Perfect Instrument. *He was a rural mail carrier for thirty-three years and worked in his shop building instruments after work. Wayne is also an acclaimed musician, winning top honors at the Old Fiddlers Convention in Galax, Virginia, using his distinctive three-finger picking style of playing. He is a veteran of three tours with the Masters of the Steel-String Guitar, and has played at*

Carnegie Hall, the Smithsonian Institution, and on tour in Europe, Africa, and Asia (www. waynehenderson.org).

I was in this little town in Washington State and I saw this sculpture in the city park. It got my attention because it was an old man playing a fiddle with a kid on his knee. It'd been carved out of brick. I'd never seen nobody do that. This fellow said he knew the man that made it, took me to meet him, and we got to be friends. I asked him what it would take to get him to come to Virginia to put up something in my yard. He said, "One of those mandolins you build would do it." I got his mandolin done and they came here last fall. He took a big old brick saw, some diamond blades and grinders and such, and started sawing and cementing it together. There's no paint to it, just different-colored bricks. It took him a week to do the whole thing.

One of the first guitars I ever made was out of a carton of snuff, that old-timey kind of dusty snuff like my granny and all the old women around here used. There was a fellow lived in the neighborhood here named E. C. Ball who was a really good guitar player and even famous people today record some of his songs. He had this little store out the road there. He'd let me play his old Martin guitar. That thing sounded so good it got me into wanting to make one, because I couldn't afford anything like that. I thought, "That thing's just made out of wood, I should be able to make one," so I drew a few patterns around it and started trying to collect stuff to make one.

I had observed that my mom's dresser drawer had a board in the bottom that had walnut veneer on it. It was sort of frazzled loose and I thought, "That's the wood. It's thin and it bends." I slipped that board out and put it

in the branch up behind the house. The next morning it was loose, so I pulled the veneer off, dried that board, put it back in there, and my mom didn't know nothing about it. I worked on it all summer and had it almost done. I had glued it together with old rubber glue but the "spring" was still in that walnut veneer, so when it got hot in August it blossomed like a morning glory and the whole thing come totally apart.

My dad wasn't too much into this guitar-making stuff. I was a teenager at the time and was supposed to become a farmer like everybody else. I hated to say anything about my guitar blowing up but I wanted it so bad that I told him what I'd been doing. He said, "The next time it's rainy to where we can't work I'll take you to see Albert Hash." Albert was a pretty legendary fellow around here for being a wonderful fiddle player and maker. I met Albert and he turned out to be one of my best friends, somebody I played music with for years. He was a machinist, built clocks, guns, and just a genius when it come to making things. He got his fiddle out and showed me. I just couldn't believe that anybody could make something like that. I thought a beautiful instrument like that would have to come from a music store. Albert gave me an old mahogany door and told me how to bend wood using water and a hot pipe. I went home and started working and it probably took me a year to make that guitar. The first thing I had to do was show it to Albert. He said, "Son, if I'd knowed you'd done this good I'd a got you some better wood." So that sort of got me started making instruments and so far I've made three hundred forty-one guitars, a hundred mandolins, fifteen banjos, four dulcimers, two ukuleles, one Dobro, and two fiddles.

I've been playing since I was five years old and I'm fifty-eight now. My dad was an old-time fiddler and I would hear him play occasionally. Most of those old guys quit playing when they started raising a family, had to work all the time on the farm. My brother taught me three chords on an old guitar and I had a neighbor that showed me how to play some Carter Family tunes, and several cousins that played and we would get together and pick. Any kind of entertainment was pretty scarce around here. We didn't have cars but you could walk to the neighbors and have the best jam session you ever heard. It sounded like it to us, anyway.

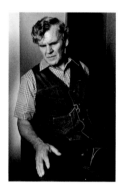

page 21

DOC WATSON *was born Arthel Lane Watson in 1923 near his current home in Deep Gap, North Carolina. Although his professional career didn't really take off until he was middle-aged, he has played since childhood. Eventually, he took up the electric guitar and played everything from country to rock to popular music at local venues while working as a piano tuner by day.*

When folklorist Ralph Rinzler came to North Carolina to record Clarence "Tom" Ashley during the 1960s folk revival, he met Doc and convinced him to switch to acoustic guitar and concentrate on a more traditional folk, bluegrass, blues, and gospel repertoire. Watson's career took

off and during the next two decades he and son, Merle, frequently performed together until Merle died tragically in a farm accident in 1985. Doc and his wife, Rosa Lee, paid tribute to him by establishing Merlefest, an annual festival held in Wilkesboro, North Carolina, where tens of thousands of people gather to hear music.

The master flat-picking guitar player, singer, and songwriter has been named an NEA National Heritage Fellow, inducted into the International Bluegrass Music Hall of Honor, and awarded the National Medal of Arts by President Clinton, and he's earned five Grammy Awards. Watson still records and regularly gives concerts with grandson Richard and friend David Holt (www.docsguitar.com).

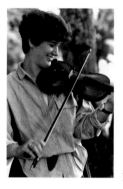

page 22

LEESA SUTTON (BRANDON) *grew up in the Candler, North Carolina, community, always around music. She took lessons from locals including Liz Shaw, Donny Lewis, and Arvil Freeman and listened to and learned from many other area greats for years. She started performing with her family band, which included her father, Jerry, and brother, Bryan, as a teenager at Asheville's Mountain Dance and Folk Festival. As an adult Leesa worked for about five years as coordinator for festivals and for the Shindig on the Green, a weekend summer event that draws thousands to listen to*

traditional music from the mountains of western North Carolina. Currently she works for the state of North Carolina through a community development program designed to bolster local heritage tourism opportunities. Married and living near where she grew up, Leesa is the mother of a three-year-old who already has an affinity for banjos and fiddles.

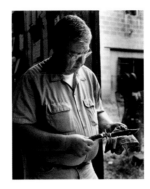

page 24

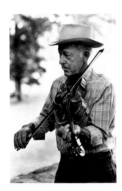

page 23

GROVER SUTTON *(1916–1994) was a fiddle player and patriarch to a well-known musical family from Haywood County, North Carolina. Following a twenty-year career in the navy, he pursued a greater interest in fiddle music, playing at local square dances and jam sessions in the Asheville area, and he was a regular at Nelia Hyatt's Music House. Grover eventually developed an interest in building and repairing fiddles, and some of his favorite instruments were those he made himself.*

His son, Jerry, granddaughter, Leesa, and grandson Bryan, along with many other family members are widely recognized and active in the music community. Bryan learned several tunes from Grover and has gone on to play with Ricky Scaggs and Kentucky Thunder, Dolly Parton, and the Dixie Chicks while garnering the coveted International Bluegrass Music Association's Guitarist of the Year Award in 2000, 2003, 2004, and 2005.

MIKE HENSLEY *apprenticed as a blacksmith under his father, Bea, and together they operate Bea Hensley and Son Hand Forge in Spruce Pine, North Carolina. Mike learned an ancient "hammer language" from his father that allows a smith and his striker to communicate while working together on a piece just by using hammer blows. This language is reputed to go back to the time of the building of Solomon's Temple. Their work can be found in numerous museum collections including the Pasadena Museum of Fine Arts, the North Carolina Museum of History, the Governor's Palace at Colonial Williamsburg, and the Smithsonian Institution.*

I started blacksmithing when I was four. My first job was helping Dad work on chandeliers that were six foot in diameter and had twenty-eight lighting fixtures on them. I've been able to design and draw since I was five and I was probably five or six when I learned the electric weld, acetylene weld. I've been blacksmithing fifty-one years.

I actually do more ornamental work than I do practical work. We do fifteenth- and sixteenth-century blacksmithing, which is decorative functional blacksmithing. In America, in the 1600s, 1700s, out in the villages and hamlets they needed utilitarian blacksmithing, hinges to go on the door,

that type of thing. It wasn't decorative, though, unless you were in someplace like Williamsburg or where you had a capital and rich people. You had wide divisions of blacksmithing at that particular time and everybody specialized. You had clock smiths, gold smiths, and pewter smiths. Some people made armor and nothing but armor. Others were blade smiths and made nothing but swords and knives. You had cutlery specialists that did cooking utensils and pots and all and they became known as tinkers in the United States. Now we have switched back to a more artistic type of blacksmithing and that's what I do here.

I like to do wrought-iron work, but really and truly my first love is knives. I love working them, watching them literally grow, and seeing people's faces and reaction when they get one. Actually, I've got about thirty-five knives that I've got to do. Some of these people have been waiting five years for me to get these knives done, but I've been busy on big welding projects—fireplaces and gates.

All our knives are functional. Most of them are for hunters, but whether they hang them on the wall or use them that's up to the individual. I am doing them for folks all over the United States. We custom-make them for each person. I make the handles out of sambar stag from India, which is much harder than our whitetail or mule deer or elk antlers, and it's got less marrow in it so I can do the scrimshaw on them much easier. I use a hand engraver. I like to do animals more than anything else. Turkey are my favorite because I like to turkey hunt.

We're not on the Web. We don't have a computer and all of that. Everything is strictly word of mouth. That's what I depend on and we don't lack for orders. I even have girls coming in all the time now getting knives. I did

one for a girl that lives on Lexington Avenue in New York City and I wrote her when I shipped the knife and said, "Please don't tell me what you're going to hunt on Lexington Avenue!"

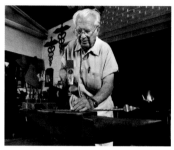

page 25

BEA HENSLEY *was born in 1919 near Flag Pond, Tennessee. His father moved the family to Burnsville, North Carolina, when he was young. As a teenager, Bea went to work at the forge of Daniel Boone VI, a direct descendant of the famous frontiersman, as blacksmithing was changing from a utilitarian craft to one of producing ornamental ironwork, and Bea's career followed that arc. In 1937 Boone contracted to do restoration ironwork for the colonial village at Williamsburg, Virginia. After World War II Hensley returned to help with this work and later bought the shop from Boone and went into ornamental ironwork full time. Today, Bea and his son, Mike, operate a forge along the Blue Ridge Parkway near Spruce Pine. He is a member of the Southern Highlands Craft Guild. In 1995 the NEA presented Bea with its highest honor, the National Heritage Fellowship Award (www. ncarts.org; search recipients).*

I started out shaping metal when I was just a little fellow of six or seven. I'd get my mother's flat iron and make little watch hands for those big fancy dollar watches and I've been making knives since before I ever started really

blacksmithing for a living. What give me the bug, though, was that I lived close to Daniel Boone's forge. When I finished high school, I asked him for a job. He was an easy fellow to get acquainted with and easy to learn from.

I first started blacksmithing commercially for the public back when they logged with horses. We made J-bars and grab hooks and all kind of full-hauls, they called them, and made pieces to repair saws in sawmills. The logging industry changed in the forties. Nobody used horses anymore. They began to use tractors, groundhog skidders, different methods.

I had a pretty bad accident in the early fifties. I was building up a corner and the dipper come unlatched from the loader, caught my welding helmet, and like to have killed me. I had double vision, lost my balance, and a lot of problems with my eyes. I had a pretty tough struggle, in and out of the hospital for about seventeen months. When I got out, my friend, Doctor Jack Horner, come by to check on me. He said, "Have you figured out what you want to do?" I said, "I'm going to put me a up a blacksmith shop." He said, "How much would it cost to put you in business?" I said, "I don't know. No use me trying to borrow money, because I don't know if I can work and pay it back." He made a phone call, said, "Put this amount in Bea's checking account." I like to have had a heart attack.

I built my shop and a showroom, had a pillow and blanket over here where I could rest. Enough people had been saving me their work that I was six months behind the day I opened the door. We made andirons, fire sets, screens, chandeliers, wrought-iron tables, and anything that goes on tables. To make a long story short, I had the money paid back in three years.

Doc Horner was a man with compassion. He hardly ever missed a week that he didn't come to see me, and we become good friends. No matter what we had on the table he would go wash his hands and come sit down, eat, and we would chat. It was a little bit strange to me, the interest he took in me, but I remember he said, "You may wonder why I come out here and chat with you, but everybody needs somebody to talk to." That's never left me.

My son, Mike, come along and he ain't been out of the shop since he was about four years old. He has always been a blacksmith, grew up with it, didn't have to learn it, he just went ahead and done it. We have two different forges but we work together on some jobs and produce a lot of work. We have work all over the world: Australia, New Zealand, England, Africa, France, Germany, and the Hawaiian Islands.

Some folks ask me when I'm going to retire. I kid them that the Lord don't need preachers and blacksmiths in heaven, so he leaves us down here as long as he can. I say that with a bit of reverence but a lot of the blacksmiths in this country lived to be old. I knew one that was blacksmithing when he was ninety-five. Maybe it's the exercise you get. You have to pour on the steam if you are going to make anything out of a piece of iron. I sit up in the morning and go like a freight train. My wife figures she ought to be able to do that too, but we're all not the same. On my mama's side, if you ain't lived to between ninety-eight and one hundred and four, you ain't lived. She died in January and she would have been one hundred years old in August. My daddy lived to be ninety-two years old. I figure I'm blacksmithing easy until I'm ninety-five. I kid people that it could be until I'm a hundred and fourteen!

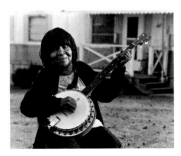

page 26

ALGIA MAE HINTON *was born into a musical family in 1929 in Johnson County, North Carolina, and started learning guitar at age nine from her gifted mother, Ollie, who played many stringed instruments. She spent most of her adult life farming and raising her seven children, largely on her own after her husband's early death. She did not make her professional music debut until she was nearly fifty, but since then has made up for lost time—performing at the National Folk Festival, Carnegie Hall, Merlefest, and many blues festivals. It's not easy to manage the intricate, rhythmic footwork of buck dance while playing Piedmont blues guitar at the same time, but Algia Mae Hinton does both exceptionally well. She has appeared on numerous CDs including her own,* Honey Babe. *She received a North Carolina Folk Heritage Award in 1990 (www.musicmaker.org; search artist).*

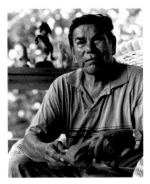

page 27

GEORGE "BUTCH" GOINGS *is a wood carver who lives in the Birdtown section of Cherokee, North Carolina, with his wife, Louise, a basket maker. Butch began wood carving while attending Cherokee High School where he studied under renowned carver Amanda Crowe. He is a member of the Qualla Arts and Crafts Mutual and demonstrates regularly at the Mountain State Fair in Asheville and the North Carolina State Fair in Raleigh (www.cherokee-nc.com/qualla).*

I've been in wood carving forty-some years. I don't come from a crafts family. I never turned out no crafts until I got out of high school. I learned mine from Amanda Crowe. She was an instructor at the Cherokee High School and taught young boys wood carving. I carve just any kind of animals I can think of, just whatever comes into my head. Usually I sit down, draw a pattern on a piece of wood, cut it out on the band saw, and then go from there.

I make just any size animal. When I'm out on the job and they cut a couple of walnut trees, I'll bring big blocks of it in here and take my power saw and cut them in half or whatever size I can get out of the piece of wood. I like to carve black walnut because it's a real hard wood and you can get more detail to it. I'll sit down one evening and may work on a carving a little while, get up, go out, pick up a piece of

stone, and work on it. My son, George, and me also do a lot of flint napping. In high school he was doing beadwork and after he'd come home out of service, and didn't have no job, I said, "There's carving." His mother started teaching him basketry, and he's got real good at that, so now he carves, makes baskets, arrowheads, blowguns and the darts, all that.

I've also been doing stone carvings for about eight years. I use different colors of alabaster, which I buy from the guy right over here at the old mill. In carving, you try to get your main body first, and any part you think may break off or something, the less you handle it, the less chance you're going to break it. Now, something like this piece I'll start with the head, then work down his body and finish up with his legs. I just look at a piece of stone and see what I want to make. The other day another stone carver asked me, "What do you see in this piece of stone?" I said, "The woman's head is right here. The baby will be on her back. You can put a sheet around her and make from just her waist part up. Carve her some hair and put a handkerchief, because the old ladies tie the handkerchief around their head."

I mostly work right here in this chair or sitting at the table. When I do stonework, like this red catlinite, it will be all over the floor and I have to mop a couple of times. But if I do wood carvings, I have chips all over the place, right. That's why I need a shop. I've almost got mine built down there. I ain't got no lights in it yet but I got my saws and everything set up. If I make a mess down there my wife won't be hollering at me.

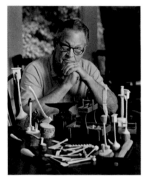

page 28

BILL HENRY *was born a coal miner's son in Gatliff, Kentucky, in 1929, and grew up in Appalachian communities where every boy owned a pocketknife and whittling was a practical pastime. In 1944 he moved with his parents to Oak Ridge, Tennessee, where he lives today. Around 1960, while working at the Oak Ridge National Laboratory, Henry took up whittling as a hobby. During the 1970s, he honed his skills serving an apprenticeship with the late woodworker and NEA National Heritage Fellow Alex Stewart. The self-styled "itinerant whittler," Henry started out carving accurate miniature versions of the antique farm tools and implements he loves to collect and has raised traditional whittling to an art form. He became a member of the Southern Highland Craft Guild in 1965 and a life member in 1991, and is known for his generous support of other traditional craftspeople.*

I've been whittling seriously for at least forty years. I worked over at Oak Ridge National Laboratory as a chemical operator, an hourly employee. I was in a high-tech outfit where I probably didn't belong but managed to get my points in and hung it up, and it was an exciting place to work, really. A lot of bright people around, good supervision, good working conditions, and when things were going well the coworker and I had a lot of time on our

hands. They furnished electricians' knives and I began to whittle with one of those, and been doing it ever since.

Most wood guys get bent out of shape if you call them whittlers, but that's what I do. I tell them, in this part of country they were whittling before they were ever wood carving. When I was growing up every man and boy whittled. I never was a "wood carver" until I joined the Southern Highland Craft Guild.

Currently what I do is the size on the table. The jackstraws are kind of a favorite of mine. In each set I have twenty-five different pieces, one of which has a wire hook on the end. The idea is you hold that one aside, use it as a tool. After you drop the other two dozen pieces in a heap, you take it and try to get another. It's an old traditional game like pickup sticks, but for adults. You take liberties with scale, decide how long you want them, and make them all that size regardless of how big the original was. I have a couple hundred items on my list, and there's so many potential jackstraws, over time you get kind of wacko. I have Dolly Parton's training bra and Nancy Kerrigan's skaters' knee and a coon hunter's toothpick, on and on.

My wife has been in this assisted living facility in town since June of last year with Alzheimer's. Prior to that I didn't whittle near as much as I do now. My routine is to get up and read the paper, have breakfast, whittle from about eight-thirty or nine o'clock until about noon or one o'clock, have lunch, go see her, and come back. I'll average twenty hours a week, which is probably more than I ever did, except when I was working!

I'm loving it more and more, and I don't make any bones about it, I'm doing the best whittling that I've ever done because I'm still learning. That's the way it ought to be, you

need to keep progressing. I feel extremely fortunate that I've found something I can get so wrapped up in. I've never had that many varied experiences in life, but I've never done anything where I could just sit right down and go for six or eight hours at a time, even at my age, and take a break and go back to it again. It's just a wonderful activity, and since my wife got ill I find it infinitely therapeutic. You gotta have something to kind of get wrapped up in, lost in.

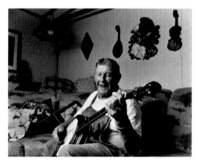

page 29

Lee Sexton is a banjo player living in Line Fork, Kentucky. Born in 1928 in Letcher County, he started playing at age seven and is a master of the clawhammer (drop-thumb) and two-finger styles on the banjo, sings, and plays the fiddle. He learned to play listening to neighbors and from his uncle the renowned banjo player Morgan Sexton. Playing on the weekends at square dances, house parties, and the like, he spent thirty-four years working in the coal mines. Sexton appeared briefly in the movie Coal Miner's Daughter, *playing in a square dance scene. In 1999, Kentucky governor Paul Patton presented Lee with the Governor's Award for Lifetime Achievement in the Arts. His classic LP* Whoa Mule *has been rereleased and expanded on CD (June Appal, 2004).*

I still live on the old farm where I was born and raised. I've been here, soon be eighty year, and I been a-playing the banjo over seventy, started

when I was about six, seven year old. I lived right around a whole passel of old-time banjo and fiddle players, and I'd just go from door to door and listen at it, and got to wanting to learn. I went to school with a boy, said he had a banjo he'd take a dollar for. Well I tried to borrow a dollar off my grandpa but he wouldn't let me have it. Right over there was about three acres, *all* of that bottom, in corn stalks. They done gathered their corn, and Grandpa said, "If you'll cut all of them stalks and pick every one of 'em up and burn 'em, I'll give you a dollar." So, whenever I'd come in from school, I'd work till dark trying to earn that dollar. It took me three or four days of hard work and he give me that dollar. I run every step down Line Fork Creek here to where that boy lived, and bought his banjo. It had a groundhog hide on it, with its tail still on, hanging down. It didn't have no frets on it and had wooden screws. I learned "Cripple Creek" and thought I was Earl Scruggs then. I've still got that banjo, but the tail has rotted off.

I had an uncle, Morgan Sexton, and learned from him. I'd say he was the best banjo player around here. I learned some from Old Man Hardin Campbell who was a good old-time banjo player, and Boyd Watt and Dee Whitt, who played fiddle, and then I got to hearing my cousin Roscoe Holcomb. My father played, but I was too small then and can't remember hearing him and can't get ahold of no recordings he done. He was fooling around shooting off dynamite one Christmas and a stick went off right in his hands, went *shewwww*. Blowed his hands off and they stuck to the ceiling of the house. That was on Christmas Eve and they thought he'd die of a minute. The next day at nine o'clock he was still living and they put him on a cot and carried him out of this creek here,

straight across the river to the train station. He was in the hospital eleven days, come out and bit him off a mail route, and he retired carrying the mail. Never got no artificial limbs or nothing. His stubs were just as tough as a hog's snout.

That's how come I had to go to work when I was so young. I worked at the coal mines thirty-four year. I watched my hands like a hawk, buddy, when I was working there, about getting 'em hurt. And I'd say about a month before I retired I had an accident down in the mine, caught my finger and broke it square in two. Then a damn coon bit me right there on my hand and broke both them bones. Now my hand's busted up so much I'm lucky to play "Cripple Creek," I sure am. I've had to relearn how to play.

Then we farmed, too. My cousin down here would have a corn hoeing, invite a whole bunch of people. I've seed seven and eight teams of horses with plows come in and they'd be enough people here to clean a field out in a day. They'd cook a big dinner and eat supper, then drag out a big five-gallon stone jug of moonshine. Nobody never got a drink, now, till a day's work was done, and supper was eat. They'd carry their furniture right out in the yard to make room, square dance all night: I'd play till there'd be a blister on my thumb. They'd give me a drink, I'd take a sip out off a big old gourd, it'd drip off my chin, and I'll bet you that hide on my old banjo was five hundred proof!

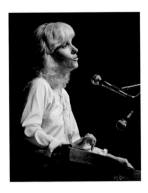

page 30

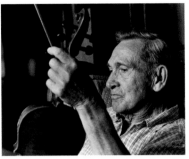

page 31

MAGGIE LAUTERER *was a feature writer for the* Asheville Citizen-Times *(North Carolina) newspaper for more than five years before joining WLOS television as an on-air reporter, producing features. She began playing music at the Mountain Dance and Folk Festival in 1983 and has performed there every year since. She studied three years at Union-PSCE seminary in Richmond, Virginia, and is minister at Burnsville First Presbyterian Church in Yancey County, North Carolina. She grew up in nearby Crossnore, and her performances draw much inspiration from childhood memories of her grandfather singing on his farm. Maggie says that while performing she often thinks about her childhood and those who taught her the old folksongs and "can smell the cattle and hear the milk squirt against the milk pail, beating its own rhythm, as Granddaddy would sing in his clear high lonesome tenor. How could I not keep those songs alive?"*

GORDON FREEMAN *(1922–2004) came from a musical family in the hills of Madison County, North Carolina. Although never a professional musician, he played many dances and at festivals, including Merlefest, and won awards at the Bascom Lamar Lunsford Festival, the Mountain Dance and Folk Festival, and at Fiddlers Grove. Although he and his younger brother, Arvil, both played fiddle, Gordon favored old-time while Arvil is known as a bluegrass musician. Many people learned tunes from him, and his music is part of the Smithsonian collection.*

I grew up in Paw Paw, about ten miles out of Marshall. There was a man, Paty Cody, who lived across the hill from us. He was one of the smoothest fiddlers I ever heard and a fine banjo and guitar player. He played tunes like "Chicken Don't Roost Too High," "Sweet Bunch of Daisies," "Tennessee Wagoneer," all them old ones. He passed away several years ago and the worst part of it is, nobody got a tape of him or nothing. It's a pity to lose all that music but back then nobody didn't know what a tape player was.

My granddaddy played fiddle and could solid whistle. I was just a youngster but I remember him sitting on the porch, whistling. I learned a whistling tune from him. He called it "Sandy River," but others called it "Hickory County," and it's got four or five more names.

He also played harmonica and give me one for Christmas when I was ten years old, and I've wore out a truckload of them over my life.

I learned a lot just by listening to the radio and playing around the house with my brothers, but really it was my second cousin that got me into music. He played like Chub Parham, that two-fingered style banjo. He could play "Cumberland Gap" and "The Bucking Mule," just make your hair stand up. His sister, Pearl, played guitar, I played harmonica, guitar, and banjo, so we'd all get together and jam. They would have corn shuckings and ice cream suppers around the community and we would play, eat ice cream, what have you.

There was five of us playing, but we didn't have a fiddle. There was a fellow, Woodrow Randall, that ran the grocery store down at Barnard. I noticed he had a fiddle hanging on the wall and asked him about it one day and he loaned it to me, and that's when it really started for me. We didn't have the instruments then like you have now, you just played what you could scrape up and beat on. The first guitar we ever owned we give five dollars and ninety-five cents for from Sears and Roebuck. That's back when you raised a tobacco crop and it brought thirty-six dollars.

We would also have stud dances, just a bunch of boys and men, get together in an old house and play music and dance. Usually there would be some kind of event once a week. That was when everybody did free-style dance anyway, so you didn't need couples. You just got up and danced to the tune.

There were thirteen kids in my family. Five of us played out of the eight that lived. My brother Carmen played bass with the Sauceman Brothers back in Bristol, Tennessee, and my brother Arvil played the fiddle. Arvil

can play anything, the old tunes and bluegrass. Personally, I like traditional music better. I like the timing, the notes, and melody. Seems to me like good old-time music has got more life to it, more punch. Of course there's a lot of good bluegrass fiddlers, but really, some of them, you can't tell what they play.

My granddaddy was the first one that got the radio and we'd all crowd around on Saturday night and listen to the Grand Ole Opry. All the stars would come out on the road, done their shows at the local schoolhouse. Me and a bunch of boys used to walk four or file miles from Paw Paw to music festivals over at the Walnut school. Our parents were just poor dirt farmers and we never had no cash money. We didn't have enough money for all of us, so one of the boys would pay the quarter to get in and go open a back window so the rest of us could slip in. Them was the good old days. Life was simpler. You didn't have nothing to worry about.

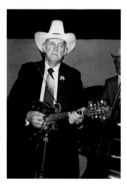

page 32

BILL MONROE *(1911–1996) is known as the father of bluegrass music. Monroe was a singer, composer, and instrumentalist who created this new American genre out of the folk, string band, African American blues, and church music he heard and played while growing up in a musical family in rural Rosine, Kentucky. Those*

elements later jelled into bluegrass, with its breakneck tempos, virtuosic instrumental solos, and tight, intricate vocal harmonies.

Originally playing with brothers Birch and Charlie, Bill broke with them to form his Blue Grass Boys in 1939, the same year he joined the Grand Ole Opry. The albums they made in the mid-1940s with the incarnation of the band that included legendary guitarist Lester Flatt, banjo player Earl Scruggs, and fiddler Chubby Wise are considered the first bluegrass recordings.

Over the years many musicians were part of Monroe's Blue Grass Boys including Mac Wiseman, Jimmy Martin, Kenny Baker, Vassar Clements, Carter Stanley, and Peter Rowan. During the 1950s, Monroe entered a period of relative obscurity as rock and roll hit the scene, but during the folk revival movement of the 1960s folklorist Ralph Rinzler championed Monroe and helped re-establish his popularity. He went on to win Grammy Awards, was a National Endowment for the Arts Heritage Fellow, and was inducted into the Country Music, IBMA, and Rock and Roll halls of fame (www.billmonroe.com).

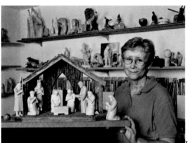

page 33

HELEN GIBSON *is a wood carver living in Brasstown, North Carolina. A member of the Southern Highland Craft Guild, she is the author of numerous books, including* Carving the Nativity with Helen Gibson, Helen Gibson Carves Saint Francis of Assisi, Helen Gibson Carves the Animals of the Nativity, *and* Carving Moses with Helen Gibson. *She is the John Campbell Folk School's Resident Wood Carver and teaches workshops there and throughout the Southeast (www. southernhighlandguild.org; search members).*

I've always lived in the Brasstown community and a lot of people here carved. Hope Brown is well known for her angels, cherubs, cats, and stuff like that, and Fannie Ivester carved little lambs, cats, and napkin rings. My mother learned to carve at the John Campbell Folk School. They had a guy there that cut out the wooden blanks for all the carvers. They'd go down and pick them up and bring them home and carve and the Folk School would buy the finished work. My mother carved napkin rings, birds, cats, just a lot of the little things you see in their gift shop, so I grew up around it. I actually started carving when I was about eleven years old and just kept at it.

When I started all you had to have was a knife and that was just two dollars. With the type of carving I do I could take it anywhere and carve. Probably the biggest thing I do is twelve or fourteen inches so it's not like you

need a lot of equipment. The majority of the Brasstown carvers, including myself, work with basswood. It's a light-colored wood, not real hard, and works good. It grows around here, but the northern basswood is better than our southern basswood—it's bigger and whiter. I order mine from a guy who works for the Forest Service in Minnesota. I cut out the blanks with the band saw and then put it in a vise and use the coping saw and knock a good little bit off, then use some gouges and go over it with that. I used to use a rasp a lot if I was working with hard woods, but with basswood you can do most everything with a knife and gouges. Once you get them carved you sand them by hand and put a finish on them.

When Maggie Masters was the director at the Folk School, Jack Hall used to be the main wood instructor. She asked us carvers if we wanted to take classes with Jack on a "space available" basis to learn to do the nativity figures because, at that time, he was the only one left doing them besides Hope Brown. That's how I started doing the nativity figures and the Saint Francis. I've also got a Moses and Jesus praying in the garden and do little deer, bears, and smaller stuff. Mostly, though, I like to make Santa Clauses and Christmas tree ornaments.

Maggie had me come down and take over classes after Jack got sick, so I sort of got into teaching at the Folk School and at the community college. I also do a couple of classes each week here at the house, and teach out of town. I really enjoy teaching. You meet so many nice people and you learn a lot from them.

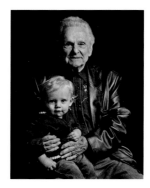

page 34

RALPH STANLEY, *born in 1927, performs the traditional bluegrass that has its roots in the evocative, often mournful ballads and hymns of the Clinch Mountains of Virginia where he was raised and still lives. From 1946 until 1966, Ralph and older brother, Carter, performed as the Stanley Brothers with the Clinch Mountain Boys. While the outgoing Carter played guitar and sang lead, the more reserved Ralph sang tenor harmony and played the banjo in a unique three-finger style, influenced by Earl Scruggs, that came to be known as the Stanley style. In the mid-1940s, the Stanleys were early converts to Bill Monroe's bluegrass music, but the Stanley Brothers' fortunes waned with the rise of rock and roll in the mid-50's. Their popularity rose again in the 1960s during the folk music revival.*

After Carter died in 1966, Ralph decided to honor his memory by carrying on his own musical career. The singer, songwriter, and instrumentalist is a member of the Grand Ole Opry, the recipient of the National Medal of Arts, an NEA National Heritage Fellow, a Grammy winner, and has been inducted into the IBMA's Hall of Honor. He has appeared on some 170 albums, tapes, and CDs, and in 2000 he contributed a haunting rendition of his song "O Death" to the O Brother, Where Art Thou? movie soundtrack (http://drralphstanley.com).

In choosing songs for my Carter Family tribute CD, I went through about three or four hundred songs. I didn't try to do the ones that was popular, I done the ones that I could sing the best, do justice to, ones that suited me and that I enjoy singing. They were songs that I grew up listening to, mostly on the radio. The Carters were recording with Jimmie Rodgers the year I was born, 1927. I never did see them, the whole group in person on the stage, but I met all of them. They lived over close to Bristol, Tennessee, and I recorded my first record in Bristol.

I don't read music, just play by ear. I started singing, I guess, before I started playing the banjo. I went to church starting when I was very young, Primitive Baptist. They didn't have a choir. They wouldn't know what a part was, they just all sang lead, a capella—they don't use instruments. I was about eleven years old when I picked up the banjo. My mother tuned it up for me. She played when she was young, but didn't through the later years. She just played for her own amusement, didn't perform out anywhere. She could play the clawhammer style, picked a little bit, and showed me a tune.

The first time my brother, Carter, and I performed together on stage was just after World War II, around October or November of 1946. We both served in the war, Carter in the air force, and I was in General Patton's Third Army, the infantry, went to Germany and stayed a year. Carter passed away in '66 and I started my Hills of Home Bluegrass Festival in 1970, and we've done it every year since then at the old home place near Coeburn. I wanted to start something that would keep Carter's name alive, not to make any profit off of, but to let people know that I started with him, because there's thousands of people that never heard of the Stanley Brothers.

We started playing professionally in October of '46, so I've been on the road almost sixty years now. Coeburn is a pretty central location for us to travel from. I preferred to stay at home and do my music and not move to a big city. Never had the temptation to move to Nashville. I can be there in about five hours if I need to go. We stay busy all the time, usually do a couple of shows a week, stay on the road for three or four days at a time. We keep our tour bus parked down in Coeburn and meet up there.

I've had to cut down on my traveling a bit, but I'd miss it if I quit. I still enjoy playing, but I don't enjoy the traveling, long trips and everything. It's hard to get out of it when you've been in it so long. I don't know what I'd do with my time. Most of the guys in the Clinch Mountain Boys have been playing with me a good while, and Ralph II has been with me since he could crawl—not playing, but you know, traveling. I put him on the payroll when he was sixteen. My grandson Nathan's lived with me since day one and has been playing with us for about two years now. And here's Ralph III, he's Papaw's baby boy. He's got the music in him, him and Nathan.

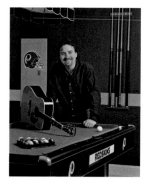

page 35

RALPH STANLEY II, *son of bluegrass legend Ralph Stanley and nephew of Carter, began singing along with both Ralph Stanley and George Jones records at age two, at three played the banjo, and at five decided to switch to guitar. Known by his nickname, "Two," he is currently a lead singer and rhythm guitar player with his father's Clinch Mountain Boys, a band he joined before graduating from high school. Both his father and fans frequently compare his voice and songwriting to that of the late Carter Stanley, who died ten years before Two was born. In addition to his work with the Clinch Mountain Boys, with whom he shared a Grammy, he launched a solo career in 1996, producing CDs that feature both country and bluegrass songs. Two of those solo efforts have been nominated for Grammy Awards (http:// drralphstanley.com or www.rebelrecords.com).*

Before me and my wife got married, I took her to the high school prom. She was a senior and I was probably nineteen, twenty years old. I was playing Stanley Brothers songs, letting her hear what they sounded like. One song was called "Seek Jesus, He Still May Be Found." Uncle Carter really sung that good, and even though I didn't know him—he died before I was born—for some odd reason I've always felt like he's been on my shoulder.

I got inspired by that to go to the cemetery, and took off up toward the festival grounds where he's buried up there at the Hills of Home Park in Coeburn. I went in there and said, "Kristi, I'll be right back." I walked up to Carter's mausoleum, and said, "Carter, you're the best lead singer that I ever heard in my life." I just wanted to tell him that. As I was getting ready to leave, I got that funny feeling, like somebody's watching you or something's behind you. Do you ever get that way, get spooked, your heart starts racing? I got back in the car, didn't tell Kristi anything. I guess she knew who was in there but she didn't know much about the history of this place at the time. I was driving down the road and she seen a couple of tears in my eyes, I guess, and said, "I got a feeling that you ought to turn this car around and let's go back. I'm going to walk in there with you this time." I turned around and went right back up there.

We could see a little wind blowing, but there wasn't nothing moving. I said, "Uncle Carter, if you can hear me, make this flag up here move." As soon as I got that out, just the awfulest gust of wind you ever seen in your life come through there and blew that flag and it went berserk. That wind went through and was gone, and then it was just nothing again. Things like that happen, funny things, you know. So that's a good memory I've got, 'cause I feel like he might have been with me. That led to the line on my CD *Carrying On* being wrote where it said, "If I ever get back to Coeburn, have a talk with Uncle Carter, tell him how I feel." And I did. I went up there and told him how I felt about him.

That CD come out in July of 2004 on Rebel Records and was my second Grammy-nominated album. To be nominated for a Grammy and be in my shoes is really extra special because, coming up the ladder, a lot

of people said, "You'll never fill them shoes, you'll never do this, never do that." But I never did really want to try to fill no shoes. I never looked at it that way. I just love music, and I love to sing, and the title song I wrote sort of explained that. I respect my heritage, where I come from. You can't help where you're born or who you are, but I couldn't ask for two better peers or singers or family members ahead of me, to maybe hand a little something down to me. Like I told people before, if I had a little of Carter and Dad's talent, I'd be okay. But it made me feel good to be nominated, made me feel like I'd done something. I want to stay true to my roots when I do a CD, but I also try to find myself more and more with each one I do. I become my own man a little bit more.

When I was fourteen, fifteen years old I used to get a guitar and a banjo out. I'd carry a banjo in to Dad, and say, "Let's play some." He said many times, I sort of got him back in the mood to really play, kept him motivated. He'd had me a banjo made when I was a boy, but for some odd reason it just didn't suit me. The guitar felt more natural, and I was never one to want to just go out and play a bunch of different instruments. I just want to write songs, play good rhythm guitar, and try to sing the best I can. But now Dad got my little son Ralph III a real nice banjo made up, and I ain't going to force it to him, but I got a funny feeling and I believe he'll pick it up. I sure do.

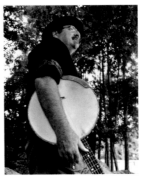

page 36

JERRY ADAMS *is a musician living in Newport, Tennessee. He grew up across the state line in Madison County, North Carolina, and is a pharmacist by trade. Well known and respected as an old-time banjo player Jerry appears at many area music festivals.*

Peter Gott taught me my first song back in the 1960s, but I didn't play much, just occasionally in the home, till about 1983. When I started back I just had the style I started with, so from that point on I sort of developed it as I played. Some of the speed and other stuff came from when I added fingernails to the playing and that allowed me to play clawhammer, which is a down lick with the fingers, and old-time, which was, around here, an up lick with your fingers. The nails allowed me to play the banjo both ways, down licks and up licks.

I think that, in the past, music styles were a regional thing passed from one generation to the next. Today, though, there's a lot of young people playing music styles like old-time, even though they may not be from the region where the music was formed. It's gotten wider exposure, and it just goes along with the spread and fragmentation of music. Now, if you find players and singers that you like and want to emulate them, you can listen to their albums or tapes. You can go to festivals and hang around a person while they play, or take

classes like at Mars Hill College's Old-time Music Week, where you take a lesson with the person you like. I listen to tapes and things, but if I have a choice of listening to somebody play or listening to the tape, I'd want to hear and see them play, get the whole ambience.

I listened to a lot of different music growing up, but what got me interested in this music was that I had an uncle, Nolan Adams, who was really close to old man Lee Wallin, Jack and Doug's dad. Uncle Nolan's daughter and I both got interested in playing about the same time, and I'd play the guitar and she'd play the banjo. They were interested in helping her learn to play, so we'd all go over to the Wallins' every Tuesday night and play music with whoever showed up. On Saturday they had a muzzle-loading rifle shoot out front, and we'd go shoot guns and play music between shots. Jack and Dale didn't shoot so they sat on the porch and played banjo and fiddle. After old man Lee Wallin died in 1972, I got busy raising a family and working and sort of drifted out of it. Later, I would go to a jam over at Doug Wallin's nephew's place. Doug saw me over there and liked the style I was playing and how I played it, and we sort of hooked up and he gave me a lot of confidence in the sound and stuff and we went from there.

There's just a lot of musicians that were originally from Madison. I was born in the Sodom section, but my mother won't acknowledge that. She reminds me very carefully that my grandfather was the postmaster of Revere—they wouldn't call it Sodom. The isolation, lack of television, people listening to the radio and all, all contributed to the music culture. Many folks have moved out but if you go to Mrs. Hyatt's music place or to Shindig on the Green in Asheville, half those people are from Madison originally. It might be called a genesis place from where they all scattered.

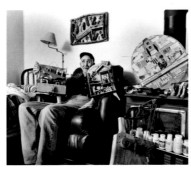

page 37

HAROLD GARRISON *is a master wood carver and folk toy maker from Weaverville, North Carolina. His folk art is widely sought after and his Government Machine, an intricately designed working wooden construction that highlights all the bureaucracy in government, is on display at the Smithsonian American Art Museum in Washington, D.C. Garrison makes a variety of wooden toys including tops, gee haw whimmy diddles, and limberjacks— which he has danced at many local music events. For many years Harold has been a presence in music circles in the area, and at six feet ten inches tall his lanky frame is hard to miss on Friday nights at the Depot in Marshall and Saturday nights at Asheville's Shindig on the Green. He was the recipient of the Minstrel of the Appalachians Award in 2007.*

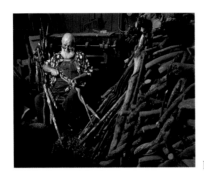

page 38

RALPH GATES (1937–2004) *worked for Grumman Aerospace as an engineer on the lunar module for NASA before making a career and lifestyle change in 1973 to learn broom making from renowned craftsman "Pop" Ogle in Gatlinburg, Tennessee. He is considered by many to be the first master broom maker and is credited as being the person who transformed making brooms into an art form. Gate's pieces are in museums and private collections including the Ogden Museum of Art's Center for Craft+Design. He was an active member of the Southern Highland Craft Guild and traveled the country selling brooms at arts and crafts fairs. Today his son, Marlow, and daughter-in-law, Diana, continue to operate Friendswood Brooms in Leicester, North Carolina (www.friendswoodbrooms.com).*

I learned to make brooms from Pop Ogle over in Gatlinburg who was making and selling brooms for tourists. He'd been doing it since the Depression and discovered that he could make old brooms like your grandmother made and sell them alongside the road for fifty cents apiece and make more money than he could working for the state for seventy-five cents an hour. His Log Cabin Broom Shop is still in the family. Pop learned from his grandmother Granny Ogle, who was a broom maker for the Gatlinburg valley back in the 1800s. The broom she came out with about 1840 pretty

well locked brooms there into the form they are now.

If you actually use a grocery store broom, you're doing good to get two or three years out of it, whereas a handmade broom will last anywhere from fifteen to thirty years if you take care of it. When I was working at Pop's shop that summer a lady came in and wanted to know if I would tie a new broom on her handle. She said Pop tied it for her just after the war and she finally wore it out. Turned out it was Pop's father that tied it and it was World War I she was talking about. She'd had that broom since 1922, used it every day, and this was the seventies.

Pop's name was Lee M. Ogle. He invented the double broom, mainly because he was a lazy old cuss and kept making the broom wider and wider to sweep out his shop so it wouldn't take so long. He could only make it so big because broomcorn is very slippery and would slide out. One day he saw a forked stick and said, "If I put a broom on that I can make it even wider." He was honored for it in *National Geographic*. He even started picking up vine-wrapped handles and calling them "fancy" and charging a little bit more for them. So he was the first generation of professional broom makers. I represent the second, and my son, Marlow, is the third.

There's an interesting photograph from the Civil War that shows a typical country peddler with his horse and wagon and all his stuff hung on the sides. On the back of the wagon is a barrel with brooms sticking out and they look exactly like what you would buy in Kmart today, because when the broom-making machine came along around 1840, people in other areas who were making their own just stopped. The design was frozen from that time. Around here, it wasn't worth

dragging one of those machines up Old Fort Mountain, so consequently commercial brooms never really hit here until we had good rail service into Knoxville. They were tying by hand clear up until the 1930s.

All my children learned to make brooms. I'm slowly trying to push the whole thing over to my son Marlow. I prefer to spend my time on design work creating one-of-a-kind pieces rather than on production work. Craftsmen in other mediums started producing objects that were useful but also pretty to look at, and we're starting to explore color, shape, texture, size—all of the things that's done with an art form. As a craftsman you get bored doing the same thing over and over. You think, "What if I raised this neck just a little bit, or flared it out, or wouldn't it look good with a bunch of little triangles on it?" I do them more as an object of art, something that you can hang on the wall and look at rather than just sweep. In other words, moved brooms into functional art. What we're doing today is catching up to where the professional broom makers would have been if there had ever been one.

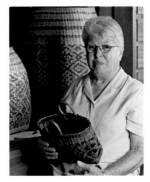

page 39

BETTY DUPREE *spent almost twenty-five years managing the Qualla Arts and Crafts Mutual, an organization that is primarily responsible for keeping alive the arts and crafts of the Eastern Band of Cherokee Indians. The Mutual, founded some fifty years ago, is made up of artists and craftspeople from the tribe and operates a retail sales shop in town.*

Betty left her native Cherokee when she married her husband, who worked for the Bureau of Indian Affairs. They lived in Colorado, Arizona, and New Mexico, where she worked in shops and galleries, learning how to sell crafts, manage businesses, and work with both the public and the artists. After moving back to Cherokee, she applied for a job managing Qualla, and under her direction it became the most successful American Indian owned-and-operated cooperative arts organization in the nation. She is nationally recognized for her work there and has been sought out by many other tribes and organizations to share her knowledge. Betty has been a strong champion and advocate for Cherokee artists and has successfully nominated many for the North Carolina Folk Heritage Award.

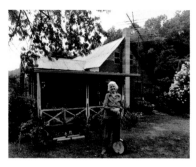

page 40

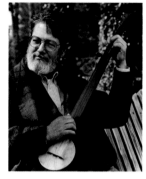

page 41

MARY JANE QUEEN (1914–2007), *ballad singer and clawhammer banjo player, was not only born into a musical Jackson County, North Carolina family but also married into one. Her father, Jim Prince, was a talented banjo and guitar player; her mother, Clearsie, was a singer, and her five brothers were accomplished musicians as well. She picked up banjo by watching her father and learned songs from her mother, members of the community, and itinerant workers. Mary Jane married banjo player Claude Queen, and they had eight children, including four daughters, Dorothy, Carolyn, Kathy, and Jeanette, and four sons, J.C. Jr., Albert, Delbert, and Henry Queen. After Claude's death in 1984, she began performing at festivals, sharing the stage with many of her children, all musicians.*

Although best known as a ballad singer, her repertoire drew widely from European, American, and African American traditions. She won the 1993 North Carolina Folk Heritage Award and a 2007 NEA National Heritage Fellowship. In addition, she was the model for the character Viney Butler in the 2006 film Songcatcher *(www.henryqueen.com and www. ncarts.org; search recipients).*

JAN DAVIDSON (bio. page 184)

The Campbell Folk School is the main example of the Danish-type folk school in the United States. Our founder, Olive Campbell, was a graduate of Tufts and married John Campbell around 1906. He was an educator, raised in Wisconsin, who went to Williams College and then to seminary. After his first wife died he had health problems, so the doctor sent him to take an ocean trip. He met Olive on the boat and they married. They got the Russell Sage Foundation in New York to help finance research of the mountain region and produced a book from it. They worked on it from about 1907 to 1918 or so. John died in 1919 and Olive took their material and wrote *The Southern Highlander and His Homeland.*

She was one of the first ballad hunters in the mountains, back in 1907, and the basis of the movie *Songcatcher*. The movie made it a conventional "woman-passed-over-by-male-chauvinist-pig" plot, but what really happened was she thought her material was of such value that it should be double-checked by the best scholar in the field. She got Cecil Sharp to see if she had done it justice, and they published *The English Folksongs of Southern Appalachia*. By 1921 she had written, with Sharp, the best folk song book ever done in this country and the best Appalachian study ever done, as far as some are concerned.

She got interested in folk schools. She and John asked mountain people what they wanted to see happen in the future. People complained that if you wanted to get educated you had to leave home, and to use what you learned you had to stay gone. There was a need expressed for adult education, close to home, that wouldn't disrupt your family life. The Campbells determined that it would be a good thing to figure out some kind of schooling for these adults that did not impinge on their extreme independence and dignity. The way I explain this is that they figured out if you pit one mountain person against the other, somebody's going to get killed before it's over.

Being scholarly people, they researched rural adult education. Turned out the Danes had been doing this stuff for fifty years. The Campbells planned to go over there in 1914, but the war came along and they didn't make it. John never did. Olive went with Marguerite Butler, and they spent two years there and checked out folk schools in Sweden and Finland, too. When they came back, Olive started writing *The Danish Folk School*. They began looking around for a location to do this type of school here in the mountains. Marguerite came to Murphy in 1925. She met Brasstown store owner Fred O. Scroggs, and they got the whole community behind this. The land and labor to build the buildings was donated, and it really was a joint effort of the local folks and these Yankee ladies.

The school here is most known for crafts. People tend to stereotype us as being very traditional, but the school has always been very forward-looking. It's never stuck to the past and never tried to stop time. Besides crafts we teach music, nature studies, writing, and cooking. There are an incredible variety of things we do. That's what keeps it so alive.

Most of our teachers come from the mountains, but our students come from everywhere. Some are just looking for a vacation, but a lot come because they've decided they want to do this as a major hobby, sideline, or job. We are not a vocational school. We might teach you what you want to know to make a living but we don't do it for that reason, because it tends to say to people, "You have to get through this education somehow, and you will be rewarded later." The whole point of the folk school is that it's very "in the moment." You should be having a whale of a good time right now, not thinking, "I'm tolerating this because later I'll get a good job."

You see people wanting to make their own music, cook real food, grow their own gardens, get control of those parts of life that are mass produced and meaningless. It's also a connection to history. It's rooted in what has otherwise become sort of a rootless society. It has the feeling of timelessness about it.

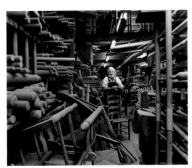

page 42

MAX WOODY *is a sixth-generation chair maker who lives near Old Fort, North Carolina. He opened his shop in 1950 and today his two sons work with him producing one-of-a-kind rockers and chairs. His reputation has brought him recognition in national media including being featured in Home and Garden TV's* Modern Masters *series. His creations are in*

homes in about every state and numerous foreign countries. When not building chairs, Max can be found relaxing at his log cabin a few miles from his shop or playing fiddle at a local music event.

My people come to this country from the old countries. Supposedly, there was three brothers came over and settled in different areas around these parts. Most of 'em got into timbering, logging, sawmilling, and carpentry, that type of thing. In those earlier days, the Woodys was pretty well known for building wagons, and my mother's family, the Arrington's who settled Haywood County, built fine handmade furniture. So, I've got a dose of the woodworking on both sides. My ancestors go back at least seven generations, counting my two sons. My father used to help his dad in the chair shop, and then they both left chair making for a while and went to work for the railroad, because it paid better. My dad got hopelessly crippled in a railroad accident and had to quit, but he always had that desire to build chairs.

I finished high school with great difficulty 'cause I had to work a lot, my dad being crippled and passing away when I was fifteen. I had a homeroom teacher that didn't care much for me and predicted that I was the least likely to do anything worthwhile. Some people said it was cruel, but to me it was funny. But we had a vocational shop there where we had tools, and that teacher saw it was something that I wanted to do, and every minute he could he'd let me work there. Now the people that graduated in that class of 1947 have all agreed that I have been the most successful. Not monetarily, but just being happy in what I'm doing. Your life has truly not been a success if you don't enjoy what you're doing.

After my dad died I got a job in a furniture factory. There wasn't many girls'd date you if you didn't have a car, so I didn't have much to spend my money on. I hired a ride to and from work and saved half of what I made each week. I made sixty-five cent an hour when I started working, and eighty-three when I quit. After almost three years I had saved eight hundred and fifty dollars. I quit the factory and caught a bus to Charlotte, spent seven hundred and thirty-six dollars of that money that day, bought my machinery, came home, and went to work.

In the meantime, Granddad was making chairs about three miles up the road. To him I was still just a boy even though I was twenty-one. The first day I went to work we assembled six chair frames. That was the most anybody had done in a day's time, so the second day he hired me. I built my own shop in 1950 and I've built chairs ever since. After the first couple of years, I can't remember a time when I didn't have orders on the book. At the current time, I'm between five and seven years behind on orders. Of course I'm getting older so I only work half time, twelve hours a day!

I custom-build my chairs to suit the person. It depends on how tall, short, healthy, or strong, whatever. For instance, a musician fellow in Sylva wanted a chair with no right arm so he could play guitar. Another man was an executive with a big company, developed a serious crippling illness and needed a rocker that was high in the seat. He knew he wasn't going to live long enough for me to build him one of my regular chairs, so I took one of the tall porch rockers I had on hand and extended it. His wife brought him out a few times to try the chair, and he was in such pain one particular time he couldn't get out of the car. I took the chair to his home and he was amazed. His eyes said, "Why are

you doing this for me?" I lost money if I'd kept time on it but I made the man comfortable.

God's blessed me with good health and work that I enjoy. There's no way to explain the pleasure that I've gotten out of building chairs. Someone started to leave here one day, and said, "Mr. Woody, you have a good day." I said, "All of my days are good—some just better than others," and I hope it's always that way.

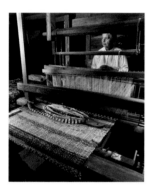

page 43

BARBARA MILLER *is a weaver living in Brevard, North Carolina. She and he husband, Bob, volunteer demonstrating their crafts at the nearby Cradle of Forestry in Pisgah National Forest where she works with visitors and school groups. A native of Haywood County, Barbara teaches weaving in the area and is a member of the Southern Highland Craft Guild (www. southernhighlandguild.org).*

This loom was donated to the Cradle of Forestry for the original visitor center. We figure it's probably from the early 1870s to 1880s. At one time everybody that was able to weave would have had one. Even if they didn't do anything fancy they would have made blankets, rugs, lindsey-woolsey for clothing, the hard men's work clothing. According to the 1847 census there were something like eight hundred families in Haywood County and seven hundred had looms in their homes. A loom like this would usually have been out on the porch or in the little side building because of the space it took up inside the house.

Traditionally cotton, flax, and wool were used in this area. Nearly every family had a patch of flax and they would process the flax and wool and use the flax for the warp or the weft to make clothing, blankets, or sheets. A lot of times one woman out of the family would do the weaving for the whole family and that included raising flax and sheep and everything. By the 1830s, '40s, '50s, people with money were able to buy cotton thread that was done up in skeins instead of spools. They called it bunch thread and lots of times would use that instead of having to grow flax because flax is such a process. Like tobacco it's a fourteen-month product from the time you plant it until you are ready to use it.

My main interest is in the old fabrics. I've been working for about ten years on the collection of pattern drafts of Frances Goodrich and her work at Allanstand. I ended up doing some work in Scotland to find a connection between the weaving patterns that we used and our Scots-Irish heritage. I have ones from her that were written on, "This came from Ireland in 17-something, this came from Scotland in 1810," so they came with the settlers. One thing that's interesting about the Appalachians is that basically it was the women who were the weavers, whereas in other places men were. In all of Goodrich's papers that I've been through I don't think she ever mentioned a man weaver, just one more task that the women could do, I guess.

I didn't know this until just a few years ago but my great-grandfather had been a weaver. The whole time I knew him he was blind and

quite elderly but they said he wove and taught school because he wasn't no good as a farmer.

My dad was one of eleven kids and my grandmother said that the hardest thing was to keep everybody clothed—they started out too big and just grew into them. There was a photograph of my dad and one of his sisters when he was about three years old and he was wearing a little pinstriped suit of clothes, had on a pair of pants that buttoned to the shirt. It surprised me because most of the time boys was photographed in dresses at that point. Part of it was practical as it was easier to make a dress than pants, and I suspect part was superstition. It was unusual to find a family where there weren't two or three children dead in the line as they grew up because there were so many childhood diseases. Parents felt like if they pretended the boys were girls they wouldn't lose the sons. I asked her, "Why didn't one of the other kids wear it?" She said, "I tried to keep one outfit that each one of them wore without handing it down."

Back then, there was no money to buy, and no transportation to get, the store-bought goods in. You used the clothing until it wore out then made rag rugs out of it. They never wasted anything because they didn't have anything to waste. On two harnesses on the loom they could do their entire textile needs—sheets, household linens, and clothing. It would take one person doing nothing but that because they say it's six months from the time the fiber is ready for spinning until the garment is ready for wearing. They would have woven everything from the baby's diapers to the shroud they buried you in. They buried people in shrouds because their clothes were worth more than anything else they left behind.

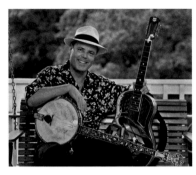

page 44

David Holt *is a musician, storyteller, historian, television host, and entertainer. Earning four Grammy Awards, he has performed and recorded with many of his mentors including Doc Watson, Grandpa Jones, Bill Monroe, Earl Scruggs, Roy Acuff, and Chet Atkins. David is host of public television's* Folkways, *a North Carolina program that takes the viewer through the southern mountains visiting traditional craftsmen and musicians. He hosted the Nashville Network's* Fire on the Mountain, Celebration Express, *and* American Music Shop *and was a frequent guest on* Hee Haw, Nashville Now, *and* The Grand Ole Opry. *David hosts* Riverwalk Jazz *for Public Radio International. While collecting the traditional music of the mountains, Holt discovered folktales and true-life stories, which he weaves into his concerts along with a wide variety of musical instruments. David tours the country performing solo, with his band the Lightning Bolts, and with Doc Watson (www.davidholt.com).*

I got interested in percussion at fourteen and started out as a rock-and-roll drummer in California. In the late sixties I fell in love with the sound of clawhammer banjo and ventured to Asheville, North Carolina, looking for old-time banjo players. Byard Ray, Obray Ramsey, and Tommy Hunter were some of the first people I met there. Having grown up in Texas, I really wanted to get back to the South.

I returned to California, finished college, then decided to move to Asheville in 1973.

At that time folks like Tommy Jarrell, Dellie Norton, Walt Davis, Etta Baker were between seventy and ninety years old. Their musical repertoires were from the early 1900s. These folks couldn't slow their music down and teach me, but if I watched closely and taped them and played with them, I could learn the songs and tunes. These became long-lasting relationships, developed over many years. I guess I was in search of musical grandparents and I found lots of them.

There's a soulfulness about mountain music that really can't be put into words. That's why it's expressed in music. There's a power in the fact that it has been hand-rubbed and reworked by generations of people, not just by one guy trying to make a buck by writing a song or trying to please an audience. It's hundreds of people that have passed these songs down. Take a fiddle tune like "Soldier's Joy." Nobody can say how old that song is, hundreds of years I'd say. It's been reworked and remolded all these years. When I play it I'm getting the spirit of those old people and the power they had. Hopefully a little bit of that comes through me. I feel like traditional music restructures the brain in a positive way, sort of like mantras that you say over and over.

The isolation of the mountains played a part in keeping the purity of traditional music. But the minstrel shows of the 1850s, Civil War and vaudeville tunes, blues, early jazz and swing influenced and slowly changed the sound. Many of those tunes are still heard, not as antiques but as something that's still being played today. Records and the radio appeared in the early 1920s. Until that time the music was localized with very distinct regional styles. Just like the people, the music was very individualized. Now everybody's much more homogenized, and the music is too. I was fortunate as a young man to see the end of that era. It doesn't exist anymore.

To me it's really incredible to see how all the influences that came into the mountains mixed together. The English and Scots-Irish brought their music with them, but when it mixed with the African American music early on, it became distinctly American. This area was very isolated and there weren't many black people, but the black musicians around here influenced a lot of people. That mix created a powerful sound, a hybrid that was attractive and strong musically. You don't hear a banjo tune and say, "Dang, that sounds like blues," but if you went back a hundred years it's a very bluesy thing, because the banjo was African. Those old bluesy notes that you hear in banjo didn't come from the white people. They heard black people doing that and added the blue notes to it, so it's a pretty wonderful amalgamation.

I have learned a lot from people here in the mountains, but I hope people remember me as a person who gave back, too. I think only performers would know this, but there's something that happens when you have a group of people together. You, as the performer, create a spirit of togetherness in that room and the audience leaves, saying, "That was fun and inspiring. I really enjoyed that and want to hear more." That's an amazing thing to have happen, and when it's over, it's gone, but people carry it with them. I really love that. It's powerful, it's beautiful, and then it's gone, just like life.

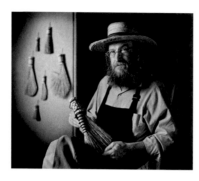

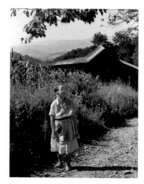

page 45

page 46

CARLSON TUTTLE *is a craftsman who makes brooms and baskets, weaves, and makes lace. He is a member of the Southern Highland Craft Guild in Asheville, North Carolina, where he regularly demonstrates his techniques. His father was originally from Kentucky but Carlson grew up in Detroit, moving to Yancey County, North Carolina, in 1971 to pursue his love of crafts. Carlson spends part of each year in Belize, where he sells baskets and runs an anthropological research library, studying the culture of the Garinagu on the coast of Central America. He has learned to make many of their traditional baskets, including a nine-foot-long version the women use in making cassava bread. Carlson is one of the few people, including tribe members, who can still make them.*

DELLIE NORTON *(1898–1993) was a ballad singer from Madison County, North Carolina, and part of a family of musicians and singers that included Berzilla, Doug, and Jack Wallin, Lloyd and Dillard Chandler, and Byard Ray. Her aunt Zipporah Rice sang for the British musicologist Cecil Sharp around 1917. Norton sang the old, unaccompanied, largely English and Scottish ballads and love songs passed down through her family and other members of the community. She sung for musicologist Alan Lomax, and later for John Cohen, who included three of her performances on his* High Atmosphere *anthology, and was in his film* The End of an Old Song. *She received a North Carolina Folk Heritage Award in 1990, performed at the Smithsonian Folklife Festival in Washington, at the 1982 World's Fair in Knoxville, and at local folk festivals. In addition to singing, she played the banjo and farmed tobacco in the remote Sodom Laurel section of the county. She influenced a large number of younger musicians, most notably her great-niece Sheila Kay Adams, who talks about Dellie in the interview below.*

I grew up in a community and a culture where everybody knew everybody, took care of everybody, and was related. When my mother's mother died I started spending a lot of time up at my great-aunt Dellie's and I've called

her Granny ever since. I went a lot because she always welcomed me there. I guess part of it was because her husband had died in the early 1960s and she was lonesome. There were these really neat things like the music and the food, planting by the signs, just all of it. It was a whole lifestyle, singing just happened to be a part of it. I realized when I got older, in college, that, no, everybody didn't grow up like I did, and, no, people didn't get together and play music and sing songs. I started to realize not just the uniqueness of Sodom where I grew up but also the importance of those traditions and how the entire culture was dying out.

Granny said that right before World War I folks had just about quit singing the love songs. But when Cecil Sharp showed up in 1916, 1918, everybody her age, between ten and twenty, got real interested in singing them again because he said it was important. Sharp made note of the fact that the love songs that he was hearing here in the southern Appalachians were purer in form to the original than what was being sung in England at that time because the industrial revolution and all had changed things over there. He predicted that the tradition would be dead by the early fifties, and it probably would have been if it hadn't been for Frank Brown coming through, and Alan Lomax, who came through in the 1930s.

Granny said people had just about quit singing again by the 1950s. Then John Cohen came through in the early sixties and made that documentary movie and did his records. Them folks were real upset with John and thought that he'd come in there and done all this recording and made that big movie and was making all this money, but of course he wasn't really. But I think that caused enough of a stirring up of interest to where they were at least singing them again, which was crucial

for my generation because if it had died out in the fifties we would never have learned it. They would just have been gone.

So while I think the outside influences changed the tradition, I think that folks coming in from the outside kind of had a function because, if nothing else, they stirred up the natives. And recording the songs was important, like upstairs I've got lots of CDs that came right out of the recording that John Cohen did of Granny's singing, and Dillard Chandler, Berzilla and Lee Wallin. A lot of those people are dead and gone now and they would never have been recorded had it not been for some of the folklorists that came in. The songs became entrenched in the culture and as time went on folks even forgot they had been brought here. I mean Cas Wallin used to say, "This song is one of the oldest I know, George Washington used to sing it." Actually, it was written back when the Normans invaded the Saxons, but to them the fact that Washington used to sing it made it incredibly old and they were totally unaware that it went back six hundred years before that.

The biggest thing I'm dealing with right now is just letting go of a lot of this stuff because it can't really be my mission to go through life trying to shove this tradition down anybody's throat. I was receptive to Granny and her generation and if I find somebody that's open to at least this one element that survived from this wonderful culture, then I'll be more than happy to pass it along. But if I don't, that's okay, times have changed and the world will move on.

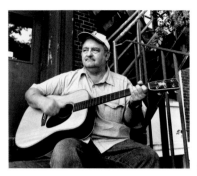

page 47

BOBBY MCMILLON *was born in Lenoir, North Carolina, in 1951. He is a musician and storyteller, nationally known for his "Jack Tales," or folktales with a tall-tale twist. He began recording and interviewing relatives when he was seventeen, documenting their old stories and songs. Bobby plays guitar, banjo, dulcimer, harmonica, and juice harp, and has performed at a variety of schools and colleges, in film, and on radio and television programs. He has participated in national storytelling conferences and numerous festivals, including the A. P. Carter Memorial Festival and the Smithsonian Folklife Festival in Washington, D.C. He was the recipient of the North Carolina Folk Heritage Award in 2000 (www.ncarts.org; search recipients).*

When I was a sophomore in high school my English teacher introduced me to an old folk song professor of hers, Dr. Cratis Williams from Appalachian State. He showed me how to document the ballads that I was learning, and I would write down all the songs that I knew. My dad knew a few old love songs, like "Barbara Allen," "William Hall," and "Pretty Fair Maid in the Garden." His oldest sister used to sing "The Blind Child's Prayer" and my grandmother McMillon would sing "May I Sleep in Your Barn Tonight, Mister?" She told me about her uncle who sang "The House of the Rising Sun" and one called "Seaport Town," which I found out later was a version of, I think, "The Two Brothers."

I never could write a story to suit me, though. There was just something about it that wasn't right on paper, so I don't really know how many stories I know. I took an interest in Jack Tales, and my grandfather used to preach sometimes at the church the Hicks family attended up there close to Beech Mountain. I got acquainted with Ray Hicks and with Stanley Hicks, especially, and learned a lot of stories from him.

I also learned stories and songs from family members and other folks in the community. My dad's oldest brother married a girl in the community where they were raised. Her mother was named May Phillips. I called her Mamaw because her grandchildren did, and she taught me close to a hundred songs that she had learned in the course of her life in east Tennessee. A lot of folks up there sang because they had "singing schools." Most of them couldn't read music. They sang the shape-note hymns.

Mamaw Phillips's mother was called Aunt Becky. She'd married a Fowler and had two sons by him. He took up with another woman and put her out, wouldn't let her see her own sons. She was forced to work as a hired woman, would stay with somebody and do the washing and work around the house in exchange for a place to stay and food. She stayed with this old widow man in Newport who had children coming up. He promised to marry her, so she went to bed with him and got pregnant with Mamaw, but then he wouldn't marry her.

Aunt Becky worked in the commissary for the Southern Railroad at Newport, Tennessee, for five years washing clothes and cooking, then met this young man from Morristown.

She was going to marry this man and go away with him on a train one weekend. In the meantime, a band of gypsies come into Newport and she went to a fortune-teller who told her, "You're going to marry an old man with a gray beard that comes over the mountain on a walking stick." Aunt Becky said, "You're crazy, I'm getting married this weekend to a young man that's gonna come on a train to take me to Morristown." It just happened there was some kind of a flu or something and he got sick, couldn't come, and didn't have no way to send her a message. She thought he had stood her up like the other old man so she wouldn't talk to him no more.

One of her parents' friends that lived up in the McMillon settlement near Cosby knew a widow man that needed a wife and brought him across the mountain. He had a white beard and come on a walking stick and that's who Aunt Becky married. Mamaw was five whenever they got married. At about twelve they were aggravating her at home, so she became a hired girl, stayed with mountain people, and learned songs that way. She learned her songs from that oral tradition. Her singing wasn't as ornamented as, say, Dellie Norton's and Berzilla Wallin's. It was still a capella, but it was going away from that old glottal-stop singing that they had. After she died, her family found a box of songs that she had learned as a girl and songs that she'd learned from the tapes that I'd given her. She'd written 'em down on paper in the old style. That's how the music stayed alive.

page 48

TOM SAUBER *is a multi-instrumentalist, singer, and teacher. He is known for his longtime partnerships with Oklahoma fiddler Earl Collins and North Carolina banjo picker Eddie Lowe. Old-time fans have heard Tom's music on his recently released CD* Thought I Heard It Blow, *with harmonica virtuoso Mark Graham, and on his recording* One-Eyed Dog *with Dirk Powell and John Herrmann. Bluegrass fans know of his work with Byron Berline, John Hickman, and Alan Munde, and he has also performed with cowboy and Cajun musicians. He holds a master's degree in folklore and teaches at major traditional music workshops across the country. A native of southern California, Tom hosted a traditional music program on KPFK radio in Los Angeles and has helped bring authentic traditional music to the film industry, appearing in movies and on television including roles in* The Long Riders, Bound for Glory, Geronimo, *and* Dr. Quinn, Medicine Woman *(www.tombradalice.com).*

I didn't have any family or community connections with traditional music growing up in the suburbs outside of Los Angeles. I didn't start playing anything close to what I do now until 1963, in the midst of the folk music revival. Pete Seeger and people like that were my initial inspiration to play. My brother Mike, a friend of his, and I went to a Pete Seeger concert in the summer of 1963.

Pete encouraged people to pick up instruments and play themselves. It was a homegrown kind of music, very inspiring, and my brother and his friend each bought a banjo that summer. I guess it's not an uncommon story, but he didn't learn to play and I did, and I started playing the guitar about the same time.

Very shortly after that I became exposed to the music of Mike Seeger, Pete's half brother, and his group the New Lost City Ramblers when they came to LA to play the Ash Grove. It was a folk music club owned by Ed Pearl, who had a great love of music and brought fabulous traditional musicians out there to play. It was one of the first places that Doc Watson performed professionally—came out with Clarence Ashley, Fred Price, and Clint Howard. A whole raft of musicians played there in the early sixties including Mississippi John Hurt, Maybelle Carter, Bill Monroe, Flatt and Scruggs, and the Stanley Brothers.

One of the things that was great about Mike Seeger and John Cohen and those guys was that they went to great lengths to showcase the old-time musicians they had sought out and learned from, a lot of them older musicians who had made 78 recordings in the twenties and thirties, but who were still around, some of them actively playing, some not. I heard the music of Dock Boggs, the McGee Brothers, Roscoe Holcomb, and people like that and was inspired to meet some of them. I ended up taking a cross-country trip in 1968 and met Sam McGee, and Dock Boggs in Virginia. It was just a great experience, and they couldn't have been warmer and more open with somebody like myself, a strange youngster from practically a foreign land. I went home with that experience under my belt and started going to local events, like the big Topanga Canyon Banjo and Fiddle Contest near LA.

There was a fiddle player there, a skinny old guy named Earl Collins, who seemed practically ancient, although he was probably the same age I am now. He grew up in Oklahoma and moved out in the mid-thirties when he was about nineteen or so, with all the other Okies. Aside from Earl, there was a whole raft of other old-time musicians who had moved from parts East to California. I met a banjo picker who grew up in Surrey County, North Carolina, named Ed Lowe. His uncle Charlie Lowe was a famed sort of patriarch of clawhammer banjo pickers in that country.

Eddie ended up leaving the mountains when he was eighteen or nineteen, went down to Winston-Salem, and worked in the RJ Reynolds factory. His job was putting a drop of rum in every can of Prince Albert tobacco, and he said he didn't stick with that very long because apparently not enough drops got into the tobacco cans. He joined the army, got mustered out on the West Coast. I met him when he played at the same Topanga Fiddle Contest around 1972. I distinctly remember being up on the hillside in the audience, and this gentleman gets up on stage with a fretless banjo, says, "Well, I'm going to do a tune here. On one side of the mountain they called it 'John Brown's Dream,' and on the other they called it 'Pretty Little Girl.'" He launched into it and it was a life-changing experience. His energy and virtuosity were just overwhelming. I remember running down the hill, and I might have jumped over a person or two, to meet him.

I got to know him and we played music together up until he died, in 1996 I believe it was. He ended up being kind of a surrogate grandfather for my kids, just a great fellow. Hooking up with Eddie gave me a great excuse to learn his repertoire, and that led me

to the Surrey County musicians like Tommy Jarrell, Fred Cockerham, and Kyle Creed, all of whom Eddie had known as a youngster. Unfortunately, with the passage of time, there are very few of the older generation of fiddlers left to learn from. I like to think of folks like Brad Leftwich and myself as young fiddlers still, but I think it's fortunate that we learned what we did when we did, from whom we did, because now we can pass it on. People like Benton Flippen and Clyde Davenport are almost the only ones left from that generation of fiddlers. Of course, now I have my own sort of aging process going on, and I laughingly tell people that I've finally discovered the secret to that old-time fiddle sound, and it's arthritis.

page 49

Brad Leftwich's *music is a direct link to the traditions of the southern Appalachian and Ozark mountains. He grew up hearing the old-time music of his father, grandfather, and great-uncle and learned from many of the last great traditional musicians from the turn of the twentieth century. A well-known fiddler, banjo player, and singer, Brad has been performing and teaching traditional music for more than thirty years. Recordings of his music appear on the County, Copper Creek, Rounder, and Chubby Dragon labels, and he has published instructional materials with Homespun and Mel Bay. Brad has won the fiddle contest at the* prestigious Appalachian String Band Music Festival in Clifftop, West Virginia, and critics in magazines as diverse as Billboard and Bluegrass Unlimited *have acclaimed his fiddling. He tours internationally and has performed at venues from Merlefest to the White House. Brad continues to appear with his wife and longtime musical partner, Linda Higginbotham, and also with Tom Sauber and Alice Gerrard in the trio Tom, Brad & Alice (www.bradleftwich.net and www.tombradalice.com).*

What got me interested in old-time music was actually hearing it. My dad plays old-time guitar and sings and grew up in Kansas, and his parents were from Carol County, Virginia. My grandfather actually played five-string banjo and his brother played fiddle, so I got to hear them play when I was young. When I was about fifteen I heard a recording of Earl Scruggs, or something similar, thought it was exciting, and said, "I'm going to do that." My parents got me a banjo for Christmas and I started off trying to play that three-fingered bluegrass style.

I did that for a year or two but I began to discover that what I liked the best sounded older, more like what my grandfather played. I also found an old violin in my grandmother's attic, got a few lessons, and started trying to scratch out a few fiddle tunes without really knowing what I was doing. It was kind of hard to find recordings of any kind of bluegrass or old-time music in Oklahoma at the time. I thought if I really wanted to learn it, the thing to do would be to go to fiddlers' conventions, so in the early 1970s I started spending time in Virginia and North Carolina. I was probably eighteen or nineteen at the time.

A lot of the classic players and singers of traditional music are dead now and we were so fortunate to be around them while they

were alive. I think they really appreciated that younger people were interested in what they were doing and liked to share their music. It was the tail end of that generation and when that was gone it was just different. It really struck me when Tommy Jarrell died in 1985 because I had been accustomed to going down visiting him several times a year and it was like getting my batteries recharged. I'd go learn a few tunes from him, make some tape recordings, and go home and play the tunes and be full of excitement and inspiration. When I'd reach a point where I just felt like my muse had left me, I'd go back down and visit him again, and it went on like that until he died.

When I went down to the funeral and thought, "This is it, I'm not going to be able to do this anymore, at least not with Tommy Jarrell," it struck me that at some point I was going to have to generate it from within myself. That's one reason I like playing with other people like Linda, and in the band with Alice and Tom. Since a lot of that older generation is gone, I find my principal pleasure is in playing music with other people who have had the same experiences as me, who spent time with those older musicians and know what I'm talking about, what I'm feeling, and what the music means to me.

You reach a certain point with your playing skills where you don't really have to think that hard about what you're doing. There's something really enjoyable about that, especially if the other musicians are in a similar place. I don't know how to express it exactly, but it feels like the music's playing itself and you're just sitting there enjoying it. You can be struggling with it and all of a sudden something will kind of lock into place and it takes over and you just go with the flow. It's not work anymore. It's fun.

ALICE GERRARD *is a tireless advocate of traditional music and performs with Tom Sauber and Brad Leftwich as Tom, Brad & Alice as well as solo and with friends locally. She has won numerous honors including an IBMA Distinguished Achievement Award, a Virginia Arts Commission Award, and the North Carolina Folklore Society's Tommy Jarrell Award. In 1987 Alice founded* The Old Time Herald *and served as editor until 2003. She is particularly known for her groundbreaking collaboration with Appalachian singer Hazel Dickens during the 1960s and '70s. The duo produced four classic LPs (recently reissued by Rounder and Smithsonian Folkways on CD) and influenced scores of young women singers. Besides the albums with Hazel, Alice has two solo albums,* Pieces of My Heart *and* Calling Me Home, *as well as several albums with friends including her most recent,* The Road to Agate Hill, *with Gail Gillespie and Sharon Sandomirsky (www.alicegerrard.com).*

I primarily play guitar but about the time I'd met Brad I had sort of gotten interested in playing the fiddle. I got one of these individual heritage grants to study with musicians and was taking lessons from Tommy Jarrell down in North Carolina. I found out about Tommy through Mike Seeger. I was living in Washington and we went down to talk to him. We got to be real close and I moved down there.

A lot of people came to visit Tommy, including Brad, and Tommy had a lot of respect for his fiddle playing. Brad and I didn't get together professionally, though, until about 1995, along with Tom Sauber. We all ended up teaching at the same music camps one summer. There's a lot of informal jamming that goes on at those things and we liked

playing together and shared a similar aesthetic about traditional music.

Growing up in California I listened to the radio, pop music and stuff, but it wasn't until I got into Antioch College in Ohio that I met some people who were really interested in traditional music like what was on the *Harry Smith Anthology of American Folk Music*. They had 78 recordings in the library and I remember hearing Clarence Ashley playing "Cuckoo Bird" and it just blew me away. There was something about the quality of the music—and the lonesome side of it. For whatever reason, it really resonated with me. I also think my interest in this music has a lot to do with hanging out with people who kind of steered me in that direction instead of to the Kingston Trio, Peter, Paul and Mary, stuff like that.

Later I moved to Washington, D.C. They had country music parks, two in particular, and we started going to those every Sunday. One was Sunset Park in Chester County, Pennsylvania. They had country music shows that came through and they'd play for an hour, then the house band would play for an hour, and this went on all afternoon. Ola Belle Reed and her brother, Alec, headed the house bands at the parks. Mainly it was bluegrass and some of the best you would ever want to hear—Bill Monroe, the Stanley Brothers, people like that. You would go with all your friends, take a picnic, eat fried chicken and pickled eggs. It was like a little carnival. They had a Ferris wheel and games.

I would have been about eighteen or nineteen. My boyfriend at the time, Jeremy Foster, who later became my husband, said, "There's this little skinny woman you've got to meet. She's got this great big voice." That was Hazel Dickens, and I met her in the late fifties.

She was living in Baltimore and we started singing together but we didn't do anything professionally for a long time. Every weekend there was a party in DC or Baltimore and we would occasionally sing at those and hang out with people who were getting interested in this music, like Pete Kuykendall, Dick Spottswood, John Kaparakis, and John Duffy. We were young, educated to a more or less degree, basically raised in urban environments. Then there were all these country people who had moved up from different parts of the South, so there was a real cultural interchange going on. We were searching the music out, getting to know people, and every corner bar in Baltimore, and the Shamrock in D.C., had bluegrass music.

Peter Siegel and David Grisman came to one of the music parties and heard Hazel and me sing and said, "Hey, why don't you guys make a record." David played mandolin, Lamar Grier played banjo, Chubby Wise, one of Bill Monroe's early players, was on fiddle, Hazel played bass, and I played guitar. We just went into the First Unitarian Church and Mike Seeger recorded it live. Hazel and I made four albums together. People say that two women doing bluegrass back then was this big thing but I don't think we were as aware of it at the time as in retrospect. At the time I don't remember feeling that just because I was a woman I couldn't do it. Our friends were very supportive and Bill Monroe was very encouraging of what we did.

I've often wondered why some people who grew up like us, more middle class, moving around a lot, parents died or divorced, whatever, and for some reason not feeling very rooted, kind of gravitated toward what appears to be a more rooted kind of life. In some way you want that in your life too, and this music

and the people that play it represent that. Maybe it's their sense of place or knowing who they are but there's something about the way they are, just as people, that I find very appealing, and I'm drawn to that.

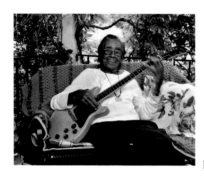

page 50

ETTA BAKER *(1913–2006) is of African American, Cherokee, and Irish ancestry, so it's only fitting that she grew up to be a virtuoso performer of the eclectic Piedmont blues, a finger-picking guitar style that blends elements of African American blues, white country music, and English fiddle tunes. Born in Caldwell County, North Carolina, Baker lived most of her life in Morganton, raising nine children and working in a factory, but she never stopped playing the music she loved. She first appeared on a compilation recording,* Instrumental Music from the Southern Appalachians, *in 1956. Although she didn't put out her own album,* One Dime Blues, *until 1990, her cuts on* Instrumental Music *were enough to establish her as an important influence on the emerging folk music revival. Bob Dylan and Taj Mahal were among her disciples. After her retirement she performed extensively, including an appearance at the Knoxville, Tennessee, 1982 World's Fair. Her excellence as a traditional artist won the instrumentalist numerous awards, most notably the NEA's National Heritage Fellowship in 1991 (www. musicmaker.org; search artist).*

I was three when I started playing music, sitting up in the middle of the bed, couldn't hold a guitar but Daddy would lay it up there and keep it tuned for me. He played banjo, guitar, harmonica, violin, and taught me what little I know about music. I could do my three basic chords when I was three and took up violin when I was about this small. Wasn't no written down music. He got his playing from his daddy, and his daddy got it from his.

Right after I was three years old we left here, we went to Chase City, Virginia, and I was raised there. When I was a teenager we came back here. I remember this man came in and played a blues, learned my daddy, "Carolina Breakdown." That was the first time I'd heard Daddy play a blues, and he learned it to me. All three of my sisters played, too. Now, Cora played banjo and guitar and the older sisters just played guitar. My brothers took up guitar so we all just get together and have a country band right at home.

Sometimes there would be a party at my mama and daddy's house, and they'd start fixing chicken and dumplings late Saturday so everything'd be good and fresh at night. The people begin to come in, and back then you didn't load up your equipment in trucks, cars, and whatever. You put 'em on your back and start walking! I can just lay way in the night and hear the old tunes that I used to hear my daddy play on the banjo.

I dream a lot of my chords, put 'em together. I dreamed the chords of "Knoxville Rag." We had played and played over at the fairground, and when I hear music I don't sleep sound, just enough to dream on. We went to our room and I got up out of the bed and went out on the porch at quarter to three. I stole my sister's guitar out from under the bed—it wasn't electric—took it out on the porch, and put

my dream together. I eased back in, and come back in on that sleep mattress with such force I slid over under her bed and I waked up. When I went on stage the next morning, I told 'em I had a brand-new song but had no name for it. They said, "Play it, we'll name it," and they named it "The Knoxville Rag."

I started performing in 1958. I got a late start! The first trip away from Brackett Street here was to Statesville. It was just a little party they was having, and from there I went to Wolf Trap. Joe Wilson was there and got me to come. Well, I went and there was a man that wanted me to come to Whitesburg, Tennessee. I went and somebody there wanted me to come to Texas. I went to Seattle, over to Port Townsend, to Blue Hill, Maine, to Germany. Went out to St. Louis, El Paso, New Mexico, Mississippi, and all the way down to Florida. I've had a wonderful time doing my music making, meeting nice people, seeing new places. I've been a little bit around the world. Came back here though because there's nowhere like home, Carolina.

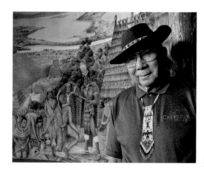

page 51

JERRY WOLFE *is from the Big Cove area of Cherokee, North Carolina. Born in 1924, he attended the Cherokee Boarding School before joining the U.S. Navy, where he was a part of the D-day invasion force in 1944 as a crew member on a landing craft. Returning home*

after the war, he worked as a stonemason, raising five boys and three girls with his wife, Juanita Bradley. A member of the Eastern Band of the Cherokee Indians, he works at the Museum of the Cherokee and conducts cultural programs to area schools and museums sharing his abilities as a storyteller and knowledge of the Native American game of stickball (similar to lacrosse). He was honored with a North Carolina Arts Council Heritage Award in 2003 (www.ncarts.org; search recipients).

I make the sticks for the stickball game. I made all the sticks for the women's teams— thirty-six, fifteen per team plus some replacements. I make them out of hickory, because it will bend and not break, and also it's the sacred wood that's meant for making sticks for ballplayers.

They're probably just over two feet long. Mainly, I just use a pocketknife to carve them because a long time ago that's all they had to use. Today we have sanders, so I sand the handles, hone them down. I peg it two or three places up through the handle so it'll hold together. Originally you'd have strung the pockets with some kind of animal sinew, but it's artificial stuff now. Squirrel hide was good to make the little strings out of—it's really strong.

I've been making the sticks about thirty years. A lot of them I've put designs on, maybe a snake or a big rattler wrapped around the handle all the way down. I put a crisscross mark on mine, kind of burn 'em on. Then some have teeth, just little notches, so they don't slide off when you clap 'em together to hold the ball. If they don't have a tooth, then they're slippery and you're just liable to fumble. I use seven notches for the seven clans of the Cherokee.

I played stickball for the Big Cove team growing up, back in my running days. They had teams for all the different communities, Wolf Town, Paint Town, Bird Town, and Cherokee. Each team would have ten to twelve men—just as long as it's an even number on both sides—most of them eighteen to twenty years old. Once the game gets under way, they don't have any time-outs and no substitutes. You play to the duration of twelve points. A game lasts from probably an hour and a half to two hours. If it's pretty well evenly matched, then it could last longer, so you've got to be in real good shape to play. Winter's too cold, you know, to strip off and play, so usually you just play in the summer.

As schoolboys we used to play right after lunch. You couldn't go back in the classrooms till one o'clock, so we'd get out there on the field and play. At the Cherokee Fall Festival in October, which is about the only time it's played now, they do it in a mowed grass field, but early on they played in the high grass 'cause they didn't have anything to mow with.

Stickball was played as a competition between communities but it was also a mixture of things. The games were used to settle disputes and as a decision maker, too, like if a council locked up on an issue and they couldn't untie it, they'd play a game to settle things. Some call it "the little brother of war" because it's so tough and competitive. In fact the girls' teams had been banned since 1870 for playing too rough. They re-formed in 2000 and asked me to coach their team. They've played for about three years now.

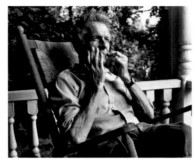

page 52

MIKE SEEGER *was born in 1933 to composers and musicologists Charles and Ruth Crawford Seeger, who occasionally collaborated with John and Alan Lomax when the latter were at the Archive of Folk Song in the Library of Congress. As a child, he listened to early field recordings of traditional folk music and began collecting songs on his own from traditional musicians as a young adult. He is a founding member, along with John Cohen and Tom Paley, of the old-time string band the New Lost City Ramblers, which was formed in 1958. Mike has received six Grammy nominations, three on his own, two with the New Lost City Ramblers, and one with John Hartford and David Grisman, and is recipient of four NEA grants, a Smithsonian Research Fellowship grant, and a Guggenheim Foundation Fellowship. He lives in Rockbridge County, Virginia (www.mikeseeger.info).*

I think that my parents had everything to do with what I have done with my life, playing and collecting music, doing documentary work, and advocating for traditional music. They brought us up feeling that music was an important part of their life and our family life together and with a feeling of mission, and each of us, my three younger sisters, and myself, took it in a different way. And really it took hold on my brother Pete.

When we get into the question of nature versus nurture and the different ways we

respond to how we were brought up, there are just some mysteries in life. As to why somebody does something, it's because it resonates with them and they respond. Ever since I was four or five, music has been important to me. I was curious to listen to the old field recordings and I learned some of the songs by the time I was five years old. My sister Peggy did, too, but then one of my sisters didn't.

Both of my parents had piano training. My mother taught and tried to give me lessons. I hated scales so that didn't work. She had an Autoharp to do her educational work, to take with her where there wasn't a piano, and I started scrubbing on that, but that wasn't really playing music to me. We had an old, literally, gut-string guitar and a dulcimer. The dulcimer was handmade in western North Carolina. It was the old-fashioned one with the nails made into kind of staples. I tried playing that but it really wasn't playable so that didn't work.

The first instrument I tried playing seriously was guitar and once I started everything else fell by the wayside. It was about another six or eight months and I started playing the banjo. Then somebody gave me a piece of a banjo mandolin, and I started playing the mandolin and eventually the harmonica and the fiddle. It was the seventies before I started playing a jew's harp and quills. I stayed pretty much with those instruments and they're the ones that I feel like are part of my music.

I decided after I'd been playing for a couple of years that I didn't want to play any other kind of music but southern music. I didn't want to play commercial music, or commercialized folk music. I went to electronics school, and about the time I got out the New Lost City Ramblers started. After a couple of years of that I started to play on my own and that's what I've done since 1960.

When I'm at home, Alexia will tell you that I love to play music on my own, and we play music together, too. This evening, I really needed to play a couple tunes, and a friend invited me to take part in a jam session and it really felt wonderful, physically, to play the music and to hear it. I love listening to recordings of other people playing, but really it's the live music that is a thrill, interacting with other musicians.

I have four or five ideas for CDs that I want to do all at once. I did one with banjo styles and I'm going to do something similar with guitar styles. There's such a wealth of different ways of playing the guitar that rural people have evolved over the past one hundred years. I can do some of them, and then I can at least say there are others and try to steer people toward those. I think at the center of my approach to music is the sound, and at the center of that is style. That's not to say I don't think of the lyrics or melody at all, because I do—these are all together. But style is very important, so I'll try to play a bunch of different styles but also have a fair cross section of repertoire and some of the different kinds of tunes like I did with my banjo record.

I'd like to think that some of the music I'm making will be worth listening to when I'm gone. Some of it's unique and some of it's just characteristic. I've tried to be true to tradition and sometimes creative, too, because that's the way it's done. There are also the recordings that I made of traditional musicians and the little bit I've written about them. There's a bunch of us that are all part of this old-time music movement. A lot of people had a part in it and everybody has something to do in it, and amongst people whom I've known, there will be something there that will go on, too, I hope.

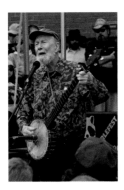

page 53

PETE SEEGER *took a trip to North Carolina in 1936, and it was there, at Asheville's Mountain Dance and Folk Festival, that the sixteen-year-old New York City native first heard the five-string banjo. It marked the start of his long career as a musician, songwriter, storyteller, music historian, and key figure in the folk music revival of the mid-twentieth century.*

In 1940 he met Woody Guthrie and helped found the Almanac Singers, and in the 1950s Pete helped form the Weavers, both groups forerunners of the folk music revival. The cowriter of such classics as "Where Have All the Flowers Gone?," "If I Had a Hammer," and "Turn, Turn Turn," Seeger spent a lot of time in the South during the civil rights marches of the 1960s and helped fashion the civil rights anthem "We Shall Overcome" out of an African American spiritual. His music has always been part and parcel of his political activism.

Over the course of his life, he has gone from being blacklisted during the McCarthy era to the recipient of the Presidential Medal of the Arts and a Kennedy Center honoree. In the 1970s and '80s Pete began to champion more environmental causes such as the cleaning up of the Hudson River. He's been inducted into the Rock and Roll Hall of Fame and received numerous Grammys, including one for lifetime achievement. His grandson Tao Rodriguez-Seeger carries on the Seeger family musical

tradition, one that includes Pete's musicologist father, Charles, violinist mother, Constance, and half siblings Mike and Peggy (www. peteseeger.net).

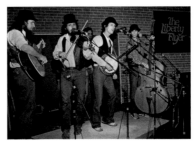

page 54

JOHN HARTFORD *(1937–2001) was a master five-string banjo player, fiddler, author, riverboat captain, award-winning songwriter, and performer. His 1967 hit "Gentle on My Mind," also recorded by Glen Campbell, earned four Grammys and gave him a measure of financial independence. He was one of the first to bring traditional Southern music styles to the general public's attention. Hartford was a regular guest and contributor on the Smothers Brothers Show and Glen Campbell's Good Time Hour, added music and narration to Ken Burns's Civil War series, and recorded a catalog of more than thirty albums including his landmark Aereo-plain (1971) with Vassar Clements, Norman Blake, and Tut Taylor, which set the stage for "new grass" music.*

Starting in the mid-1970s, he created a one-man act where he donned his trademark bowler and vest and sang, told stories, and played banjo, fiddle, and guitar, all the while clogging on a piece of amplified plywood. In his later years he returned to the more traditional folk music of the Appalachians and the Missouri foothills and became obsessed with honing his already considerable skill as a fiddler. Shortly before his death, he won another Grammy for his contribution to the soundtrack of O Brother, Where Art Thou? (www.johnhartford.com).

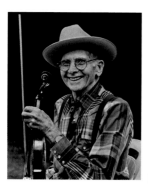

page 55

OSCAR "RED" WILSON (1920–2005) *learned to play guitar as a boy, then banjo and the fiddle, for which he is best known. In the 1950s he joined the Toe River Valley Boys, playing the fiddle in their lineup of country and blue-grass tunes and for square dances at Geneva Hall in Little Switzerland and at the Penland School of Crafts. Red lived in Bakersville, North Carolina, with his wife, Marie, and performed for several years at the Carolina Barn Dance, broadcast nationally as a weekly radio show from nearby Spruce Pine. He received the North Carolina Folk Heritage Award in 2003 (www. ncarts.org; search recipients).*

My dad played but there were eight of us kids and I was the only one that took up music. I've been playing since I was about eight. I first played a banjo my dad built out of cherry and oak. I plucked around on it a little while, then picked up the fiddle. I think it was from Sears and Roebuck because that was about the only place you could get 'em back when we started. Cost about three or four dollars. I was about ten or twelve at the time and learned to play "Redwing." It took me all day long to learn that tune.

Before I learned the fiddle I'd bought me a guitar. They were easier to find and cheaper, too. I ordered it from the Spiegel mail order house for twelve dollars—one dollar down

and a dollar a month. They had a program at the Bonnie Kate Theater in Elizabethton, Tennessee, on Saturdays. Me and some other guys went down there and that was the first public appearance I made, playin' the guitar and singing. They broadcast it on the radio. I can't remember the year but it was before I was drafted.

I was in the army during World War II, served three years eight months and eleven days and got wounded in Italy. When I got out I started playing serious. I worked at the radio station and played the Carolina Barn Dance every Friday night till they closed up. I played with the Toe River Valley Boys. We made several albums, but they wanted to play bluegrass and I didn't, so I quit them. I went back to my old style of fiddling and had a band of my own.

I didn't play a whole lot back in the Depression because I done everything just to make a living. When I got big enough, I worked at this sawmill ten hours a day for fifty cents. You was lucky to get a job at that because back then there was people begging for jobs. Then I got to playin' with my uncle, Steve Ledford, and played some with Wade Mainer and Panhandle Pete. Panhandle used to play in Asheville, was a one-man band, had fourteen instruments, drums and everything tied all over him. Me and him, Steve Ledford, and Junior Duncan played at WLOS radio over there a while, when they first went on the air.

I used to walk across the mountain and down the other side to my uncle Steve Ledford's when I was about fifteen or sixteen and sometimes stay a week at a time. People was around there playin' music about all the dern time. The whole family played, even the girls played and sang. My early influences

were Big Howdy Forrester for one and Arthur Smith was another. Arthur used to come by my granddad's house over on Rock Creek and stay a week at a time. I'd go over there and listen to old Fiddling Clarence Green and all of them, try to catch some of their tunes, and they was trying to learn off of Arthur.

My granddaddy was Waites Ledford and his sons Will, Taft, Handy, and Steve were my dad's brothers and all played music. My dad was illegitimate, went by his mother's name, that's how come I'm a "Wilson," and I was redheaded so I've been called "Red" since I was just a little fellow. Later on I recorded an album for Uncle Steve called *Fiddling on Ledford's Front Porch*. We used an old photo of a big group of twenty or so of those folks on the cover. My father's in the picture. He was probably fifteen or so at the time. He's holding a little banjo. The head on it's only about six inch across, made from a groundhog hide. He made it before I was born and I'm eighty-two now. I seen him hold it in front of the fireplace to dry it out and make that head draw up and get tighter. It ain't worth much, but I wouldn't take a million for it. I'll hand it down to my kids.

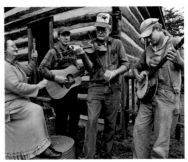

page 56

BILL BIRCHFIELD *and his wife, Janice, are the core of the Roan Mountain Hilltoppers, which began in the 1970s as a family old-time traditional mountain music band. Bill plays left-handed fiddle and Janice plays washboard bass and over the years family members and friends have rounded out the group. They've played at the 1982 World's Fair in Knoxville, the Country Music Hall of Fame, Carnegie, Brandywine, Library of Congress, Smithsonian American Folklife Festival, as well as at numerous music festivals. They have been featured on CMT, in* Rolling Stone *magazine, and done many television, radio, magazine, and Internet interviews. The Hilltoppers have been sought out by other musicians including Sid Vicious of the Sex Pistols, Boy George, and Malcolm McLaren, whose visit inspired the "Duck Rock" movement of punk and landed the Roan Mountain Hilltoppers a number 9 hit on the London pop charts (www.myspace.com/ roanmountainhilltoppers).*

My dad farmed for a living. Granddad farmed, did logging jobs. I do a little of everything: mechanic work, plumbing, electric wiring. I can build houses, repair cars, make fiddles, whatever you want done. I started playing fiddle when I was about fifteen. I play left-handed, upside down, backwards. My father kept telling me, "Bill, you're left-handed. When you're playing the banjo, guitar,

mandolin, Autoharp, Dobro, you play them all upside down, but the fiddle you'll never learn. There's no good left-handed fiddle players." I said to myself, "I'll show you," and I'd have died a' trying.

All my uncles and aunts could play, and my grandma and great-aunts, but I'm the only one left in my family that can play. My father got his fiddle playing mostly from his uncle, Johnny Birchfield. He was one hell of a fiddle player and could make the steel click on the tracks and double whistles blow with his bow. Best bow arm I have ever witnessed. When you hear an old sawmill fiddle player like him pull full double drones and hear that bagpipe sound, that's old-time music, boy. He had the awfulest-looking hands you ever looked at, big old clubby-looking fingers, but he made clean notes. When you heard him you could feel the hair stand up on your arms. That's why I wanted to learn. I said, "If I can't play near that, if I have to play it like these others, I won't fool with it, I'll quit, throw it in the fire and burn it." And I would have.

Back years ago in West Virginia, Johnny and Waites Ledford and another boy got in some trouble with the law. They all were to pull a year and a day in the penitentiary but Johnny never pulled a day. They found out what kind of fiddle player he was and instead of going to jail he taught judges and lawyers to play. He made money hand over fist and came back here a whole lot better off than he went.

Old-timers like him wanted four instruments in a group—banjo, guitar, fiddle, and bass. The mandolin and Dobro doesn't fit, they're bluegrass instruments. Old-time music is hard drive from start to finish and if you aren't ready for it you won't be there long before you fall out. It's the hardest music there is, because we don't take breaks and feature one instrument while the others sit back and rest like bluegrass players do. In old-time, all four major instruments work together and they all drive it hard and keep it rolling.

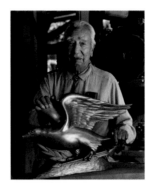

page 57

GOING BACK CHILTOSKEY (1907–2000) *was a member of the Eastern Band of Cherokee, and renowned as a master wood carver and sculptor. His carving career began at the age of ten when his brother gave him a knife and wood-carving instructions. He went on to study woodworking at school in South Carolina, Kansas, and New Mexico. Chiltoskey taught woodworking and carving in the Cherokee High School before joining the Army Corp of Engineers around the time of World War II. He studied at the Penland School of Crafts, Corcoran Art School, Chicago Art Institute, and Purdue University, and was a member of the Southern Highland Craft Guild and the Qualla Arts and Crafts Mutual. After retiring in 1966 he returned to Cherokee and devoted himself to carving and teaching. His work is in numerous museum and private collections including the collection of the Smithsonian American Art Museum.*

I started carving when I was ten, making things for myself, and selling to other folks that liked what I was doing. I've made just about

everything in wood from animals to household furniture including cabinets and desks. I even made a violin once just to see if I could, because I was always told that if you could make a violin you could make about anything.

When I was ten I also started to learn English. Until then I only spoke Cherokee, and we were punished in school if we spoke our own language. Now, none of the younger generation wants to learn it, and they have to require it in school. My parents never learned English and my father only had two weeks of schooling in his life.

I had the opportunity to attend many schools, including Purdue University and the Art Institute of Chicago, but I never worried about getting a degree. I studied industrial arts and just enjoyed taking classes I was interested in. During the summers I would find jobs that enabled me to travel. I've traveled all across the country and lived different places, including Kansas, Mexico, South Carolina, and Virginia, but I've always come back here. I was a model maker for the Army Corp of Engineers, retired fourteen years ago, and my wife and I moved back here to Cherokee.

I've taught for the government at the Indian school in Cherokee as a shop teacher for twelve years now, and many of my students have gotten to be very good wood workers. I started my niece Amanda Crowe in woodworking and she took over my job there. I only work on commissions now and I've got enough orders to last me at least the next five years. I've got all I need right here—my wife of twenty-four years, my garden, woodworking shop, and a fishing hole right behind the house.

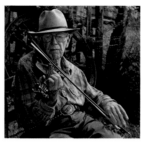

page 58

CHARLIE ACUFF *was born in 1919 and lives in Alcoa, Tennessee. A rare left-handed fiddler, he has been performing for audiences for nearly seventy-five years. In 1989 Charlie became the fiddler for the Lantana Drifters, an old-time string band. They have won numerous awards and performed on Garrison Keillor's* A Prairie Home Companion *in 1999. Charlie was the 2005 recipient of the Governor's Award in the Arts and an Uncle Dave Macon Days Heritage Award winner. His CD titled* Charlie Acuff: Better Times a-Comin', *issued in cooperation with Cleff'd Ear Productions, includes twenty-one old-time fiddle tunes from the Acuff family tradition (www.tennesseefolklore.org).*

I started playing when I was twelve years old. I was staying with my grandfather in Knoxville, and he asked me did I ever try playing one of my daddy's fiddles, and I told him no, I was left-handed. He said, "We'll just see about that." He placed a paper on the fingerboard and put dots on there where to put my fingers, and we started from that. I'd learn maybe three notes of a tune and he'd say, "Play them over and over and when you've got them pretty good, go on to the next one." We would go until we finished the tune. I learned a lot of them that my grandfather had learned.

My dad and Roy Acuff are first cousins. All the rest of the Acuffs played, but he was the one that made the money. My daddy made fiddles. The first one he made was in 1923,

and the last one was in 1973. He just took it by spells. In the forties he made six or seven and after he retired in the 60s he made four or five. He made thirty-six in all, each numbered, and would put the date in there whenever he went to put it together. His great-uncle that was in the Civil War made the tools to make fiddles with. When he was getting old he told my daddy, "If you make one fiddle I'll give you my tools, providing you won't loan them to nobody. If you do you'll never get them back." So my daddy made the first fiddle and brought it down and he played it. He said, "Well, you've made a better one than I did on my first one, but my second one was a world getter."

I started playing in 1932 on the first one my daddy made. This fiddle I'm playing today is Number Five, made in '33. I played this one all through grammar and high school. My brother's got Number One, Number Two was sold, and I've got Number Five, Eighteen with the shell inlay, Thirty-three, and Thirty-six. Sold Number Nineteen to Roy Acuff, and Max Snodderly got Number Twenty-two I think. They all have different sounds. Number Eighteen is really as good a fiddle as I've got, but it's not hardly as loud as Number Thirty-three, which I like better for bass fiddle and competition and concerts. I've got the number Thirty-six fiddle to learn a tune on around the house. It's sweet toned but it don't have the volume.

I hired in at the Alcoa Aluminum Company in 1941 and retired in 1982, a little over forty years. I've played more since I retired than I did before. I played a lot going through high school. Me and my brothers had a band and played a lot for square dances. Played on WROL radio in Knoxville with a fellow that lived in Union County by the name of Esco Hankins, back on March 17, 1938. He stayed in the business all of his life after that and got to be right well known.

They have music on the cabin porch here at the Museum of Appalachia from March to December. I play here every week on Wednesdays and Thursdays, April through October. People drop by to listen to us play, and some even bring instruments and sit in with us. First time I come up here was back in 1979, a few weeks before the first homecoming. They have it every October. I've not missed one yet, and this will be the twenty-fourth year.

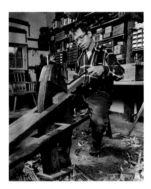
page 59

Drew Langsner *runs the Country Workshops where he teaches chair making and woodworking and has been doing traditional woodworking since 1972 when he apprenticed with master cooper Ruedi Kohler in the Swiss Alps. He was introduced to Swedish spoon and bowl carving in 1977 under the tutelage of Wille Sundqvist. Drew began making ladder-back chairs in 1979 and Windsor chairs in 1983. He is the author of numerous articles that have appeared in* Fine Woodworking, American Woodworker, Woodwork, *and other magazines. His five books on woodworking include* Country Woodcraft *and* Green Woodworking. *Drew's latest book is* The Chairmaker's Workshop *(www.countryworkshops.org and www.drewlangsner.com).*

I was one of those kids who was always making things. If I needed something, rather

than try to get the money together I'd try to make it. When I went to college I got a degree in anthropology but found myself taking more art classes. I thought I was going to be a university art teacher but had a bad experience and said, "I'm out of here." In 1972–73, my wife and I traveled to Europe and around, and then moved here.

We started Country Workshops in 1978 and have focused on teaching traditional woodworking with hand tools. We have roughly a hundred acres, three-quarters in mixed hardwood forests and the other pasture and farmland. We converted an old tobacco-curing barn into a workshop and another old house into a summer dorm. At this point we do about twenty classes a year. We thought we were going to be training professional woodworkers but we gradually learned that we're in a specialized kind of vacation business. People take a week off of work and come here to a place where there's expertise, proper tools, and like-minded people. They've ranged literally from being rocket scientists to someone working on a landfill and everything in between. Some have come back year after year and become very close friends, which is really a nice thing.

We're doing traditional crafts but almost always with a contemporary take. We're making chairs approximately the way they were done in a preindustrial context. Although we use a chain saw to a limited extent and some modern tools, we are starting with the log. That really puts you in communication with the nature of wood.

If you use simple hand tools like we do you've got to understand how wood fiber works and not fight it or you get into trouble. We do some sawing of parts to length but almost all the other divisions start out by splitting the wood, essentially undoing the "glue" between the lengthwise fibers. Oak is a fabulously hard and tough wood but it splits nicely because of its straight fiber. It's really good to use if you're making a chair the way we are, which starts by splitting it and then shaving parts with a drawknife on a shaving horse. We do the shaping using hand tools when the wood is freshly cut because it's wet and cuts really easily, probably with a third of the effort compared to when it's dry.

After we've made all the parts comes the assembly. For a post-and-rung, ladder-back, or Windsor chair, almost all the joints use cylindrical tenons. They're round and they go into round holes so it's a very simple kind of joinery but it's also very precise. You have to get everything in the right placement and proper angle and learn techniques that allow you to master the geometry and make it all work.

Not that many tools are required. We're using the splitting tools, crosscut saws, drilling tools, and mostly just two shaving tools—the drawknife and the spokeshave. Occasionally we use a hand plane, chisel, and hammer. A drawknife is a tool where you are in charge. It has no guide for the blade, for depth adjustment, or anything like that. The accuracy of the cut depends on how you set that blade on the fibers, tip it a certain way, and use your muscles, eyes, and intelligence to make it work. There are certain things we can do with our hands that have a special quality that the machine-made thing is never going to duplicate. That's the attraction of making the chair.

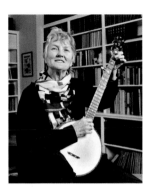

page 60

PEGGY SEEGER *is a renowned folksinger and part of a strong musical family. Her mother, Ruth Seeger, was a music teacher, composer, and the first woman to win the Guggenheim Fellowship for music. Her father, Charles Seeger, was a pioneer ethnomusicologist. Her brother Mike and half brother Pete are both musicians of great accomplishment. She attended Radcliffe College where she majored in music and began singing folk songs professionally. In 1959 she settled in London with Ewan MacColl, the British dramatist and singer/songmaker. It is for Peggy that MacColl wrote the classic "First Time Ever I Saw Your Face." Peggy has made twenty-two solo discs and has taken part in more than one hundred recordings with other performers. She is considered to be among North America's finest female folksingers and songwriters and took a leading role in the British folk music revival. Peggy teaches at Northeastern University and is intending to return to the UK in 2010 (www.pegseeger.com).*

I was brought up in a family that played and taught classical music and was simultaneously fascinated with folk music. Both my parents were highly literate musically but were entranced by the seeming spontaneity of don't-need-to-read-those-notes music. They were part of Franklin Roosevelt's WPA project of "keeping the South at home and treasuring their traditions" in the late 1930s through the '40s. A lot of collectors went down to the South, among them John and Alan Lomax. They brought back songs they recorded and decided to put them into books. My parents were living in Washington, D.C., and the Lomaxes approached my mother, asked, "Would you transcribe some of this music onto paper so we can put it into our books?" It was a daunting task, as folk music doesn't fit into those five lines of the staff. It's full of pitch and rhythm irregularities, glottal stops, slight yodels, and so on. In order to put a song down on paper she'd often have to play it for three or four days, line by line. So the music was playing day and night, and we picked it up by osmosis.

I started playing the guitar when I was seven, banjo at fifteen, and classical piano running underneath all. I started out as a singer of traditional North American songs that had come originally from England, Scotland, and Ireland, peppered with songs my mother transcribed: Negro prison songs, Cajun laments, cowboy songs. These are my heart music, home music, hearth music, and that's what I was singing when I met Ewan. He and I were very different. I was brought up in a liberal family, he in a Marxist. He was working class and I was middle class. From two different countries, two different age groups, but we both had this deep love of folk songs.

You feel at home with the traditional folk songs because they have the same principles of creation and development that your spoken language has but in a crystallized version. The types of folk tunes that we have are consonant to the way we speak. One of the reasons you can sing a folk song to somebody who's never heard it before and they feel they have known it all their life is because song and speech are

so intertwined. It's probably why art music looks down on folk music. They think it's embryonic, natural, that anybody can do it, but really its one of the things that just any-body can't do. If you talk to the really good singers, stylish singers, ones who make the hair stand up on the back of your head, they work at it.

During the heyday of my working in England there were many more singers than instrumentalists because musical instruments as accompaniment virtually disappeared there in folk music over the two hundred years between the mid-1700s and now. The industrial upheavals were so great that cultural traditions were lost, and in Scotland the Calvinist movement discouraged playing instruments. The fiddle was the devil's instrument. It's not like Ireland where the musical instruments flourished, although they were used more for dancing than accompanying. As a result of all these historical factors, a lot of the songs became unaccompanied and tunes became stronger because they didn't depend on the crutch of instruments.

I have three children, Neill and Calum and Kitty. They said, "Mum, we think you're singing the traditional songs better than you ever have." And in the old days I sang them with a lot of pyrotechnics on the instruments, the hormones were galloping, and I certainly sang an awful lot of them too fast and didn't taste the words as they went by. So the *Home Trilogy* was broached, a set of three CDs of traditional songs. I'm recording them again because I'm seeing things in them that I haven't seen for years. I'm seventy this year and getting on in life gives you a whole new perspective not only on the things you've done but also the ingredients of your life. You begin to treasure things much more before you pass to wherever the next place is and I'm enjoying singing these songs so much.

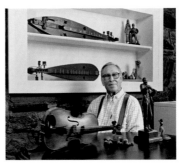

page 61

WADE MARTIN (1920–2005) *came from a family of musicians and craftspeople. His father, Marcus Martin, of Cherokee descent, was a champion fiddler, and his mother, Callie Holloway, played banjo. They had a daughter and five sons, and all five boys served in the military during World War II. Wade learned to carve from another soldier while stationed in the Philippines, and sent his first carving, a hula girl, back to his bride of six months, Frances (they were married for more than sixty years). He brought home his interest in carving and passed it on to his siblings. His brother Edsel built and played dulcimers and was a renowned carver of wooden birds during the craft revival period. Brothers Fred, Quentin, and Wayne, and sister, Zenobia, carved as well.*

In 1954, after his father was injured on the way to work at Beacon Blanket Manufacturing Company in Swannanoa, North Carolina, Wade began employment there to avoid the family being evicted from the company housing. He worked in various departments over the years and retired in 1983. Most of his carvings were done in the 1950s, but he remained active in the craft and music communities throughout his life and wrote a Martin family history titled Swannanoans: Wood Carving Mountaineer Style.

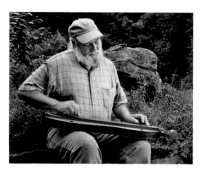

page 62

DON PEDI *is a nationally recognized master of the Appalachian dulcimer who maintains a rigorous performance schedule. He developed the unique "fiddle pick" style, influenced by fiddler Bruce Greene and other old-time musicians. Before retiring from festival competitions in 1982, he had won more than thirty first-place awards. In 2003 he represented Appalachia at the Smithsonian Folklife Festival in Washington, D.C. Since 1985 he has been an on air radio host promoting traditional music on NPR affiliate WCQS-FM in Asheville, North Carolina. Don has been instrumental in sustaining the annual Asheville Mountain Music and Dance Festival, has been a repeat instructor in dulcimer at the Swannanoa Gathering, and has appeared in musical parts of the movies* Songcatcher *and* The Journey of August King *(www.donpedi.com).*

Traditional music appeals to me because it harkens back to a simpler time, a slower-paced way of life. People would farm all day working with horses and mules, tend their gardens, and play music in the evenings and on weekends. It was a time when people played from their heart, not from their head. They didn't analyze the music. They just played because they enjoyed it. It was handed down from one generation to the next on front porches, and the coves and hollers insulated them from many of the outside influences and helped preserve the music, or at least the feel of the music in its original form.

A lot of what people play today that's supposed to be traditional has been adapted and modernized. Bruce Greene and I play together a lot and we like music from the pre–Civil War era, 1820s to 1850s. He's really good at playing those old fiddle styles and we both enjoy finding people who know how tunes were originally played. I have four or five dulcimers but this one is one of the oldest. It just has staples for frets under the melody string so the other strings just drone when you strum it. That's a large part of the dulcimer's sound. New ones have frets, like guitars, but I like picking the melody on one string on a lot of tunes.

Traditional music fits in with the simpler, slower-paced lifestyle that I enjoy. When my wife, Jean, and I were looking for a house, we looked in Asheville but it was too noisy. Then we found this place in Grapevine in Madison County and we love it. We're slowly fixing it up, and I built a big porch so people can come by and pick and sing. We live a pretty simple life. We only get one channel on the TV and not much of it. We do have a VCR so we can rent movies, but I don't keep up with the news or worry much about what's happening beyond our community.

Mostly, I was attracted to folk music because of the times, the sixties and such, with the folk music revival going on. I went to the Newport Folk Festival and they had Doc Watson, Frank Proffitt, Almeda Riddle, Phoebe Parsons, all those old traditional players and singers, and that music just grabbed me. In the Boston area where I grew up, there was a lot of Irish music and English and British Isles kind of singing and playing. So at first I kind of mixed the old-time and that together, but

then my interests shifted more toward southern Appalachian old-time style.

I come up in a poor, lower-class family. My dad became a cop after a long time of doing other little nowhere jobs. I'm the oldest of eight and we grew up very similar to a lot of the rural people here as far as education and poverty level, so I can relate. This music was part of a subsistence style of living, and no matter how educated or whatever I've become I still live pretty much at a subsistence level. I guess I just have things to do that are more important to me than chasing dollars.

I enjoy hanging around with folks who take two hours to say something I can say in ten minutes. It's not that they're any less intelligent. There's just a different rhythm to the lifestyle. A lot of people nowadays think it's a waste of time, but when you get into that rhythm life goes by a different way. The music came out of the rhythm of an agrarian culture and is affected by that. It's an older way of looking at things. I like the simple life, simple people. I like the agrarian style of living like my neighbors'. They're in touch with the earth, not out in space in their heads all the time.

The local public radio station offered me a two-hour time slot as a deejay and instead of doing more jazz or classical I told them I wanted to do traditional music. *Close to Home* features mostly traditional, mountain music, mixed on occasion with folk music of other places and urban folk revival coffeehouse music from the sixties and seventies. Radio is perfect for me. I like staying out here and working on a weekly radio show for public consumption. It's public service without having to see the public. It suits me, and I dress for it.

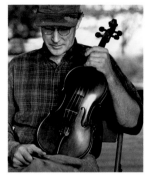

page 63

BRUCE GREENE *was born in 1951 and learned to play the guitar and five-string banjo in his teens, mainly from listening to records growing up in New Jersey. His interest in traditional music started during that time and led him to the fiddle, inspired by some of the field recordings that were starting to become available. Bruce later moved to Kentucky to study folklore and met some of the local fiddlers. In the 1970s and 80s he immersed himself in Kentucky fiddling, tracking down as many surviving musicians as he could. This foundation helped him build a repertoire and unique style of playing that maintained many of the traditional elements. He moved to Yancey County, North Carolina, in 1978 and formed a friendship with Oscar "Red" Wilson, a fiddler and neighbor. Their musical partnership lasted for more than ten years, until Red passed away in 2005. Bruce was instrumental in Red being awarded the North Carolina Folk Heritage Award. He has taught classes and performed at festivals around the area, produced three CDs, and is considered by many to be the best old-time fiddler of his generation (www.brucegreene.net).*

I was always interested in folk music, the folk revival, as a kid. I tried to play the guitar, then I started hearing bluegrass and banjo and stuff like that. I mostly got started listening to records. When I got out of high school I

went to college in Kentucky and met some fiddlers and banjo players there and learned how to play. I spent about seven or eight years roaming all over Kentucky looking up these old musicians. Many of them were born in the 1880s and 1890s so their music was very old and not much influenced by modern technology. Eventually I moved over here to Burnsville, North Carolina, and have kept on learning from the old folks whenever I can.

I always look for the older people who play the old-fashioned stuff. That is the music that has been passed down by ear and has been in danger of being lost, because it was never written down. After I settled here it was harder to run around learning the music because I was raising a family and working, but I tried to keep seeking out the local traditional stuff. Then I ran into Red Wilson, and we've played together about ten years now, along with Rob Levin. Red has been a real inspiration because he has such a good time playing. He loves to entertain people and keeps me from taking myself too seriously. It's hard to get a group together that doesn't have all kinds of personality conflicts but we get along real good. We've never had a fight anyway, and we don't have a whole lot of ambitions about making it big anywhere.

I don't know why I got interested in folk music, but the more I learned about it the more I was attracted to the roots of it. I enjoy hearing people play what they grew up with, the old traditions, and wanted to learn to play the way they do instead of the city stuff. I wanted to go to the South where it came from. I play this kind of music, we call it "old-time," because old-time music takes you back, gives you a feeling of another time.

I like older things, older people. I like their music and to be part of their lives. It's funny, after you've fooled with it long enough you don't think about why you like it, it's just what you do. There's something real special about music that people grew up with and passed down through generations, didn't get it off the radio or something. It was just part of their everyday lives and they held on to it because it kept them connected to their past. I want to keep the spirit of that alive.

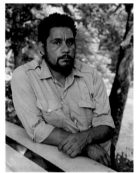

page 64

JOHN JULIUS WILNOTY *is an internationally known carver and member of the Eastern Band of Cherokee. Born in 1940, he lives in the Wolf Town area of the reservation in Jackson County, North Carolina. He is considered to be one of the best primitive-style artists in America today. Self-taught, he began carving in the 1960s, working in dark-hued pipestone or steatite, found locally, and in wood and bone. Wilnoty first explored pre-Columbian motifs in pipe bowls, banner stones, and vases and later concentrated on Cherokee-inspired themes. He sold work primarily through the local Medicine Man Gift Shop and the Qualla Arts and Crafts Mutual, then, after being encouraged by these merchants and local collectors, began a powerful series of figurative sculptural carvings for which he is best known. His expressive, interlaced sculptural forms are of a very spiritual and symbolic nature and John's own life and beliefs reflect this spiritualism. Two of his three sons, Fred and John Jr., also carve.*

The old Indian laws of the Cherokee seemed to work better than modern federal laws. They helped the Cherokee people get along together, too. One law said that if you passed a man who was working in his field and you didn't have anything to do, you were to stop and help him. The law also kept people more honest because of the severe punishments and due to the fact that you never knew who "the law" was. They wandered among the tribe and since no one knew who they were except the man in charge, people tended to watch what they did when they were around others. You could go off and leave your tools laying and your house unlocked and come back a week later and nothing would have been touched.

If a man was doing wrong he was warned to mend his ways. Say he stayed drunk all the time and didn't provide for his family, then a bundle of hickory sticks would be thrown up against his door as a warning. If he didn't begin to mend his ways, the law would come after him some night, take him from his house, tie him to a stake and beat him with hickory sticks as big around as your finger, until he was almost dead. They would wear hoods so they would not be recognized. It wasn't because they were ashamed of what they were doing, but that way no one could catch them out by themselves and get revenge. I'm told that after such a beating most men never touched a drop of liquor again. Now, if they had food on the table for their families and wanted to get drunk once in a while, then that was all right.

I believe that a person, once he has full control of his spirit, can leave his body and time no longer exists—like stepping into and back out of a river. Indian doctors could do that, could go back in time as well as into the future, and so could foretell events and warn you not to be at a certain place at a certain time or harm might come to you. They were men who, when they came of age, had doctoring knowledge. They didn't have to be taught. An Indian doctor once told me that a blow to my head, when I was a child, caused my narcolepsy and told me how it happened. Years later, white doctors confirmed that was what caused it.

An Indian doctor once cured a knot on my neck by pulling a red-hot coal from the fire, put his thumb to it until the coal turned black, then put his thumb against my neck. It felt like I was on fire and I could barely stand it, but the knot went away a few days later and the doctor didn't have a mark on his thumb. It hadn't even burned him. I have been told that there are three medicines that could be used in different combinations to cure any sickness that man has. Also that all Indian medicines are poison—like many modern medicines. Controlled doses could cure instead of kill. It's like fighting snakebite with snake venom.

Indian doctors took on only so many patients because they knew they could make errors if under too much pressure. The ones I've seen have always been in the poorest health because they don't get much rest and because they had a rule that they could never doctor themselves. They usually didn't live to be very old.

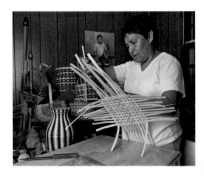

page 65

Louise Goings *is a basket weaver who lives in the Birdtown section of Cherokee, North Carolina, with her husband, George ("Butch"), a wood carver. She learned her craft from her mother, Emma Taylor, a renowned basket maker. Louise creates baskets from white oak, maple, and honeysuckle. She is a member of the Qualla Arts and Crafts Mutual and demonstrates regularly at the Mountain State Fair in Asheville and the North Carolina State Fair in Raleigh (www.cherokee-nc.com/qualla).*

I learned to make baskets from my mama. She made baskets up to about a month before she died last December, and she was eighty-two, so probably sixty years or more. Made all different types, but mostly white oak baskets. She made some double weave river cane that she learned from Lottie Stamper, an instructor at the Indian boarding school, and made me a honeysuckle basket for my birthday one time, and Butch has a fish basket. She went to a lot of different colleges and demonstrated, and to New York, Japan, and the Smithsonian. She worked at the Oconaluftee Indian Village about fifteen years and in her prime she was one of the most distinguished basket makers on the reservation.

Her mother, the older daughters, even the boys in her family all made baskets. I only had one son, no daughters, so I taught him. My oldest grandson, Zack, and little granddaughter, Lauren, make them, so basketry has passed from generation to generation. I was about eight or nine when I started, just picking up pieces off the floor, making bottoms, and weaving small baskets from material Mama already had prepared. She said, "If you're going to be a basket maker you have to learn how to start from the very beginning, to go out to the woods, cut the tree, bring it home, bust it up, take your splints out and scrape them with a knife to make them smooth, and get all your material ready." I tell my grandchildren that they're not basket makers, they're basket weavers, because I still do all of that preparation for them.

You have to stain the splints with roots and barks. To get the brown color we use different parts of the walnut tree, like the green leaves and walnuts. We use the butternut tree to make black dye and the orange comes from the root of the bloodroot plant. Some women like to use the yellow root but I hardly ever use that. To use the yellow root bush you either scrape the bark off or beat the roots, and put it in the water bath and dye your splints. The walnut process takes longer than the yellow root and the bloodroot, about six or seven hours at least in that solution.

After you get your tree cut up and your splints scraped, then you have to spend another day and cut what we call weavers, the little thin strips. If you want to make a lot of baskets you probably want to strip up about three or four hundred of them because you need some for each color—white, brown, orange, and yellow. I strip up the weavers and separate the weaving splints from the bottom splints. Those that are thin go in one pile and those cut kind of thick are put in another to make the bottoms with. Then you're ready to weave baskets.

Mostly you make the type of basket that

your mom showed you how to make, or, like me, find some old books and try patterns from the 1950s that's not used much today. I might also go out and buy a pattern at a hobby store and try some of those shapes and designs. The cane baskets, I guess, are the oldest patterns because they've been used since Europeans came to this country. On the white oak you kind of design your own, or use one of the old patterns that have been used again and again.

Each family has distinctness about their baskets. You could look at one and kind of tell who made it. I don't know how to describe ours, but when other folks look at ours they know it's either Emma Taylor's basket or Emma Taylor's daughter's basket. Just like the Welch family up at Big Cove, you can look at one of their baskets and know it's the Welch women's basket. Our family makes wastebaskets, planters, pocketbook baskets, big market baskets, picnic baskets, and burden baskets like women carried a long time ago on their backs to gather corn. We carried a lot of picnic baskets to church when I was growing up to have Sunday dinner, but mostly baskets are used for decoration now.

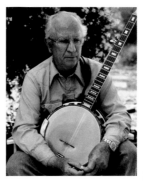

page 66

OBRAY RAMSEY (1913–1996) *was a banjo player and farmer from Madison County, North Carolina. He played as a duo with cousin and fiddler Byard Ray and produced several albums, including* White Lightnin' Fresh Air *and* File Under Rock *with New York producer John Simon. Ramsey and Ray appeared in the psychedelic rock western movie* Zachariah, *making trips to New York and California to record and film. Ramsey has also recorded on his own, including a 1960s album of folk music,* Obray Ramsey Sings Folksongs from the Three Laurels. *He was considered one of the finest banjoists for accompanied singing and has been compared to Dock Boggs. A member of fiddler Tommy Hunter's Carolina String Band in the 1950s, he performed regularly at folk music festivals in the Asheville area. His song "Cold Rain and Snow" was covered by the Grateful Dead.*

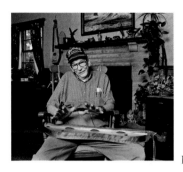

page 67

HOMER LEDFORD (1927–2006) *was a self-taught instrument maker, who produced more than six thousand mountain dulcimers and nearly five hundred banjos, plus assorted mandolins, guitars, ukuleles, and violins. More importantly, Ledford had a well-earned reputation for the high quality of his work, which ranged from the traditional to the innovative. On the one hand, he was a master of the traditional mountain dulcimer; on the other, he invented the dulcibro, a hybrid dulcimer/Dobro, and the dulcitar, which can be played as either a dulcimer or a guitar. A Ledford dulcitar, mountain dulcimer, and fretless banjo are all included in the Smithsonian Institution's permanent collection. The Alpine, Tennessee, native was a well-known bluegrass instrumentalist as well, having performed for decades with the Cabin Creek Band, which he founded (www.homerledford.com).*

When you think about it, I made six thousand and thirteen dulcimers in my lifetime, and that's a whole lot of instruments. Back in the earlier days, when I was stronger, I could make two a day. I never dreamed in my whole life I'd ever make one, much less sell that many. It was interesting how it all happened. I had rheumatic fever when I was a teenager, laid up for a year, and thought I'd never get out of bed. There came a letter from the vocational rehabilitation. They'd learned I carved some

and wanted to come talk to me and see if they couldn't rehabilitate me. We lived way back in the sticks. You had to pipe daylight in we was so far back in the country, but this man, Luther Harris, paid me a visit and told me that there was a school at Brasstown that I might want to go to. Said, "We'll sponsor you three months down there. It won't cost you a penny. You just sit around, do whatever you want to do. If you want to learn wood carving or whatever, great, but it doesn't matter, we just want to rehabilitate you," so that's what I did.

I was a teenager but I never got homesick. I loved it down there. I started at the Campbell Folk School in 1946 and I was there off and on two and a half years. I made two dulcimers for a New York shop, and people at the school seen those, and I sold eight more right there in the course of about ten days. I didn't know what I was going to do but I went back home and made 'em. At that time, there was only two other folks that we knew was making 'em for the market, Edsel Martin in Asheville and Ed Presnell at Banner Elk, North Carolina, so ever since that time, I could hardly keep up with the orders.

Later, I taught high school industrial arts for ten years. It wasn't paying anything and I had three children and needed more money. I was making dulcimers, carving, and repairing, on the side, and could make more money in a half day than I could teaching a whole day, and it was a whole lot easier, so I quit teaching. I've made a lot of different things out of wood. Just about anything you can think of from jewelry to furniture and musical instruments of various descriptions. I just love the craft and love to make things.

All my dulcimers are numbered and signed, starting about one hundred. I kind of hung in with a traditional shape. The little

heart-shaped hole has always been traditional but the very first one I made had a diamond-shaped sound hole because I didn't want to copy the hearts. I was trying to be as original as I could but more and more people wanted them with the hearts so I got back to making those unless they wanted something else. This dulcimer has the wire frets like the originals. Later, I started using the long frets all the way across, like the mandolin frets, so I don't make 'em like this anymore. I made this as a wedding anniversary gift and my wife wouldn't take a fortune for it.

page 68

LAURA BOOSINGER's *primary focus is the interpretation of traditional music from the southern Appalachian region. She has performed at the Museum of Appalachia, Merlefest, and the Smithsonian Folklife Festival. She garnered the title "Most Outstanding Performer" at Asheville, North Carolina's Mountain Dance and Folk Festival, the oldest continuous traditional music festival in the country. In January 2007 Laura performed at Scotland's Celtic Connections festival where she shared the stage with the legendary Peggy Seeger. Laura's CDs include* Down the Road, Let Me Linger, *a tribute to the Luke Smathers band, and* Most of All *with Josh Goforth (www.lauraboosinger.com).*

When I was in college we had a concert series where they would bring in musicians around a theme. One Friday night it would be all fiddlers, the next, guitar players, banjos, and string bands. The Luke Smathers String Band came and they sounded great and were just fascinating to look at. They wore big hats, their noses were amazing; Luke and Harold had these long tall skinny bodies, and everything about them was real angular. They played music that was totally different from everybody else, western swing and stuff, which I really loved. They called their style "mountain swing."

In college you could take banjo lessons and get course credit. I didn't own a banjo or have a clue that there were different ways to play it, but I knew what David Holt was going to be teaching, and it just seemed like the thing to do. I started going to the Mountain Dance and Folk Festival in 1980. I would go back stage and look for the Smathers Band. David was playing with them, and I would hang out and try to play along. I started sitting in with them at rehearsals, and when David quit about '84 they didn't have a banjo player anymore. They were really glad to have me, and I was there for the next thirteen years.

I got attracted to this music mainly 'cause I was attracted to these families and the social aspect of it all. Traditional folk music—bluegrass or old-time—is social music. People get together to play at places like Mrs. Hyatt's in Asheville to see their friends as much as to play the music. That's true about the shaped-note singing that I enjoy, too. Shaped-notes were a way to help people learn to sight read and sing without musical accompaniment. The idea was to give the notes on the staff a shape—triangle, square, oval, and diamond—

a visual connection to the tone. Every time you see that shape you know the relationship between "do," "sol," "la," and "mi" because of how they look. Otherwise, it's the same as regular music.

William Walker and B. F. White wrote a book together in 1835 called *The Southern Harmony*. When Walker took the book to have it printed in Philadelphia, he came home with a wagonload of books and White's name wasn't in there. White got mad and took his wife, who was Walker's wife's sister, and went off to Georgia, and the Walkers stayed in South Carolina. He put together his own book called *Sacred Harp*, so that's where a schism began. In 1866, William Walker published *The Christian Harmony* and instituted a seven-shaped system. So Sacred Harp uses the four shapes and Christian Harmony the seven.

Shaped-notes were part of music in colonial America and became even more popular after the Civil War. More singing masters started making their own songbooks and they would go from one community to the other offering singing schools. These were social events, entertainment, and for young people an approved courting event, too. Although, by and large, it was not music that was sung in a church service, it was always congregational singing. You were an important part of the congregation even if you weren't a great singer.

You'd go to singing school and then different churches would hold singing conventions. They'd make a whole day of singing, and maybe have dinner on the ground, which definitely has biblical over-tones of breaking bread with people. And I swear it's always a loaves-and-fishes thing where you wonder if there's going to be enough, and there's always food left over.

We don't have many things in our society anymore that are communal. A lot of people don't like to eat other people's dishes because they don't know who made it, so there's something really trusting about it when they share.

On the special Sundays when they had shaped-note singing, some preachers started bringing in quartets to sing as well, which had become popular at the time. In fact, one thing that killed shaped-note singing in a lot of communities was these quartets. People started wanting to hear this more professional singing rather than their own congregational singing. A lot of communities, like at the Morning Star Church, had to fight to keep the one day a year when you could have a couple hours of Christian Harmony singing. This past Sunday, "Old Folks Day," marked the one hundred and eighteenth year they've had it in the Dutch Cove in Canton, North Carolina.

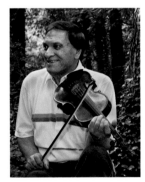

page 69

ARVIL FREEMAN *was born in Madison County, North Carolina, in 1932. He is a well-known fiddle player and instructor who has influenced many area musicians. He began playing professionally at the age of seventeen and has played with many bands including the Saucemans, Ralph Lewis, John Davis, Wiley and Zeke Morris, Arlene Kesterson and the*

Blue Ridge Mountain Band, and for more than ten years with the Mark Pruett Band at Bill Stanley's Barbecue in Asheville.

My folks were farmers in Little Pine. My brothers, Gordon and Carmen, played music around the house. I was too little to play—there's a ten-year gap between us—but I remember them doing it. The other fiddle players I knew of in that area were Johnny Randall and his son, Paul, who lived on Big Pine, and Paty Cody, who lived across the hill in another little holler. Over at Marshall there was Lincoln Davis, Marty Faulkner, and Byard Ray. It was such a long distance between musicians, though, you couldn't get together often. Sometimes you'd see them at Saturday night pickin' at somebody's house, what we call jam sessions now, but they was few and far between and there weren't many cars so you usually walked.

I didn't have an opportunity to learn like people do now. In the fifties there weren't that many good fiddle players around. I figure I was one of the better little youngsters but it just came from hours and hours of practice. I'd sit, like in that chair there, for as high as four and five hours and never get up, just play, working out a tune by ear. I can't read the first note of music.

When I was seventeen I moved to Bristol and joined up with the Saucemans, one of the pioneer bluegrass groups in the late 1940s. They were a wonderful group as far as singing, with Carl and J.P., the two brothers. Curley Seckler was with us there, and Joe Stuart and Larry Richardson. I stayed with them about a year, year and a half. We played on WCYB's *Farm and Fun Time Show* five days a week. It was a powerful radio station, about ten thousand watts, and that's a biggie. It covered

all of Tennessee, into West Virginia, some parts of Kentucky, and all the way down into South Carolina. Flatt and Scruggs played there, and lots of others.

We didn't get paid anything for it but, if you was a member of *Farm and Fun Time*, you was pretty much in demand and people would call the radio station to book you. We would play three, four, five nights a week somewhere, one-room schoolhouses, courthouses, theaters, just anything we could. We was making good money for back then—probably a hundred, hundred and fifty dollars a week apiece, but son, you was doing that schedule four or five days a week. We'd pile five people with instruments in a car, lay the bass on the top, get back in at two or three o'clock in the morning, be at the station at ten-thirty for rehearsal, do the two shows, hop in the car, and here you go again.

Nowadays if you're going any distance you probably hop a plane or bands get these elaborate buses they travel on. We did it by car and on two-lane roads—there was no interstates. It was tough and that is exactly why I didn't follow a musical career full-time, which, I don't mind telling you, I had some awful good offers back in those days—from Bill Monroe, Grandpa Jones, Mac Wiseman, the Stanleys. But when I left over there that was it as far as a profession.

I was in food service in the army and when I came out I worked for Ingles grocery as a butcher for my career, and played music around Asheville more or less freelance for different groups. I done figured out I wasn't a singer so if I followed this thing professionally all I was ever going to be was a sideman playing for somebody else on salary. I could make almost as much money doing weekend work and have the security of a job. I've had

a good musical career doing that and I really enjoyed it. Now it's time to pass the music down to somebody else. Over the last five or six years I've gotten into teaching and really enjoy that more than I am playing, and when I'm gone they'll be a bunch of people that's going to be carrying on with pretty much the style of fiddle I play.

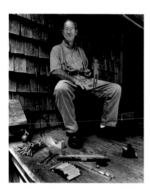

page 70

BOB MILLER *(1931–2006) was a woodworker and toy maker. A native of Haywood County, North Carolina, he retired from Olin Corporation in Brevard in 1985 after thirty-five years to devote himself to woodworking. He joined the Southern Highland Craft Guild in 1989 and with his wife, Barbara, volunteered at the Cradle of Forestry in Pisgah National Forest where they worked as living history interpreters. Known as the Toy Man, he entertained children for eighteen years in his position with the Forest Service by demonstrating and playing with old-time wooden toys he'd made himself.*

I started making wooden toys about fifteen years ago. I took an early retirement because they shut the plant down I was working in. I was a'wondering what I was a'gonna do and the folks at the Folk Art Center sent a gee haw whimmy diddle home by my wife. They said, "Tell Bob to make us some of these," so I got

into making them. I have no idea of the origin of the whimmy diddle. All over the country it's got different names—hooey stick, whistling stick, lying stick, magic stick, jeep sticks, and Indians called them hoodoos. I make mine out of rhododendron wood because it's the smartest wood around and it trains like a good horse, or mule, or oxen, elephant, sled dog. I train each one and when I tell it to "gee" it goes to the right, tell it to "haw" it goes left. We have the Gee Haw Whimmy Diddle World Championship at the Folk Art Center every year where folks compete at that.

I also make spinning tops, a horseshoe puzzle, jumping jacks, a flip ball, tops, the old marble game, yo-yos, and a toy that originally was made in China about seven hundred years ago. Then I make the old limberjack. He's one of the greatest, taught them all how to dance. He originated in the Appalachian Mountains and was first called a puppet. Then his name got changed a half dozen times along the line and finally they settled on limberjack. He can buck dance I want you to know, and even taught Michael Jackson how to moonwalk! Then I've got the old button spinner where you put a big coat button on a string and make it sing. It's a great toy and brings back more memories.

Of course the old horseshoe nails puzzle has been around for a great number of years. You went out to the blacksmith shop on a rainy day and fired the old forge up and you could make a lot of things like that. They'd also take horseshoe nails and make steel rooster spurs to fight them old game roosters. The man who lived above us had a forge and blacksmith shop and his boys and my older kin let me tag along. We'd piddle around out there all day because the forge was warm with the fire going. We would shell some corn and put it

over the forge in an old can and parch that corn to eat.

When March come we made kites, too. Get an old weed that has been standing all winter, dried out and about as hard as wood, and take a short stick off it and a good long one and tie them together, put a string around to make a frame. You mixed flour and water into a paste and glued a piece of newspaper over them strings all the way around, punch you two little holes, tie a string on it, and got an old rag and tore it up and made you a tail and that thing would fly beautiful.

Slingshots was a good toy and tool. We've got a crab apple tree out there and when there's not many people I go out and gather some apples and we shoot at an old locust. Boy, them things will hurl that crab apple, hit that thing just like it was a bomb and explode. We made them out of dogwood when I was a boy. We'd hunt a branch that had a centerpiece and two limbs coming out. We'd take them two outside limbs and bore them perfect, tie a wire around them, and bake them in the oven to dry them out. We'd cut the rubber bands out of an inner tube from an old tire. I've killed squirrels and rabbits and everything else with them. If I took a squirrel, rabbit, quail, pheasant, or what-have-you home my mother cooked it. She could really do them squirrel dumplings and rabbits. I also used to make a cute little popgun out of elderberry when I was little but anything that you toss, pitch, throw, shoot, this and that, you can't demonstrate around kids anymore.

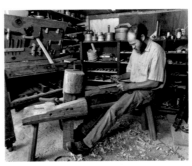

page 71

WILL HINES *is a self-taught white cooper who makes household containers such as piggins, butter carriers, buckets, churns, and canteens. He has been a member of the Southern Highland Craft Guild since 2000 and has taught summer workshops on coopering at the John Campbell Folk School. He was selected to* Early American Life *magazine's Top 200 Traditional Craftsmen for 2004, 2005, and again in 2007. He lives in Greeneville, Tennessee, with his wife and two teenage sons (www.wthines.com).*

When my wife finished at NC State University we moved to Murray, Kentucky, and she taught at Murray State for eight years. I started working at a historic farm there at Land Between the Lakes National Recreation Area. We would do farming 1850s style using oxen and horses, various things. I decided that it would be good if I knew how to make some things so I would make a few buckets for the farm and interpreted that to the visitors. There was a good cooper at the Shaker Village in Pleasant Hill near Lexington. When we would have a fall festival he would come over for it. I'd see him, he'd give me tips, and that's what got me into this.

I worked there full-time a couple of years and when our oldest kid, Tom, came along, I went to part-time, just working weekends. I did that for about seven years, then became a stay-at-home dad and raised two boys. I started

doing coopering at home and taught myself. Since my wife and I are both Tennessee people we wanted to raise our young'uns as Tennessee boys. We bought some land here in Greeneville and started building this place.

As a cooper I make a number of items from wood. I don't make anything all that big. I use a lot of short stuff, down to four or five inches. I go to the sawmill, buy me a sassafras log or whatever, cut it into stove wood lengths, then split out the log and let it dry. I do all my craft by hand. The only power tool I use is the band saw and that's strictly to make cuts to rough length. Everything else is done with hand tools.

Coopering is divided into three branches: wet, dry, and white. Wet coopers make casks, such as barrels for liquids, while dry coopers make flour barrels and nail kegs. White coopers, like myself, make household items including buckets, butter churns, butter carriers, and piggins, which is just a wooden multipurpose, staved and tapered container. One stave is left longer to serve as a handle and has a hole to hang it on the wall. They used it in the barn for carrying nails, around the kitchen to store flour, as a dipper, or to put the kitchen utensils in, just anything.

The reason they called it *white* coopering is probably because they used mainly light, soft woods, like white pine, cedars, and around the Appalachian area there's lots of red cedar and sassafras, so they used those a lot. Traditionally coopering was a profession and what they made depended on the time period. Back in the 1850s, if you were getting married, you'd go down to the cooper and order a butter churn, buckets, washtub, piggins, whatever it took to set up housekeeping. Piggins come in different sizes. Most are about six or eight inches across, not quite as big as a bucket.

Some flare out at the top and some taper in. To a lot of people the terms *bucket* and *pail* are interchangeable, but a pail flares out at the top while a bucket is larger at the bottom. When they started making metal "buckets" they were actually pails. You could nest them in each other and have a stack, which made them easier to ship and display for sale.

I enjoy working with my hands and I've done a lot of things over the years, some blacksmithing, metal casting, and just plain piddling, but something about coopering just seemed to click with me. It's the only thing I've ever stuck with to the point of perfecting it to a level of making something you could actually sell. I really enjoy all aspects of it, shaping the wood, working with hand tools, demonstrating my craft, talking to people at craft shows, and associating with fellow craftsmen.

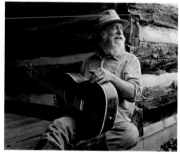

page 72

STEVE RICE *worked twenty-two years for the EMS in Madison County, North Carolina. He is a farmer and amateur musician who sings and plays the guitar. He was part of the music group the Sim Top Ramblers, along with high school friends Jerry Adams and Joe Penland, and lives on a farm in the Sugar Camp section of the county today.*

I still play the guitar that I bought in 1964 from the Home Electric Store in Marshall. Folks used to gather up down there and play

their guitars, fiddles, and banjos. Marvin Faulkner was always there with his fiddle and I would go down and play with him or Byard Ray, whoever happened to be there. I played the banjo a little bit but the guitar is a melodic instrument and goes well with singing and I was always more a singer than an instrumentalist.

Jerry Adams was my motivation for getting into traditional music. We used to play together, gospel tunes, old-time, and bluegrass. We'd go to Sodom and meet up with Lee, Doug, and Berzilla Wallin and her sister, Dellie Norton, and listen to them sing ballads. After Vietnam I quit singing. My first wife, Sheila Adams, and I got married and left Madison County off and on, then came back around 1980. I didn't start singing again until Jerry and I got back together and started playing music again. I don't call it old-time because to me old-time has a kind of a clawhammer rhythm, whereas traditional mountain music was more about singing and ballads. I think accompanied ballad singing suits me. I've got the voice, rhythm, and timing for it from shaped-note singing. I'm taking a shaped-note class down in Marshall now and I always liked those real beautiful harmonies.

I always thought mountain people had kind of a melancholy, a kind of sadness underneath, and a lot of the music expresses that. There was a lot of humor in the way older people used language but there was always a sense that there could be trouble at any time. When I was growing up, most of the old people was poor and had been through lots of troubles. They kept their heads down, mouths shut, were good to their neighbors and helped them when they could, because they knew at any time they could need the same thing. Everybody was like that, quiet and careful with what they said so as not to offend anybody, just more open.

There was plenty of trouble down through my own family. My great-grandfather owned land from the top of Walnut Mountain to the Rice Cove. He had given my grandfather Harley Rice money to get a doctor when it was time for my grandmother to have her baby because Doc Sams had told her not to have any children because her pelvis was small but she had three—my father, Aunt Jesse Mae, and Uncle Bill. He got a veterinarian instead and she died in childbirth, so he had a load of guilt from that and eventually killed himself. I mean, you just wear guilt, it's all through your life. And my Uncle Bill would have epileptic seizures and there was no medication to control it, so he eventually got tired of that and killed himself.

Music is healing and the one thing I do that I feel the freest. It seems to be the easiest form of intimate communication. That's what it was like at church. That's where you would express your joy. When you sang, it was an easy way to express emotion and emotion was not expressed that much at my home. There was not a lot of happy, good feelings. A fellow, Lyda Brown, would come over to Davis Chapel and conduct singing schools once or twice a year during the summer. They would be in the evenings, go on for a week at a time, and all you did was shaped-note singing, which is a lot like ballad singing, the same kind of inflection. He always said, "I don't care if you can sing at all, but I want you to sing as loud as you can, " so we just sung absolutely as loud as we could.

That's where I learned to sing and Dellie Norton, Cas Wallin, and a lot of people learned at them singing schools. You could hear these poor people sing—the only thing that they had was Jesus and the hereafter and, man, they would show it. So music is a great way to connect with people. You don't have

to talk politics, you don't have to talk about anything, like this morning, here at Fiddlers Grove, I had four Autoharps arrayed around me. We were singing "I'll Fly Away," and that must be what it sounds like in heaven.

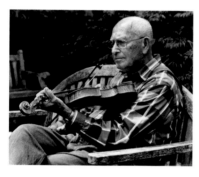

page 73

CLYDE DAVENPORT *lives near Jamestown, Tennessee. He built his first fiddle at age nine out of barn boards and used hair from the family mule for bowstrings. He continued to build and repair instruments throughout his life, worked in auto plants, ran a truck stop, served in the army, and played at music camps, festivals, concerts, and workshops throughout the country. He played at President Ronald Reagan's second inauguration and was awarded an NEA National Heritage Fellowship in 1992. He is credited with knowing more than two hundred fiddle tunes, some of which he learned from his father and grandfather as well as early influences Blind Dick Burnett and Leonard Rutherford, a renowned banjo and fiddle duo (www. fieldrecorder.com/docs/notes/davenport.htm).*

I was raised on a farm in Wayne County, Kentucky, in what they call the Blue Hole Holler. Used to be a lot of people lived in there, but now ain't hardly anybody left. I'll be eighty-five in October, born in 1921. I started playin' the fiddle when I was nine years old. The first time ever I picked it up I played a

tune. When I was a young man, all I had to do was hear a man play a tune once and I had it. Catch 'em like that and they didn't leave my head. I'd go for a month or more, pick up the fiddle, and play the tune. My head was full of 'em. I believe I could've played two or three weeks and not play the same one twice. It was that way till I got up in years.

I can't learn one now and I've forgot most of the ones I did know. I've got lots in the Library of Congress up there in Washington, D.C., but not near what I knowed. They said if it hadn't been for me, they'd have lost a lot of tunes, 'cause nobody knowed 'em but me. I guess they're right, too. I never did hear nobody else playin' 'em.

When I was young in my teens, I would walk four or five miles to some man's house 'bout every Saturday night. Be big log houses and they'd push the furniture back, have a square dance, and I'd play the fiddle. I'd sit there and play all night long. They'd have a big time. Ended up daylight, I'd go home, go to bed, and never wake up 'til Monday morning. Then I'd get up, harness up the mules, and go to work. After I got to be a man, though, I never done too much playin' like that.

I had two brothers who played the fiddle, and I played, and my daddy. He was an awful good banjo player, but you couldn't get him to play one. Once in a while, if you'd beg him, he'd play a tune or two. Boy, he could make one sound the prettiest you ever listened to. I play a banjo, too. I was good on one till I got my hands hurt, and then I couldn't hit the strings.

I used to be a real fiddler back till I quit. I quit playin' when I was thirty-five years old. Didn't have no fiddle in my hands for sixteen years. Don't really know why. I was married and had kids, had to make a livin'. Reckon I just got rid of my fiddle. Back then there wasn't nothin'

like these music gatherings going on. You just played for yourself, or some-body'd drop in, ask you to play a tune for 'em.

The old players are all gone, and the young ones didn't take it up till a few years back. Now they are tryin' to play the old-time stuff, but if you'll notice they all play the same tunes they learned from one another. They play just alike, and think the louder it is the better, but that hurts their music. They like my playin' because I do the old tunes that they never did hear, so they're new to 'em. Everybody is just crazy about my fiddle playin', and I don't think it's anythin' 'cause I'm used to it. People have come to my house from every state in the union and Italy, England, Ireland, Germany, and Spain. They're wantin' to play the fiddle like I do. I try to show them, but it don't help none. They'll never get my bowing style, never play a fiddle like I play it. They're right heavy on the bow, ride it, which makes a fiddle sound bad. You should always play light.

I never had to learn nothin'. I could play anythin' I ever tried, organ, piano, harmonica, jaw harps, guitar. I never had to fool with 'em but for a minute and I played the thing. I never took no lessons, nobody ever told me anythin' or showed me anythin', played by ear. I play the style I started with, never did try to play like somebody else. I might have been a little old boy, but I knowed better.

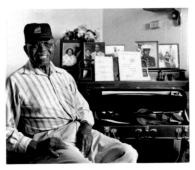

page 74

JOE THOMPSON *lives in Mebane, North Carolina, in Graham County. He was born in 1918, and he worked for thirty-eight years at White's Furniture, one of the largest manufacturers in the South at the time. Joe and his cousin Odell have performed at Carnegie Hall as well as at the Festival of American Fiddle Tunes in Port Townsend, Washington, the National Folk Festival, and the International Music Festival in Australia. Their unique style was featured in Alan Lomax's* American Patchwork *film series. In 1999 Rounder Records released* Joe Thompson: Family Tradition. *He was awarded the NEA National Heritage Award in 2007, and he has been the subject of a video documentary,* The Life and Times of Joe Thompson, *shown as part of the UNC-TV Visions series (www.ncarts. org; search recipients).*

My dad, his brother, my granddaddy, all of 'em played music. I got started under my dad, just like they got started under theirs and it come from way on back. Daddy learned my brother, Nate, how to play the banjo, and me the fiddle, and had a piano for the two girls. My mama didn't like for me to borrow his fiddle, she thought I'd break it, but he saw I was messing with it, so he fixed it so I could get to it. He built stairs going into the girls' room, put a fancy stick out from the wall with the fiddle hanging on it. He put it right in my way

hanging there and all I had to do was get it. I know now he meant to do it.

My mama had a first cousin, he sold a whole lot of seeds from the Castor Seed Company. He didn't take all his pay in money. He also took premiums. He had got two little fiddles, just half size. I went over to his house after school and got a fiddle and come back home with it. It didn't have the two first strings on it, and my brother says, "What you going to do without strings?" I said, "I'll get Pop to give me some." He says, "Pop ain't gonna get you no strings," because that was tough times back in '29 when Hoover was in there. I'd seen my first cousin Odell, and my older brothers, when a string would break they'd go to the screen door and pull a wire out, so that's exactly what I did. I pulled me two strings out that door, messed with them, and man it worked. The first tune I ever played was "Hook and Line." It wasn't long before I was playing "Soldier's Joy," "Little Brown Jug," all that old stuff.

I started playing that fiddle, and my brother playing the banjo, and we kept busy. We'd play around the house and at old-time square dances. They were one of the main entertainments. Back in those days, white folks called it square dancing and old black folk called it frolicking. We would have a frolic at a wheat threshing, corn shucking, any time straight down through to Christmas, about every Saturday night they'd have a frolic somewhere. Back then we just played for kinfolk, the community, just around mostly. It would start sometime around six or seven o'clock, after dark, and we'd go up to about nine or ten, and there'd be a pretty good crowd.

My daddy was John Arch Thompson. He and his brother, Walter, was heavy musicianeers, fiddler and banjo players, could play all them fancy tunes. Some tunes come from the 1700s, and they has never got weak, all the way down through the 1800s to today. I used to hear my daddy sing "Old Joe Clark," "Georgia Buck," "Corn Liquor," "Alabama Girl." They was high-ranking tunes for them, and we're still playing them.

They was really good musicians, but me and my brother were about as good as they was. My brother Nate was a top banjo picker. He was quick to learn, pick up something, come home with it, and we'd learn it. That's the way you played, by ear. He gone off to get himself a good job, so that separated us. My first cousin Odell was about ten years older than me, and he took it up after Nate had to leave. We went a lot of places, every which-a-way. Even played for Carnegie Hall. I never will forget that.

Before I retired, I played music mostly in the evenings and on weekends. I've traveled more since I stopped working. I used to really play a fiddle till I had this sick spell. I had a stroke down this left side. They told me I'd never play no more, but I can do pretty good now. I didn't give it up.

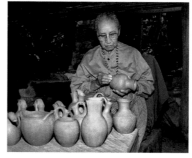

page 75

AMANDA SWIMMER *is a member of the Eastern Band of Cherokee and is one of the best-known potters among the Cherokee people. Born in 1921, she raised seven children and worked at the Oconaluftee Indian Village for more than thirty-five years demonstrating*

her craft. She has received prizes for her work at the Cherokee Fall Festival, taught pottery at the John Campbell Folk School and throughout western North Carolina, and had her work on display around the country. Amanda received the North Carolina Folk Heritage Award in 1994 and an honorary doctor of humane letters degree from UNC-Asheville in 2005 (www.ncarts.org; search recipients).

I learned pottery myself when I was about fifteen years old. I just tried to make some and got to be pretty good. When I was thirty-six I started working with the people up there at the Oconaluftee Indian Village, and I'd pick up more every year. I used to set up two dozen pieces in a day and carve 'em the next day, design 'em up. I've made as many as a thousand in one summer.

When you make pottery, the clay has to be sifted, cleaned, mixed, and all, so there's a lot of work to be done. They done that in Asheville at Brown's Pottery and then we'd just buy it by the pound from them. We didn't have to fire the pieces ourselves, the village had a big old kiln where they burned 'em for us. When they'd close up in the fall, they'd price the pots and give us a check for how many we made. They just kept 'em and give 'em away.

All my kids makes pottery, every one of 'em. They learned it from my boy and me. He had a wife that worked up at the village and she's a good pottery maker. He worked with her after they married and they made pottery. That's where I learned even more, working with her after I went up to the village. Since I've retired from the village I'm just living on the pottery I make at home again. Some people thinks it's easy, but it's a job to make pottery. You have to get clay, buy wood, stay with it when you burn 'em, everything like that. When

I first started I got my husband to just make a pit in the front yard and put wood in it and burned the pottery that way. You get different colors depending on the type of wood you use. Hardwoods smoke less and make the pots a light gray color. Soft woods, like poplar, give off a lot of smoke and make the pieces dark. I mix in other woods like oak, hickory, and locust to get all shades of brown or even orange.

All the designs they had on the bowls way back is lost. The fellowship design is the only one that remains. It meant something when they made pottery way back, but now they don't know what it was. These other patterns people use, they just made 'em up theirself. I've got some old patterns that I use, make my own wooden stick, and use bone and seashells to put the designs on. The kind of pots with a loop at the top, they're wedding vases, but the design wasn't from us Indians out here. There was a lady came up here way back and brought a piece of pottery from a Mexico Indian. She showed us that picture, so I made some of them. These others are just vases for flowers or whatever you want to use 'em for.

'Course they didn't have no iron pots and stuff like that way back. That's how come they made pottery, that's the only vessels they had to cook with, and they'd hold water. When they moved from here during the removal to Oklahoma, they had to make some pottery as they moved along, to cook with wherever they was camping. They didn't make 'em like we do, they didn't use a potter's wheel, they made 'em out of coils. They'd make a flat disk and build the coils around it, build it up as far as they wanted, then use a rock to smooth them down so they came together.

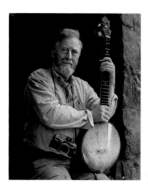

page 76

JOHN COHEN *is best known as a musician but he has also produced fifteen films and hundreds of photographs and sound recordings related to traditional roots/folk music. He has made more than twenty recordings with the New Lost City Ramblers, comprised of Mike Seeger and Tracy Schwarz (who replaced Tom Paley in 1962). The Ramblers changed the direction of the folk music revival, steering it away from commercialized acts like the Kingston Trio toward the performance of traditional music in authentic styles. Cohen made a series of documentary field recordings of traditional musicians in their home settings in Kentucky, Virginia, and North Carolina as well as in the highlands of Peru. He discovered the great Kentucky singer Roscoe Holcomb and made his first film about Holcomb's music, creating the phrase "the high lonesome sound" to describe it, which subsequently became the generic term for bluegrass singing. He worked with T-Bone Burnett as music consultant to the film* Cold Mountain *and appeared in Martin Scorsese's 2005 film about Bob Dylan,* No Direction Home. *In 2001 Powerhouse books published* There Is No Eye: John Cohen Photographs, *followed in 2003 by* Young Bob: John Cohen's Early Photographs of Bob Dylan *(www. johncohenworks.com).*

Growing up, there was a lot of singing in the home, especially my mother, and I realized the joy and the good feeling that came from what they called folk songs or folk dancing, so a certain kind of attitude about music was deeply ingrained in me. My own musical interest came together when I was sixteen years old, around 1948, when I first heard old-time fiddle records and Woody Guthrie. The first instrument that got to me was the banjo. I was at Williams College for one year, found a banjo in an old shop. I hitchhiked up to Putney School. Peggy Seeger was still in high school there and Pete had just put out his first mimeographed edition of how to play the five-string banjo and she sold me a copy of it.

I left there and went to art school at Yale. Tom Paley was teaching math and was a real hot guitar player from the New York scene and he and I would play together. We were invited to play on an early folk music FM show, in 1958. Mike Seeger was in Baltimore at that time and had heard about this, said, "Can I come along?" He'd been listening to the same kind of music and there really weren't many other people that were. We had a little rehearsal on the way, I even remember playing in the back of a van, and we went right on the air.

I was excited by that and went to see Moe Asch at Folkways Records. I said, "Here's the music that really is alive, and it feels great." He said, "Who are the other musicians?" I told him and he says, "Okay, you can do a record." Didn't listen, no audition tapes, nothing like that. I set up a concert in New York, and that first weekend we did a sold-out concert and our first record as the New Lost City Ramblers.

We never made a big deal of it and didn't plan to have a big life with this music, but it was catching on and everywhere we went to play at colleges other string bands would start.

When we would come back the second year there would be more and we kind of had a network that went nationwide. It wasn't done on the Internet back then, of course. It was from Volkswagen, to someone's couch, to a little concert hall, back in the Volkswagen, then to another couch. But we did this for four or five years and built this large network, which is sort of a basis for all that's happened since. Eventually I married Mike's sister. You can't separate the music from the family, from the life.

In 1959 Robert Frank, the photographer, was making his first film called *Pull My Daisy*, narrated by Kerouac and starring Ginsberg and others from the beat generation. He asked me to take stills for it. I saw how he used the film camera a little bit. It was a very spontaneous, improvised kind of film. I had gone to Kentucky that year and taken still photographs and made recordings that came out as *Mountain Music of Kentucky*. In 1962 I got a movie camera and went back. We didn't have synchronized sound yet but I did my first film, *The High Lonesome Sound*, which is still pretty good.

My musical interest was already there when I started doing photography and filmmaking. I worked in a lot of mediums and they called me interdisciplinary, or a Renaissance man. My answer was always, sort of jokingly, "If I'm a Renaissance man then the Renaissance would have been full of hippies."

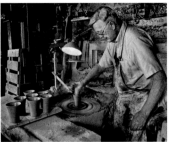

page 77

Walter Cornelison *is the fifth-generation Cornelison to own and operate Bybee Pottery. Walter and wife, Dorothy, have three children, Robert, Paula, and James, all involved in the family business. It is the oldest existing pottery west of the Alleghenies and is located in the small rural town of Bybee, among the southern hills of Madison County, Kentucky. It is thought that the pottery was originally established in 1809, and actual sales records prove its existence as early as 1845 and was one of the few potteries in the area to survive the Civil War. They make colorful stoneware in more than one hundred shapes and sizes (www.bybeepottery.com).*

I worked under my father, and played here under my grandfather Walter. He died when I was only ten. My great-grandfather James Eli built that house over there. I live there now. They all lived in this area, almost within sight of the pottery, and walked to work just like all of us.

Legend has it that the people of Fort Boonesborough come up the river and found this clay. They started making things like churns and fruit jars, what they called stoneware. They hauled it out of here on wagons, took finished pieces down to the river, loaded them on flatboats, went to Irvine, Booneville, Beattyville, and people would come down to the docks and buy what they needed, especially in the fall of the year when they were going to can food.

We evolved from that to many kinds of forms and went from salt glaze to stoneware glazes, which are two clays blended to get the color you want. We dug the clay by hand for years. It was sedimentary clay that washed in here and took the contour of the land. We'd work a twenty-, twenty-five-foot square, go down, and might get a vein. We had to leave a layer on the bottom of that clay hole to keep water from coming up in it. If we cut through it, and we did many times, we'd come back the next morning and have to bail it out. We'd take two weeks in the dry fall season and dig enough clay to last us a year. It used to be terribly hard work. We'd get down ten, fifteen feet in the hole and have to throw it out on the bank and load it into a truck, bring it home, and unload it. We've since gone to dozier work where they skim it off for us, take a backhoe in and dig the dirt, put it in a dump truck. We've got to do a lot more cleaning of the clay before we can use it, though.

When I started here, I like to have starved to death learning because you got so much pay per piece. If the piece wasn't right, Daddy threw it away. I learned to make every piece in the catalogue, and there was a time when we couldn't keep a piece of pottery on the shelf. We'd open the kilns Mondays, Wednesdays, and Fridays at eight o'clock and set stuff in the floor. Folks would come flocking in and by nine, nine-thirty, it was gone and we'd go back to work making more. It went on that way for years. The recessions would come and go, and we couldn't even tell the difference. It doesn't happen that way now. We're not complaining because it was fantastic what happened to us, but I don't know whether the pottery business can withstand the changes that are going on with imports, plastics, and all.

I'm getting up in years and I don't know

exactly what will happen. I'm certainly not going to tie my boys down to it. They've got college degrees and I want them to be comfortable in what they're doing whether it's here or not.

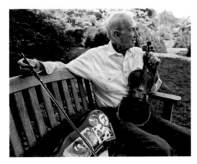

page 78

RALPH BLIZZARD *(1918–2004) was born and raised in Kingsport, Tennessee, and later moved to Blountville. At the age of fourteen, Ralph's band, the Southern Ramblers, played on local radio stations. Ralph quit playing for twenty-five years while raising a family and working for Eastman Chemical. After retiring Ralph founded the New Southern Ramblers, a top old-time band. He was a founder of, and instructor at, Warren Wilson College's annual Swannanoa Gathering Old-time Music festival. Appointed to the Tennessee Arts Commission in 1987, he was inducted into the American Fiddlers Hall of Fame in 2001, received an NEA National Heritage Fellowship in 2002, and received the Tennessee Governor's Award for the Arts in 2003 (www.oldtimeherald.org; search).*

I was born and raised in Kingsport, and there was quite a few fiddlers in that area. My dad, Robert Houston Blizzard, was a fiddler and I learned to play from him and three of the well-known ones of his age, Charlie Bowman, Dudley Vance, and John Dykes. I was raised with all four of them within eight airline miles

of where I grew up and, as a kid, played music with all of them.

When I was a boy we was all after something to play. The first thing the kids grabbed was the little horns they put in Cracker Jacks, and we'd also put cigarette papers on a comb to make a noise. A lot of the kids got ahold of juice harps because they were fairly cheap. It was a well-liked instrument back then and was incorporated more in bands than they are today. Of course we got into guitars, banjos, fiddle, anything to make music. I graduated from one instrument to another until I got to the fiddle, and played all of them. I learned by ear mostly and was playing the fiddle by the time I was seven.

Most of the older people that played traditional music played by ear. Back then people were isolated from one another and developed their own styles of doing particular tunes. That's the way music comes down, it has variations. They kid me about the way I play, say I never play a tune twice the same way. Well, I mean, I don't have no set pattern. Just because the number is written down a certain way, doesn't mean it's played the same way all the time. So I think that's more or less the way the different styles originated.

There are lots of different fiddle styles. Way back in the early days of real old-time fiddling, when they only had the fiddle to play for dances and entertaining, they played the rhythm with their lead part. When the banjo, guitar, bass, and other instruments came in, they had something behind them to provide the rhythm so different fiddle styles developed. I play the long-bow style, where you play more notes with one direction of the bow, like more forward or more backward. That lets you do more complicated musical phrasing.

I got into music professionally as a young

person and had a group, the Southern Ramblers. I went to work for Eastman down in Kingsport a little while before World War II and when the war came that interrupted the music because most of the guys had to go to service. I joined up in 1942, got out almost four years later, and went back to my job. I met my wife, Mildred, when we were playing at the Saturday Night Hayride in Kingsport. I had to make a decision to follow a professional music career or not. We bought a farm and it just occupied all my time, mind, everything, so I sort of withdrew and got away from music for twenty-five years or more.

I never intended to leave the music completely. At work I was always trying to protect my hands from injury. When I retired, I started back learning how to play fiddle again. I bought me one of these hand cassette players and got the music catalog from Joe Bussard up in Maryland. He's got a collection of about everything recorded, especially in the traditional line. You could take this catalog and list what you wanted, order a ninety-minute tape, and he'd record it for you.

I got to playing again and met the Green Grass Cloggers in 1982 at Bays Mountain State Park. They were doing a show there, and some of their musicians and I formed the New Southern Ramblers and have been together ever since. We try to preserve a lot of the old tunes because there's a world of songs out there that we've about forgotten. A lot of the musicians and singers have passed away without any record of them being preserved, and a lot of those things are gone and can't be recovered. Interest in that music declined for a long time, but did revive. Young people back in the 1960s really started picking up on it and folks like Mike Seeger did a lot to give it a boost, and it's been going up ever since.

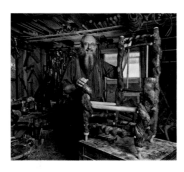

page 79

Jɪᴍ McGɪᴇ *was born in Texas and moved to the Hardy's Chapel section near Livingston, Tennessee, in 1996 with his wife and family. He makes one-of-a-kind handmade chairs and is a member of the Southern Highland Craft Guild and the Foothills Craft Guild. Jim's award-winning rockers are a part of many collections, including the Tennessee State Museum. He teaches a variety of workshops on chair making, bark weaving, and spoon carving (www.foothillscraftguild.org or www. southernhighlandguild.org).*

This used to be a twenty-five-family horse-and-buggy, nonelectric community. It was started in 1990, based on a common view of Christian faith, a simple lifestyle that emphasized family values. Our children all live right around here, too, and range in age from three to twenty-seven. We still have five at home, the oldest three are married, and we have four grandchildren.

We moved here from Texas in '96. We visited the community many times. It was one piece of property, about two hundred and eighty acres, and every family was allotted a certain amount of that farm to work on. It wasn't totally self-sufficient, but we interacted and helped each other a lot. As an example, the men took two weeks every winter and cut firewood together since we all heated and cooked with wood, which took quite a

bit of wood. In two weeks we had everyone's woodshed stocked for a year. I made the decision when we moved here and took up this lifestyle that we would put people over projects. If someone needs help, you need to lay down what you were going to do for the day and go, then get back with your own work later.

The price of land around here has multiplied since they first bought, and you don't make a living horse farming on expensive land. Some of the first families came here from Michigan and Canada and they decided to go back, so that kind of made it where everybody wanted to leave. We decided to stay since I didn't farm much anymore. A couple years later the people that bought the farm brought electricity down and we tapped into it so I have lights and a fan now. I used to work by kerosene light, try to stretch the day out a bit.

One of the first things I carved was spoons, tree ware, a pretty good entry-level thing to do with hand tools, and in time I've gone from trying one thing to the next. For years I made kind of a traditional Smoky Mountain–style chair using green woodwork techniques. Take red oak logs, split it out with a froe, took it to the shaving horse, drawknife every part down. I made a lot of those chairs but I struggled to make a living because it took so long to make a chair and it was hard to get a high enough price for one.

Then one day I made a chair that was really different, kind of stumbled on it. People just went crazy over it. I was a common guy, you know. I couldn't afford a lot of money for one so I didn't think anyone else could. I didn't have a clue how much anyone would pay for it so I hauled it around to a couple of craft shows and put a sign on it, "Taking offers until the first week of December." It sounded crazy, but within a matter of weeks the price

went through the roof. I figured that must be the market value. I've pretty much stuck with making those one-of-a-kind chairs and started making a living along the way.

I don't try to produce anything fast enough to sell cheap. I've been somewhere between twelve and fifteen chairs a year. It's just not possible for me to do more than that. I don't use any screws or nails, just a hand-whittled peg that locks everything together. It takes a huge amount of time, but I love it. I never know what's going to happen next when I start a chair. I take a big pile of these crazy old sticks, the wonderful oddities of nature, and come up with something somebody will really like to sit in, show off to their friends, keep as an heirloom. I still remember the first rocker I made. I was so excited I went and got my wife and showed her. I was just like a kid and still feel that way after every chair.

page 80

SHEILA KAY ADAMS *comes from a small mountain community in Madison County, North Carolina. For seven generations her family has maintained the tradition of passing down the English, Scottish, and Irish ballads that came over with her ancestors in the mid-1700s. Sheila learned these ballads primarily from her great-aunt Dellie Chandler Norton (whom she always called Granny) and cousin Cas Wallin. After teaching school for seventeen years she decided to pursue a career writing*

and sharing the music, stories, and heritage of her Appalachian culture. She is the author of several books and has recorded many albums and CDs. Sheila is known for her award-winning accomplishments on the five-string banjo playing the clawhammer style, has taught at music camps, festivals, and universities throughout the country, and she was technical adviser and singing coach for the film Songcatcher. *She has three children and is passing the traditions on to them (www.myspace.com/sheilakayadams).*

I have sung for different reasons throughout my life and I'm assuming that even though it was in a different place and time I sang for the reasons a lot of the older people did. When I was in my twenties, I sang because it reminded me of the way that it used to be, kind of nostalgia. It's become an even more important thing now to me than it was twenty years ago, because it's the only connection I've got left with these people and that way of life, because it's all gone, and they're gone.

They sang all the time—when they played, when they worked. Granny had songs she would sing when she was handing tobacco, working in the garden, or stringing beans. If you went out on the porch and heard Granny off in the distance singing "Young Emily," you knew she was at the barn milking the cow. A lot of them had their own style, different ways of phrasing and holding notes at different places, and that was one of the reasons they did it "Acapulco," as Granny jokingly called it, because she couldn't pronounce "a capella."

Somebody asked Granny one time if she could read music, and she said, "Not enough to hurt my singing." They were convinced if you could read what they called round notes—shaped-note singing was a whole different thing—it somehow restricted you to where you

had to sing everything in them little "blocks," as she called them. So it was strictly oral. If they wrote the words down and gave them to you on a piece of paper they referred to it as a ballad. All the rest of the time it was referred to as a love song.

I loved the stories and was always able to visualize what was going on in them. There was a verse in every love song that would grab my attention the first time I heard them: "He took her by the lily-white hand, led her across the hall, pulled out his sword and cut off her head and kicked it against the wall." Well, those were just great words. When I was first starting learning it was just by listening to them sing, but if it had more than ten or twelve verses to it, Granny would say, "Go get a kitchen chair and bring it in the front room and I'll learn you one of them old love songs." We would sit old-style, "knee-to-knee" is what she called it, facing each other with our knees almost touching. She would sing a verse and I would sing it back. She would sing the second verse and I would have to sing the first and second back, to where at the end Granny was just singing one verse and I was having to start back over and sing the whole thing. The longest one I know is "Lord Bateman" and it's got ninety-six verses. The way I learned that was that the story unfolded in my mind. Now if I try to learn a love song, it takes me a lot longer and there's no guarantee it's going to stay there in one piece. But those that I learned as a child I can recall perfectly.

If I could get across to my children and maybe a few more the importance of this tradition, of the music, the singing, and what it meant to them, I'd be happy because I can't think it will ever mean that again. Somebody referred to me once as the last dinosaur, which I thought was funny. After thinking about it, I said, "Well, no sir, I am not the last dinosaur, I am a child of the sixties, but I did see the last dinosaur."

page 81

MINNIE ADKINS, *born in Isonville, Kentucky, used to sell her carved animals at flea markets for almost nothing. Today they can be found in the private collections of Oprah Winfrey, Barbra Streisand, and Bill Cosby, in museums, and featured in the book* O'Appalachia: Artist of the Southern Mountains. *Although best known for her roosters and carved-and-painted animals, the self-trained artist also creates paintings, metal sculptures, appliquéd quilts, glazed pottery, and woven blankets, often working collaboratively with family members. A mentor to other artists, she and her first husband, the late Garland Adkins, started the annual craft festival called* A Day in the Country, *which now takes place at Kentucky's Morehead State University. She has received numerous honors including the Folk Art Society of America's Distinguished Artist Award, the Appalachian Treasure Award, and the Governor's Award in the Arts from the Kentucky Arts Council.*

As far back as I can remember, I've whittled and made stuff. I started out making popguns, whistles, slingshots, stuff like that, to play with when I was little. Back in the early 1970s, I

would sell little roosters for fifty cents and a dollar at flea markets. I started making them out of forked sticks like my slingshots, but I never got recognized till in the early eighties.

They wasn't no folk art in Morehead at the time. Adrian Swain had a little pottery shop down on the sidewalk in town. He was a-doing pottery and a-selling people's stuff on consignment. He started selling my work and was the person that seen what I was a-doing was considered artwork. Now he's curator at the Kentucky Folk Art Center at the university.

When me and Garland first got in it, there wasn't no market for it. Then we begin to make good at it. Some folks made fun of us, said, "Why, Garland quit working and started whittling." I just laughed all the way to the bank. Garland bought a new truck and people seen us supporting ourself. They begin wondering what was going on, come to me asking, "If I make something, where could I sell it?" I bought stuff from everybody and encouraged 'em in doing it. I started sending 'em to Morehead, and at one time we had fifteen real good artists around here. They've all died off, but we're recruiting young ones.

I make all different kinds of little animals, roosters, alligators, foxes, giraffe, cow, sheep, and four or five Noah's arks. The little animals are made from two-by-fours. We saw off a square block, I'll sketch out what I'm a-going to make, and saw it out on the band saw. We may use some power tools or a Dremel tool sometimes, but usually we just use pocketknives, drawing knives, and chain saws.

When Herman, my second husband, come on the scene, he was a-helping me whittle and said, "Why, anything you can make out of wood, I can make out of iron." I said, "Well, prove it." That little blue iron rooster up there was first one he ever made.

When he brought it down, I knowed he was on to something. He paints them with Ford engine blue paint, then I trim 'em up and stuff. He was a real artist but didn't know it until I discovered it. But he's added an awful lot to what I'm a-doing.

When my first husband passed away, I just couldn't get with it, didn't think I'd ever do any more. Greg, my grandson, said, "Mamaw, you can't give it up. Papaw wouldn't want you to. Come on, let's go to the work room." He'd encourage me to go on and I appreciate so much the fact that he seen the need to help me keep working. Greg loves doing this. He's been making stuff about six year, just right before me and Herman got together. He's the one that helps me with the big animals and has branched out on his own now till he's a-doing paintings and stuff, so I'm real proud. I'm involving my family because at seventy years old, I know I ain't gonna always be here, and when I'm gone I'm hopeful that they will carry on what I started.

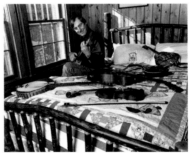

page 82

Wayne Erbsen *runs Native Ground Music, a publishing company specializing in folklore books and music. He is the author of twenty-six books and has recorded more than eighteen CDs. Wayne is an instructor who has taught at many music gatherings and offers classes and workshops in a 1940s log cabin in Asheville,*

North Carolina teaching clawhammer and bluegrass banjo, old-time fiddle, mandolin, and guitar. His live radio show, Country Roots, *now in its twenty-fifth year, is broadcast on local public radio (www.nativeground.com).*

I grew up in Los Angeles and even as a kid I wanted to move to a ranch or a farm. My parents would just laugh it off because they were happy there. That was their frontier. I wanted my own frontier and sensed there was something lacking in California. It's a rapidly changing culture that sets the tone for the rest of the country but not one that has its own roots.

I think it was the rural lifestyle that was embodied in this music, be it string, vocal, early bluegrass, or old-time, that drew me to it. My first taste of it was the banjo songs of the Kingston Trio. We were also lucky to live near the Ash Grove, the folk club, where authentic roots musicians like Roscoe Holcomb, Bill Monroe, Flatt and Scruggs, black blues players, and all the Appalachian people played. Doc Watson did some of his first performances out there and made a big impression on me. He showed up with his little band, Clarence Ashley, Clint Howard, and Fred Price, and they were the real thing. Doc performed solo one night when the others didn't show up on time and blew us all out of the water. All the guys next to me, including Ry Cooder, were elbowing each other, saying, "Look at this guy, this is incredible."

I was young and impressionable, searching for some kind of roots, something with meaning that I could grab on to, and when you're sixteen a lot of times the things that you get hooked on last you your whole life. There were a lot of good musicians around Berkeley that were into the same thing that I was, but

people we were learning from other people who were learning from the same people so I finally said, "I've got to get down to the source, the real stuff." As soon as I was out of college I jumped in my 1964 Volvo and headed southeast to see if I could track down the roots of bluegrass and get closer to the culture it came from.

I went to different fiddlers' conventions in southwest Virginia, and the music and musicians led me on down to North Carolina. Music is a wonderful link. I would go to festivals and play with these rural mountain people that normally I wouldn't be able to talk to, go back and play music with them, sleep on their couch. They let me stay as long as I wanted and were like family and made me feel welcome. So that was kind of how I got started. I had an entrepreneurial streak even back then, so after having played for six months I started teaching people guitar. I discovered my love for teaching besides my interest in music. I developed my teaching skills, entrepreneurial skills, and musical skills all together.

I'm most proud of the fact that I've taught a lot of people to play. My goal has not been to teach the hot licks or the really fancy picking stuff but to reach down and get people who harbor a dream to play and help them actualize that. I've been doing my radio show for over twenty years, and a whole generation has grown up listening to this music on Sunday nights. Through my books, CDs, teaching, and stuff I've reached a lot more. I think I've empowered people to be able to learn music. I'm proud of that because a lot of the old-timers are gone, so in a sense me and my buddies are getting to be the old-timers and we're trying to carry on, and pass on, some of these musical traditions.

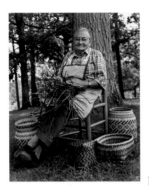

page 83

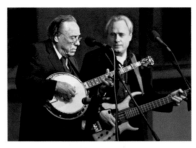

page 84

ROWENA BRADLEY (1922–2003) *was recognized as one of the most talented basket weavers in the United States, renowned for her double weave rivercane baskets, which require an intricate weaving of one basket inside the other in a single continuous weave of material. A member of the Eastern Band of the Cherokee Indians in North Carolina, she started making baskets at age seven, learning from her mother, Nancy George Bradley (Tahtahyeh), who learned from her mother, Mary Dobson. Rowena's mother was one of only a couple of women who knew how to make double weave baskets, an art that was later revived in the 1940s through the efforts of the federal Bureau of Indian Affairs and the Indian Arts and Crafts Board working with the local Cherokee craft cooperative the Qualla Arts and Crafts Mutual. A Qualla member, Rowena won numerous awards at the annual Cherokee Indian fairs and her work is widely collected.*

EARL SCRUGGS *was born in 1924 in Shelby, North Carolina. By age ten has was picking the banjo, using the three-finger style that later became known as Scruggs-style picking. He listened to many groups growing up and favorites included the Carter Family, Roy Acuff, Don Reno, and Snuffy Jenkins. In the late 1930s he played for a few months with Zeke, Wiley, and George Morris from Black Mountain, North Carolina, before retuning home to help care for his sick mother. In late 1945 he joined Bill Monroe's Blue Grass Boys, an already famous lineup that included Lester Flatt on guitar. The two left the band three years later after many great recordings and soon teamed up as Flatt and Scruggs and the Foggy Mountain Boys. They stayed together over twenty years playing at radio stations from Florida to Kentucky, garnering sponsorship for their programs from Martha White Mills, which was also influential in having them join the Grand Ole Opry in the mid-fifties. The addition of Josh Graves to the band at about that time, with his comedy sketches and talent on the Dobro, reinvigorated the band. They became the first country music group to have a syndicated TV show.*

Scruggs's picking style became well known and emulated, and Pete Seeger included a section on Scruggs's playing style in his folk banjo books, which brought Earl attention again during the folk revival of the 1960s. The Elvis phenomenon sidetracked many country

and bluegrass bands in the late fifties, but their appearance at the Newport Folk Festival in 1959 catapulted them to new heights. They appeared at Carnegie Hall in 1962, and their tune "The Ballad of Jed Clampett," used as the theme for the Beverly Hillbillies *TV show, became the only bluegrass song to reach number one on the country music charts. Early TV appearances on that and other programs influenced a whole generation of upcoming musicians.*

After the band split up in the late 1960s, Earl formed the Earl Scruggs Review, which included his two sons, Randy and Gary. Scruggs was inducted into the Country Music Hall of Fame in 1985, became a member of IBMA's Hall of Honor in 1991, and has won several Grammy Awards. Earl continues to tour today from his home near Nashville (www.earlscruggs.com).

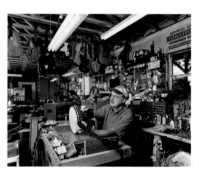

page 85

Roger Howell *is known for his "frailing"-style banjo playing and was the first person to win the prestigious Georgia State Championship on old-time banjo at the Georgia Mountain Fair. His fiddle style was developed through his friendship with respected regional fiddlers including Mack Snodderly, Arvil Freeman, Gordon Freeman, and Marvin Faulkner. In 1991 he teamed up with friend and fiddler Doug Phillips to record their album* Blue Ridge Mountain Music. *Later, Roger joined the Carroll Best String Band on fiddle*

and was introduced to the festival and concert stage where he became friends with his greatest influences John Hartford, Fletcher Bright, Benny Sims, and Charlie Acuff. He is a highly regarded session musician and has appeared on more than twenty-six albums for other regional acts. His 2003 CD, Hills & Heroes, *showcases Roger's multi-instrumental talents. Roger and his fiddle have even appeared in the films* Songcatcher *and* Rank Strangers: The Music of Mrs. Hyatt's Oprahouse. *He lives on Banjo Branch in Mars Hill, North Carolina (www. ivycreek.com/rogerhowell.html).*

It's hard to admit it, but I've been repairing musical instruments about forty years now. I first got an old banjo similar to this one. It had forty-four brackets on it. I put an old head on it and done a good job, by the way, and just kept on. You had to work on all those old banjos and guitars because they wasn't no good. There was always something tearing up on them, bridges falling over, this and that. I like working on fiddles the most, no doubt. A banjo is bolts and nuts and stuff but a fiddle is something else. Wood's amazing anyway and if you understand wood that's ninety percent of the deal.

I buy instruments to fix and resell. Anywhere I go, like an antique store or auction, I have to look and nine times out of ten I'll buy one. I try to tell my wife, "I can get some money out of that," and invariably I end up keeping it. It's a sickness! I used to could pick them up for fifty or a hundred dollars but can't anymore. Years ago you could get them anywhere but now you're lucky if you find any. You could get them down here at the Home Electric Store in Marshall where Marvin Faulkner use to work, or at a furniture store. Anybody at all would have instruments.

You just walk up, say, "Got a fiddle for sale?" They'd say, "Yeah, twenty dollars." Them days are over because of all these auctions, *Antiques Roadshow* on TV, and stuff. Now they're an antique and have become collectibles. It's sad.

I got one fiddle at an antique place that was in an old coffin case. The reason they call them that is because the cases do look like coffins. They were made by coffin makers back then. It was busted all to pieces. I took a little wood out inside, put a bass bar in it, got it fixed to where it works, and it's about the best fiddle I've got. Wasn't long after that I got another one just like it, did the same exact thing to it, but it turned out too loud. I can't stand it, can't stand to be in the same room with it. So you never know what you're going to end up with.

There was an old lady, Pearl Ball, that lived in the house right up on the top of that mountain and would sit on the front porch and play. You could hear her just as plain as day and that's half a mile over there. I thought that was the finest thing I'd ever heard. I went over there and hung out with the other kids and neighbors. They'd say, "Get your banjo Pearl, play us a song," and she would every time. I started learning by watching her. The old people that started it all, basically what you hear played on the radio now, that generation just has passed and that's sad. I played with many of them when I was a little fellow so I'll always have that, and I'll remember them.

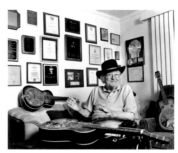

page 86

"Uncle Josh" Graves (1927–2006) *was born Burkett Howard Graves in Tellico Plains, Tennessee. He met Lester Flatt and Earl Scruggs at the Grand Ole Opry in 1957 and became a permanent member of their Foggy Mountain Boys, first playing bass, then Dobro, a brand of resonator guitar, and is credited with single-handedly reviving the instrument and introducing it to the world of bluegrass music. When Flatt and Scruggs split in 1969 he went with Flatt's Nashville Grass until 1971, then the Earl Scruggs Review until 1974. He worked as a session musician and had a solo career, then partnered with fiddler Kenny Baker in 1984, collaborating with him over a twenty-year period. In 1990 they teamed with Eddie Adcock, banjo virtuoso, and Jesse McReynolds on mandolin as the Masters, winning the IBMA's award for Instrumental Recording of the Year. Graves was inducted into the IBMA's Hall of Honor in 1997. His alter ego, Uncle Josh Graves, was created when he was a teenager to give a comic aspect to stage performances (www. myspace.com/unclejoshgraves).*

Blues has always been my favorite kind of music. Back home, in the late thirties and forties, black people couldn't even go in a restaurant. My daddy didn't care nothing about what people thought, he was just an old mountain man. Every month or two he'd have a party. My mother didn't allow drinking in

the house, so Daddy hid his whiskey down at the barn. He'd hire these two black guys, one was named Roosevelt Brown, and I'd sit right at their feet and listen to them play the blues. One played what they called a tater bug, big fat thing, kind of like an Italian mandolin, played some of the prettiest music you ever heard. They would take a little break and Daddy would say to the others, "Boys, come out here, I got you a little taste," and he would take his friends and go down to the barn. I would stay with Roosevelt, listen to them talk, whatever.

Daddy worked in the Babcock Aluminum Company, but we lived on a farm and I met this other old black man, a sharecropper. He lived across the creek from us and I would watch every evening when he'd come home from work. Had the funniest little old cabin—didn't even have glass in the windows, just shutters, and no porch, just steps. He'd eat supper then sit on them steps and play with a bottleneck on a fretless banjo and that sound would drive me crazy. I would go down, get so late that when Mama would call I'd be afraid to go home. I'll never forget him, taught me a lot of things.

Back then money was hard to come by, but when he could afford it Daddy would buy me a Carter Family or Jimmie Rodgers record. Cliff Carlisle done a lot with him—that Hawaiian steel guitar sound. I met Cliff when I was about nine years old when he played this schoolhouse in my little community. He called everybody "John" when he first meets you. He was talking to these guys and all of a sudden he seen me and come over and knelt down on one knee and said, "How are you doing, John?" It scared me so bad I think I wee-wee'd my britches. We got to be friends, and I love him to death. I hold him pretty high.

Jerry Douglas said, "You done me the same way when I was a kid." I was with Lester Flatt and the Nashville Grass then, and we was out at this campfire concert. There Jerry sat with his guitar. I started talking to him, and said, "Here, take mine." It scared him, man. He was already playing pretty good then. I said, "You ought to get something going on your own," and he did. He's a musical genius.

I took the guitar when I was fourteen years old, went to Knoxville, got off the bus. I had never been in a town that big. I was a kid but I didn't let it throw me. I went to work with Esco Hankins. First gig we worked we had an eighty-dollar house. That was big then, at fifteen, twenty-five cents a head. I stayed there, got married in '45.

I went to work with Flatt and Scruggs when I was about twenty-seven. We went fourteen years there and nobody changed jobs. It was just like a bunch of brothers on the road. We'd get into it among ourselves but nobody else better jump in. I enjoyed every day of it, until there at the end when they got to feuding and it was miserable. But money will do that to anybody.

Back in the forties it was rough. You just played anywhere you could. I worked clubs up through coal country in Kentucky and West Virginia. They'd put chicken wire up in front of the stage to keep your instruments or your head from getting busted with a beer bottle. I tell everybody I didn't make no money until I was fifty years old. Working for somebody else you don't. You build up something, get a draw, then you can get your price. Some of these groups, I don't see how they make it—must have day jobs. You go to festivals, these buses pull up, guys jump out with new suits on, open the compartment down there, bring out guitar cases that look like they just come out of the shop. You know they ain't been in it long. Any man that will tell you he ain't been hungry in this business ain't been in it long.

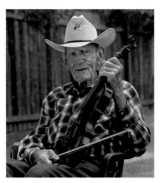

page 87

KENNY BAKER *was born in 1926 into a musical family from Jenkins, Kentucky. A world-renowned fiddler, his professional career began in 1953 when he went to work with singer Don Gibson. In 1957 Baker joined Bill Monroe's Blue Grass Boys, playing with him for more than twenty-five years, longer than any other musician. His stints with Monroe alternated with returns home to farm and work in the coal mines of his native state. In 1984 he left the group and soon teamed up with friend and Dobro player Josh Graves, whom he played and recorded with until Graves's passing in 2006. He has recorded over a dozen albums on his own, including the acclaimed* Spider Bit the Baby *(OMS Records, 2002). Baker has influenced countless old-time and bluegrass fiddlers during his long and prolific career (www.cmt.com; search artist).*

I became a musician because I was too lazy to work. That's what my grandpaw said. I asked him one time, "Grandpaw, how do you learn to play a fiddle?" He said, "Man be like his daddy, too sorry to work." He was just kidding me. My dad was a hardworking man and counted to be one of the best fiddlers in that country. Daddy wanted me to play a different instrument, guitar, so we could play together, because on Saturday nights there was always a big dance at somebody's house. They moved everything out

of the living room, and of course there would be a lot of moonshine, what have you. For them families the only recreation they got was music, particularly around them coal camps.

My ambition was to play fiddle. I loved it, really. There didn't seem to be much opportunity for making a career in music back then. I just wanted to be like my daddy. I learned to play by ear and he never made a note that I didn't take in. Hell, by the time I was nine years old I could play as good a rhythm as any man, after that kind of music. I heard it all my life. Most of the tunes were just stuff handed down. My grandfather was a player, and my great-granddaddy played. My grandmother played fiddle and I recorded a number I got from her.

If Daddy wasn't playing his fiddle on Saturday night he would listen to the Grand Ole Opry. His favorite fiddler was Fiddlin' Arthur Smith and His Dixie Liners, and mine, too, if you want to know the truth. If Daddy liked him, I had to like him. I got to listen to some Texas swing, Bob Wills, what have you. I heard his group on a radio show. I never heard a fiddle sound like that. That's what started me. I had an old buddy pick me up that record. I didn't realize there was three fiddles on it, that's what was throwing me. I got to where I could near play all three parts on that song, made the one fiddle sound like three.

My first professional music job was with Don Gibson, and I believe I learned more music from him than anybody. He was one of the finest rhythm players in the business and taught me a lot of minor changes and stuff like that. As a matter of fact, I give him credit for being one of the finest musicians, singers, writers, and guitar players I've ever seen. He was a good man to work with, too. For about five years there I would work some with him

then go back to the coal mine, come back and play some more.

That was after the service. I got discharged from the navy and went straight back to the coal mines. At that time I had done some work with Bill Monroe. He came to Knoxville when I was with Don Gibson. I guess he'd been there about three or four days, and the man never spoke to me. I was in the dressing room tuning my fiddle, and he stuck his head in, said, "If you ever get dissatisfied, don't call me, just come to Nashville, I'll put you to work." I played with him starting about 1957. I'd heard his music but I'd never really tried to play it. I'd played old folk stuff, particularly old fiddle numbers, and was more interested in that.

When he was doing some recording he'd call me, say, "Kenny, you suppose you might get off? I'm fixing to do some recording. Could run as much as ten or twelve days." My supervisor at the mine would send me to the company doctor and he'd give me some time off. I would come down, record, get that stuff put out, and go back home to the mines. Done that four or five times. I would stay with him when I was in town. If we was fixing to record he'd play me the numbers, and we'd sit there, just me and him. He would play a line, I would see what he was doing, put it all together. A lot of times I wouldn't play it the way he was playing, I would play it the way I thought it should go, but he never did say anything against it. I tell you what, he never told me to change a note in my lifetime. Some thought he was hard to work with, stuff like that, but I always enjoyed playing with Bill.

I played with him about twenty-five years. I left in '84. Me and Josh got together then. I had known Josh a hundred years, and one day we just tied up. You can't beat him. When we first got together, folks knowed both of us drank quite a bit and said it wouldn't last. I guess they thought we'd kill one another or something, but I can tell you we've never had a hard word.

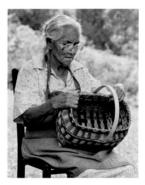

page 88

AGNES WELCH (1925–1997) *made baskets in the Cherokee, North Carolina, community for most of her life. In 1937, at the age of twelve, she attended the Cherokee Indian School and learned rivercane basket making under instructor Lottie Stamper, taking two-hour classes each day for nine months. She learned to make white oak splint burden baskets from her husband's mother in 1946 and was the first in her family to learn basketry. Mother of twelve, Agnes taught her daughters to make baskets as well. She used natural dyes to color the baskets and was known for her richly patterned designs. Born in the Big Cove section of the reservation, she was a member of the Eastern Band of Cherokee and the Qualla Arts and Crafts Mutual.*

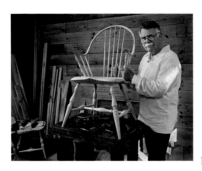

page 89

BILL SHOWALTER *is a chair maker living in Greeneville, Tennessee. One of his earliest childhood memories was a visit to Independence Hall in Philadelphia. When he returned years later, he couldn't get over his fascination with the American Windsor chairs on display there. Having done woodworking all his life, he decided to learn to make these chairs and now makes a limited number by hand in the tradition of master craftsmen of the Federal period in America (1776–1810). He is a member of the Southern Highland Craft Guild and displays his work at numerous craft fairs throughout the country (www.finewindsorchairs.com).*

In my former life as a civil engineer in the 1960s my purpose was to design and create, in my case, land development projects, subdivisions, planned communities. I had my own business in California and worked on projects throughout the western states. I sold my business in '85 and we moved here.

I've always fooled around with furniture making and been interested in Federal period furniture and Windsor chairs, which is a very narrow niche of that specialty. During this period these were common furniture for the American middle class so they were made in large numbers all over the major cities of New England, principally. A few were made in the South, in Charleston, South Carolina, and over in New Bern and places like that in North Carolina. I've spent almost twenty years now focusing on the craft of that period, the techniques and the designs. I've tried to re-create the methods of construction and joinery and understand how they were made and why so many of them endured so long.

They last because of the quality of construction, but it wasn't by accident. Chair makers were extremely aware of the characteristics of different materials and how to use them. The use of materials was very sophisticated, clever, and efficient of manual labor, as it doesn't require a lot of special joinery and techniques — mortise and tenon, that sort of thing — like formal, fancy furniture does. These were typically made by master makers who had apprenticed under other masters, that whole process. And so even though a lot of the designs and details were not necessarily perfect and pleasing, most of them were well made, interestingly enough.

The pieces I make are based on pieces made by the better-known makers of this period, but they're not exact copies. I've attempted to interpret the best elements and can take the time to focus on one chair and try to make each piece as fine as I can. I bring a little bit of engineering background to it because I'm aware of the science of materials and how they're used.

It doesn't require very much to do this kind of work, no electricity or plumbing, just hand tools. I created a main shop that is a copy of Andrew Johnson's tailor shop in Greeneville, a single-room frame structure with a fireplace, dating from about the 1830s. There's really nothing machines can do to create the piece, but I will occasionally use a motor lathe, as it's difficult for me to turn a very large number of pieces using a treadle lathe. I don't have any apprentices, or waterwheel, to run the lathe, which would have been common in that era. In the case of the turnings, the machine

doesn't create them but it creates the power to make it go around.

Every chair is made the same way with three different kinds of materials. Everything's worked green from the tree, except the white pine seats, which are sawn and air-dried for two or three years. The spindles and bent parts are always red oak or hickory and the turnings—the legs and arm posts—are birch or maple. By the time they have been shaped, the maximum dimension of any piece that I use is three-quarters of an inch and will dry fairly quickly. Everything is jointed with mechanical connections, either pegs or wedges or tapers. It doesn't depend on glue to hold it together, which is one of the reasons that these chairs rarely come apart.

I try to create something that's going to be around long after I'm gone, a keepsake and heirloom to pass on. I get the satisfaction of creating things. Actually money isn't even an element of it. I only sell them to people that I want to, that I like. Unlike the original makers, I always sign and date the bottom of it in ink with a quill pen. I dream of it being here two hundred years from now and somebody saying, "How did this get here? I wonder who the heck he was?"

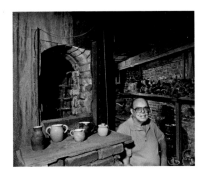

page 90

THOMAS CASE *lives in Arden, North Carolina, and runs Pisgah Forest Pottery, a family business started by his grandfather Walter B.*

Stevens. He produces pottery and sells through a shop on site. Many of the early pieces produced at the pottery are excellent examples of American folk art. Pisgah pottery has become highly collectible in recent years and is included in many personal and institutional collections including those of the North Carolina Museum of Art, the Mint Museum, Asheville Art Museum, and the Smithsonian.

My granddaddy passed away when my father was about a year old and my grandmother remarried, to Walter Stevens. He and his mother worked together making pottery out in the Midwest before he came to this part of the country in 1926 and started a pottery.

I worked at Ecusta for thirty-seven years and also here with my grandfather Stevens and Mr. Ledbetter. Mr. Stevens passed away in 1961 and Mr. Ledbetter three or four years ago, so I do this myself now. I was born and raised in the house right over here and started helping out when I was fifteen or sixteen. This kiln was originally built in the late thirties but it's been reworked several times. When I was a boy I used to have to crawl through this hole to get inside. They would hand me pieces and I would stack them on the shelves—worked from the back out to the door. When we were through with the firing and the kiln cooled down I would crawl back in and hand the pieces out.

In the thirties and forties several people worked here. They made a lot of pottery, little cream and sugar sets, pitchers, vases for flower arrangements, and quite a bit of tableware—plates, cups, saucers, and cereal bowls. They say you can't make crystalline pieces in a kiln like this but we did. Mr. Ledbetter and I fired it with wood and used it up until the sixties. Also had a coal kiln out here back in the fifties,

and my grandfather and I made a lot in that. We would fire up to cone nine and ten, which is better than twenty-two hundred and fifty degrees. I have a gas-fired kiln I use now for the bisque firing and an electric kiln for the finished firing.

Everything that's been made around here has been hand thrown on the potter's wheel. Most of the pieces have the Pisgah Forest design on the base and are dated. They made a wine color, jade green, forest green, yellows, browns, just all colors, but the turquoise blue is more or less what we're recognized for. Mr. Stevens did a lot of what they call cameo work. He put the decoration on pieces, done freehand. It's a porcelain paste where he would put a layer on and let it dry, then put another layer and build it up. It was quite tedious work. He made a lot of teapots and cream and sugar sets with the cameo designs on them, like a covered wagon and horses, a spinning wheel, musicians, and little Christmas scenes.

I don't think they've ever made a piece of pottery here they couldn't sell. Years ago, every couple of weeks when they fired a kiln, people from the Southern Highland Craft Guild would come pick out what they wanted. We also had a sales room up here, and we sold to gift shops all around. For several years we made pitchers for the Curry Company at Yosemite National Park—packed them up in barrels and shipped them out to California.

It's enjoyable working on the potter's wheel, making things. It's not manufactured or mass-produced. We even dig our own clay and make the glazes. Each piece is more or less individual. It doesn't matter whether it's a small pitcher or a mug, there's a little difference in everything.

page 91

KASPER "STRANGER" MALONE (1909–2005) *posthumously holds the world record for Longest Working Career-Recording Artist (1926–2005) in the Guinness Book of World Records. Malone recorded old-time music with Clayton McMichen, Riley Puckett, Gid Tanner, Lowe Stokes and the Melody Men, and the Skillet Lickers. He also played with swing musician Jack Teagarden, jazz with Pee Wee Hunt and Benny Goodman, cowboy swing with Gene Autry, polka with Lawrence Welk, classical music with the San Francisco, Denver, and Tucson Symphony Orchestras, and folk and bluegrass in north Georgia. His career included playing music in silent film orchestras and radio station bands and he was on some of the first recordings ever made by Columbia Records in 1926. He is the subject of* Who's That Stranger?, *a thirty-minute film documentary.*

I was born and raised in McCracken County, Kentucky. We were tobacco farmers and had sorghum molasses, a cider mill, raised chickens. My father and mother played organ, a couple of brothers played guitar, violin. I could read music by the time I entered school and started playing professionally at fifteen. My brother ran the farm after my father had passed on, but I wanted to be a musician. I told my mother and she said, "You're a good boy, you'll take care of yourself." I sold my cow and few possessions and took off.

I went to Miami. It was expensive there and no music for anyone my age. On my way back north I stopped just out of Rome, Georgia, where I saw a band tuning up. I was hitchhiking and told the driver, "I'll get out here." I joined them and we worked for a land auction company. They would buy tracts near a town, grade up streets, prepare for a cotton mill or something to come in. They would fix a big barbecue and there would be hundreds of people that attended those sales. The auctioneer would stand in the wagon and auction off the different lots, and when he was through at one place we would start the marching music and follow the wagon and bring the crowd with us to the next.

When that ended, I started playing clarinet in the movie theater orchestra for silent pictures. All at once sound movies came. *The Jazz Singer* was the name of the first and Al Jolson was the star. It was an immediate success and there were many more right away. I was working for the Princess Theater in Gadsden, Alabama, in 1928 when the ax fell. Two thousand theaters were affected, and the musicians were kicked out all at once.

I went on the road for a while. I was twenty years old and started with a miniature, or flea, circus band. We had red uniforms and played the regular circus music things, like when the jugglers came in and for the clown and the acrobats. The master of ceremonies was an English gentleman with riding boots and a whip. They did it in theaters throughout the Midwest. It was a real experience, a lot of fun.

After that show closed, I went to Seneca, Kansas, and played with little bands around there, weekend things. Then I was fortunate to get into radio as staff musician. I might be playing tuba with a German band and a half hour later clarinet for a Czech program,

then some Polish or Swedish music. This was up in the Dakotas—populated with those nationalities. It was all live music, no records played at all. That came much later, started in 1930. Then I bought a Model-T Ford, the roadster, no top, for thirty-five dollars, took off for South Dakota. I used that place for a long time. I might work there six months and get itchy feet and go somewhere else.

When I was playing baritone sax with one of the bands, some big old hillbilly fellow said, "Who's that little stranger fellow that plays that big horn?" That's where I got my nickname. Everybody in that little town had a nickname. One fellow walked a little funny and they called him Thumpy. Another old fellow they called Thuzelah, for Methuselah. They had a fiddle player there who was a little bossy called Governor. Harry Sullivan played a twelve-string guitar so they called him Harp.

I eventually married a lady from Yankton and we raised a family, two daughters. I also worked three years at WIBW, Topeka, Kansas, and went from there to the Denver Symphony, and when the war came on I was working every radio station in Denver. I went into the Maritime Service and was there two years and twelve days—played in their band, too. I've been all around the world, you might say. In 1935 I worked on a luxury liner, the Dollar Line. We went to China, Japan, Philippines. When I got back to San Francisco I took a job on the Grace Line through the Panama Canal, along South America, Cuba, to New York. I didn't care for New York so I went back home again to South Dakota.

I live in Rome, Georgia, now. That's back where I first started playing in the theater in 1925. I'm like the old salmon that goes all over the world and comes back to the lake where it was born. I guess that's the end of my travels.

Tim Barnwell is a photographer based in Asheville, North Carolina. His career has spanned more than thirty years as both a professional photographer and a photography instructor, including eight years (1980–88) as executive director of the nationally recognized school Appalachian Photographic Workshops.

His images have been widely published, appearing in dozens of magazines, including *Time*, *Newsweek*, *Southern Accents*, *House Beautiful*, *American Craft*, *Outdoor Photographer*, *Sky and Telescope*, *Billboard*, *Travel South*, *American Style*, *Black & White Magazine*, *Aperture*, *LensWork*, and *National Parks*. He is the author of two other books, *The Face of Appalachia: Portraits from the Mountain Farm* (W. W. Norton, 2003) and *On Earth's Furrowed Brow: The Appalachian Farm in Photographs* (W. W. Norton, 2007).

Mr. Barnwell's fine art work has been included in dozens of group and one-man shows both in the United States and abroad and is widely collected. His prints are in the permanent collections of the Metropolitan Museum (New York), New Orleans Museum of Art, High Museum of Art in Atlanta, Mint Museum in Charlotte, SOHO Photo Gallery (New York), Newark Museum (New Jersey), and the Bank of America corporate collection.

Jan Davidson holds a Ph.D. from Boston University in Folklife, History and Museum Studies and a master's from UNC–Chapel Hill. He has served as director of the John C. Campbell Folk School in Brasstown, North Carolina, since 1992 and has been on the board of the North Carolina Arts Council since 1996. Jan has authored numerous articles and catalogues, and prior to working at the Folk School he was director of the Mountain Heritage Center at Western Carolina University for nine years. Like his father, who plays jazz piano, he is an avid musician and plays the banjo and fiddle (www.folkschool.org).

LIMITED EDITION HARDCOVER BOOKS

Hands in Harmony is also available in limited and special editions. *Hands in Harmony: Limited Edition* consists of consecutively numbered books, each signed by the author. The second version, *Hands in Harmony: Special Edition*, includes an autographed book with a correspondingly numbered and signed original photograph, mounted and matted. Books of both editions come in clothbound slipcases.

TRAVELING EXHIBITION AND PRINTS

A traveling exhibit of photographic prints, selected from images in this book, is available to galleries, museums, and universities. The show consists of thirty framed prints but can be modified or expanded to meet the needs of the exhibitor. An information packet is available upon request.

Images reproduced in this book are also available as fine art photographic prints and are offered in a variety of sizes. They are signed by the photographer and mounted and matted on museum board.

CONTACT INFORMATION

For information on the limited and special edition books, traveling exhibit, fine art prints, galleries representing Mr. Barnwell's work, and the most current schedule of upcoming shows, visit the Web page www.barnwellphoto. com and follow the link to the fine art pages. Inquiries can also be directed to the author at Barnwell Photography, 244 Coxe Avenue, Asheville, North Carolina, 28801 or to barnwellphoto@hotmail.com.

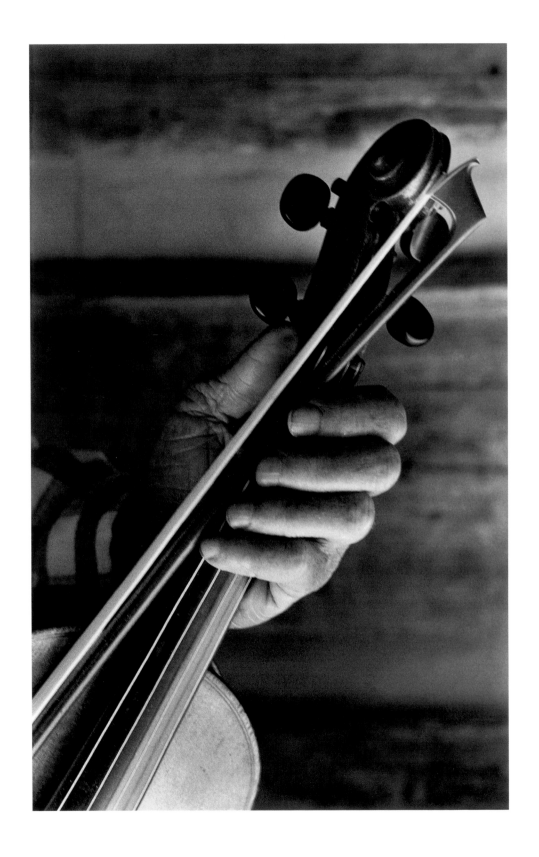

Byard Ray, fiddle and hand detail, 1978 • Asheville, Buncombe County, NC

Music on the CD

01 *Over the Hill to See Betty Baker.* Clyde Davenport from *Clyde Davenport Volume 2* (FRC 104). Released by Field Recorders' Collective. (www.fieldrecorder.com)

02 *William Riley.* Mary Jane Queen from *Songs I Like.* Released by Appalachian Mountain Folk Music. (www.henryqueen.com)

03 *Rye Whiskey.* Lee Sexton from *Whoa Mule* (JA080). Released by June Appal. 606-633-0108 (www.appalshop.org)

04 *Billy in the Low Ground.* Byard Ray from *A Twentieth Century Bard.* Released by Ivy Creek Recordings. (www.ivycreek.com)

05 *Out of Jail.* Algia Mae Hinton from *Honey Babe.* Released by Music Makers Relief Foundation. (www.musicmaker.org)

06 *Wounded Hoosier.* Marcus Martin from *When I Get My New House Done.* Released by Southern Folklife Collection, CB#3926, Wilson Library, Chapel Hill, NC 27514-8890. (www.lib.unc.edu/mss/sfc1)

07 *Young Hunting/Elzig's Farewell.* Sheila Kay Adams from *All the Other Fine Things.* Released by Granny Dell Records. (www.sheilakayadams.com)

08 *Carolina Breakdown.* Etta Baker from *Railroad Bill.* Released by Music Maker Relief Foundation. (www.musicmaker.org)

09 *Bonaparte's Retreat.* Ralph Blizzard and the New Southern Ramblers from *Fox Chase.* Released by Yodel-y-Hee Records, Phil Jamison, 53 Mt. Olive Church Rd., Asheville, NC 28804. (pjamison@warren-wilson.edu)

10 *Letter from Down the Road.* Laura Boosinger from *Down the Road.* Released by Laura's Label. (www.lauraboosinger.com)

11 *Lafayette.* Roger Howell from *Hills and Heroes.* Released by Bearwallow Music. (www.cdbaby and search)

12 *Free Little Bird.* Jan Davidson from *Nighthoots & Morningsongs.* Released by John C. Campbell Folk School. (www.folkschool.org)

13 *Two O'Clock.* Charlie Acuff from *Better Times A comin'.* Released by Cleff'd Ear Productions, PO Box 13075, Lansing, MI 48901.

14 *I'm Going to the West.* Mike Seeger. Original recording for this CD courtesy of the artist. (www.mikeseeger.info)

15 *That Pretty Girl Won't Marry Me (Uncle Henry).* Don Pedi from *Short Time Here.* Released by Don Pedi. (www.donpedi.com)

16 *Logan County Jail.* Peggy Seeger from *Love Call Me Home.* (Arranged by Peggy Seeger and Eliza Carthy). Released by Appleseed Recordings. (www.pegseeger.com and www.appleseedmusic.com)

17 *Train Killed the Mule.* Oscar "Red" Wilson from *Mountains, Moonshine, & Music.* Released by Marie G. Wilson, 147 Elkins Rd., Bakersville, NC 28705.

18 *Haven't Seen Mary in Years.* Benton Flippen from *Fiddler's Dream.* Released by Music Maker Relief Foundation. (www.musicmaker.org)

19 *Danville Girl.* Lee Sexton from *Whoa Mule* (JA080). Released by June Appal. 606-633-0108 (www.appalshop.org)

20 *Sail Away Ladies.* Tom, Brad, & Alice/Tom Sauber, Brad Leftwich, and Alice Gerrard from *Holly Ding.* Released by Copper Creek Record (www.coppercreekrecords.com and www.tombradalice.com)

21 *Young Edward.* Bruce Greene from *Five Miles of Ellum Wood.* Released by Bruce Greene. (www.brucegreene.net)

22 *Idumea.* Christian Harmony Singers/Jerry Israel, lead solo from *All the Other Fine Things* by Sheila Kay Adams. Released by Granny Dell Records. (www.sheilakayadams.com)

Hands in Harmony CD produced by Tim Barnwell and Don Pedi